nickelodeon

降击神通

AVATAR

THE LAST AIRBENDER

THE RIFT

Created by
BRYAN KONIETZKO
MICHAEL DANTE DIMARTINO

script
GENE LUEN YANG

art and cover
GURIHIRU

lettering
MICHAEL HEISLER

DARK HORSE BOOKS

publisher
MIKE RICHARDSON

editor
RACHEL ROBERTS

assistant editor
JENNY BLENK

designer
SARAH TERRY

digital art technician
SAMANTHA HUMMER

Special thanks to Linda Lee, James Salerno, and Joan Hilty at
Nickelodeon, to Dave Marshall at Dark Horse, and to Bryan Konietzko,
Michael Dante DiMartino, and Tim Hedrick.

This book collects *Avatar: The Last Airbender—The Rift* parts one through three.

Published by
Dark Horse Books
A division of
Dark Horse Comics LLC
10956 SE Main Street
Milwaukie, OR 97222

DarkHorse.com
Nick.com

To find a comics shop in your area,
visit ComicShopLocator.com

First edition: February 2021
eBOOK ISBN 978-1-50672-177-4
ISBN 978-1-50672-171-2

3 5 7 9 10 8 6 4 2
Printed in China

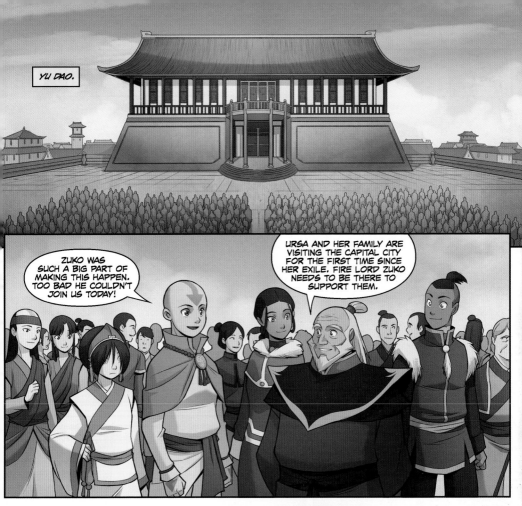

ZUKO WAS SUCH A BIG PART OF MAKING THIS HAPPEN. TOO BAD HE COULDN'T JOIN US TODAY!

URSA AND HER FAMILY ARE VISITING THE CAPITAL CITY FOR THE FIRST TIME SINCE HER EXILE. FIRE LORD ZUKO NEEDS TO BE THERE TO SUPPORT THEM.

HOW DID YOUR TENURE AS THE INTERIM FIRE LORD GO, IROH?

I HAD MUCH MORE FUN -- AND MORE *TEA* -- THAN I HAD EXPECTED! THE *NATIONAL TEA APPRECIATION DAY* WAS A ROUSING SUCCESS!

BUT IT ONLY MADE ME MISS MY LITTLE TEASHOP ALL THE MORE.

YOU'LL BE GOING HOME SOON, I HOPE?

OH YES! ATTENDING THIS IS MY LAST BIT OF OFFICIAL BUSINESS! AFTERWARDS, IT'S BACK TO BA SING SE FOR ME!

LOOKS LIKE THEY'RE READY TO MAKE AN ANNOUNCEMENT!

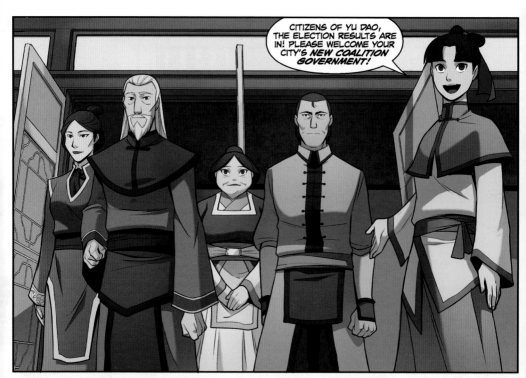

CITIZENS OF YU DAO, THE ELECTION RESULTS ARE IN! PLEASE WELCOME YOUR CITY'S *NEW COALITION GOVERNMENT!*

YAY!

HURRAH!

WOO-HOO!

CLAP! CLAP! CLAP! CLAP! CLAP! CLAP!

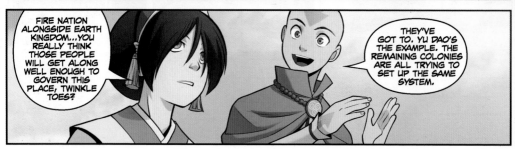

FIRE NATION ALONGSIDE EARTH KINGDOM...YOU REALLY THINK THOSE PEOPLE WILL GET ALONG WELL ENOUGH TO GOVERN THIS PLACE, TWINKLE TOES?

THEY'VE GOT TO. YU DAO'S THE EXAMPLE. THE REMAINING COLONIES ARE ALL TRYING TO SET UP THE SAME SYSTEM.

HM. I'LL BE RIGHT BACK.

EXCUSE ME! SORRY!

EXCUSE ME, PLEASE! I'M TRYING TO GET--!

EESH.

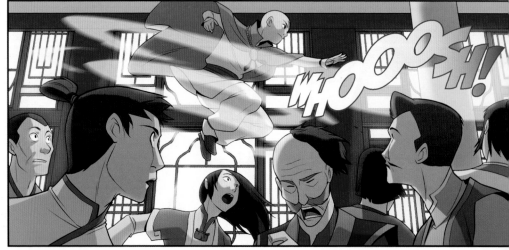

WHOOOSH!

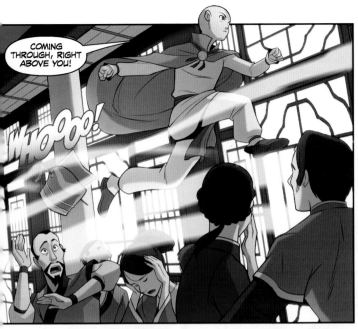

COMING THROUGH, RIGHT ABOVE YOU!

WHOOOO!

OOPS! SORRY ABOUT THAT!

HEH!

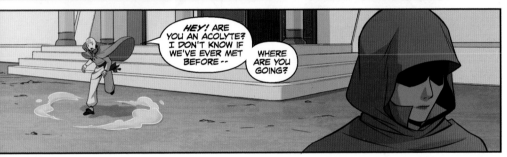

HEY! ARE YOU AN ACOLYTE? I DON'T KNOW IF WE'VE EVER MET BEFORE --

WHERE ARE YOU GOING?

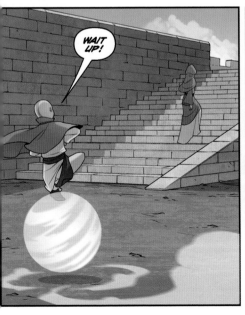

WAIT UP!

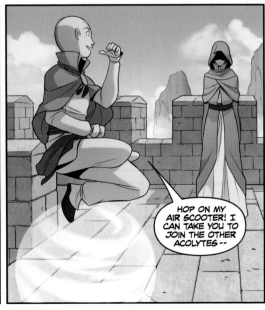

HOP ON MY AIR SCOOTER! I CAN TAKE YOU TO JOIN THE OTHER ACOLYTES --

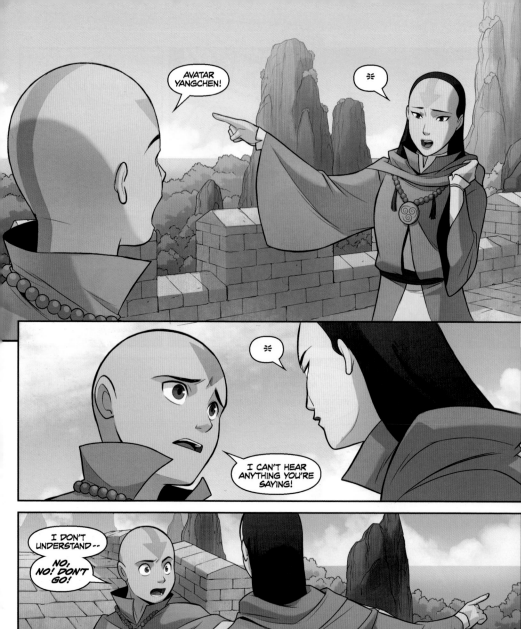

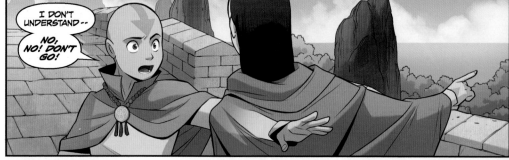

OH MAN, YU DAO'S GOTTA MAKE BRAND NEW GOVERNMENTS MORE OFTEN! MY MOUTH IS SO HAPPY RIGHT NOW!

YEE-LI, YOU'VE GOT TO TRY THE TURTLE-DUCK!

NO, THANK YOU. THE AIR ACOLYTES FOLLOW THE ANCIENT AIR NOMAD PRACTICE OF *VEGETARIANISM.*

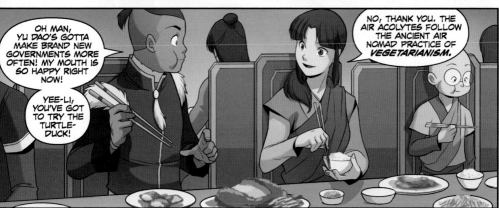

SORRY TO HEAR THAT. YOUR MOUTH IS MISSING OUT ON A WHOLE LOT OF HAPPINESS.

HOW ARE THINGS AT THE ACADEMY, TOPH?

GOOD, I GUESS.

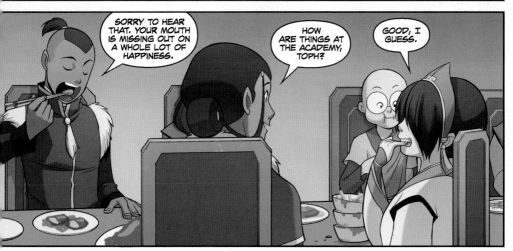

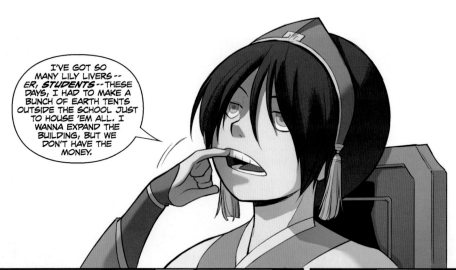

I'VE GOT SO MANY LILY LIVERS -- ER, *STUDENTS* -- THESE DAYS, I HAD TO MAKE A BUNCH OF EARTH TENTS OUTSIDE THE SCHOOL JUST TO HOUSE 'EM ALL. I WANNA EXPAND THE BUILDING, BUT WE DON'T HAVE THE MONEY.

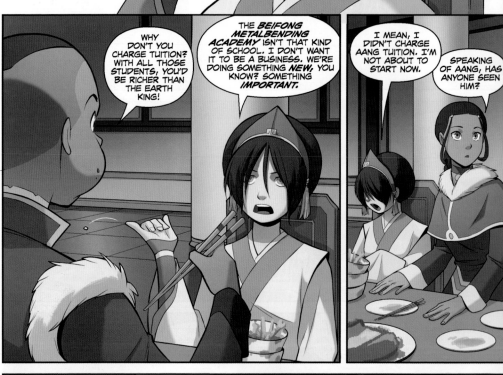

WHY DON'T YOU CHARGE TUITION? WITH ALL THOSE STUDENTS, YOU'D BE RICHER THAN THE EARTH KING!

THE *BEIFONG METALBENDING ACADEMY* ISN'T THAT KIND OF SCHOOL. I DON'T WANT IT TO BE A BUSINESS. WE'RE DOING SOMETHING *NEW*, YOU KNOW? SOMETHING *IMPORTANT*.

I MEAN, I DIDN'T CHARGE AANG TUITION. I'M NOT ABOUT TO START NOW.

SPEAKING OF AANG, HAS ANYONE SEEN HIM?

NOPE. BUT WHEN YOU FIND HIM, TELL HIM HE'S GOT TO RECONSIDER THAT VEGETARIAN THING. HIS MOUTH WILL THANK HIM!

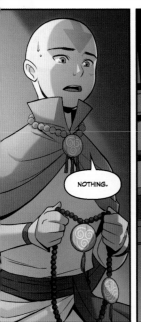

NOTHING.

AANG? WHAT'RE YOU DOING OUT HERE?

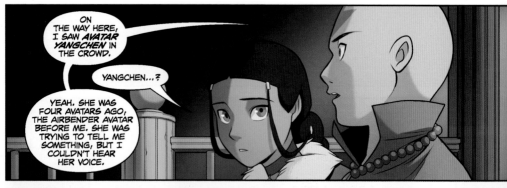

ON THE WAY HERE, I SAW *AVATAR YANGCHEN* IN THE CROWD.

YANGCHEN...?

YEAH. SHE WAS FOUR AVATARS AGO, THE AIRBENDER AVATAR BEFORE ME. SHE WAS TRYING TO TELL ME SOMETHING, BUT I COULDN'T HEAR HER VOICE.

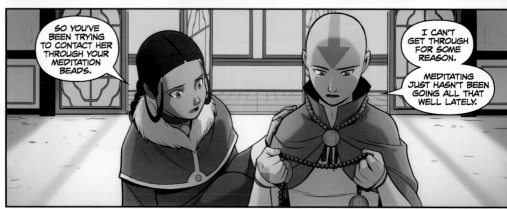

SO YOU'VE BEEN TRYING TO CONTACT HER THROUGH YOUR MEDITATION BEADS.

I CAN'T GET THROUGH FOR SOME REASON.

MEDITATING JUST HASN'T BEEN GOING ALL THAT WELL LATELY.

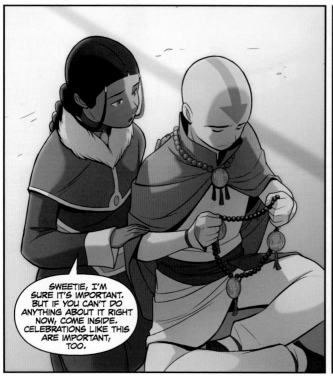

SWEETIE, I'M SURE IT'S IMPORTANT. BUT IF YOU CAN'T DO ANYTHING ABOUT IT RIGHT NOW, COME INSIDE. CELEBRATIONS LIKE THIS ARE IMPORTANT, TOO.

THAT'S IT!

CELEBRATIONS! OF COURSE!

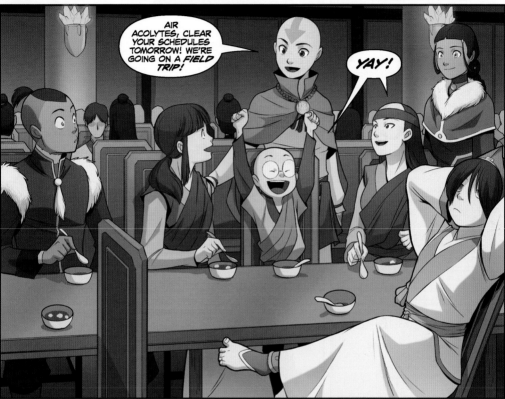

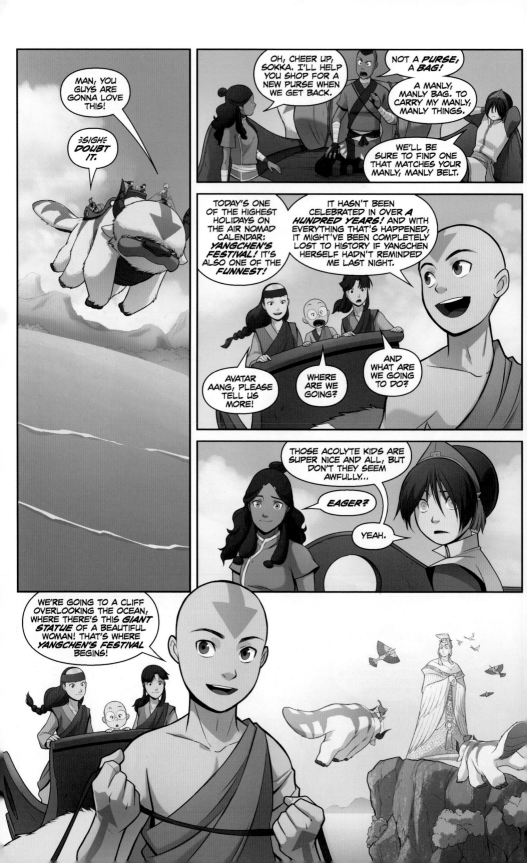

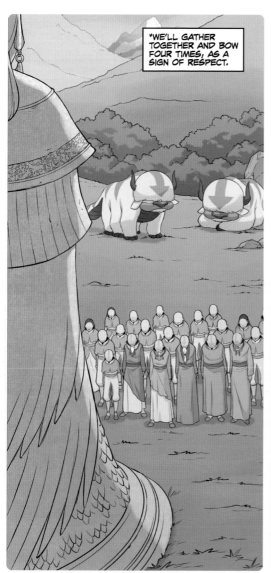

"WE'LL GATHER TOGETHER AND BOW FOUR TIMES, AS A SIGN OF RESPECT.

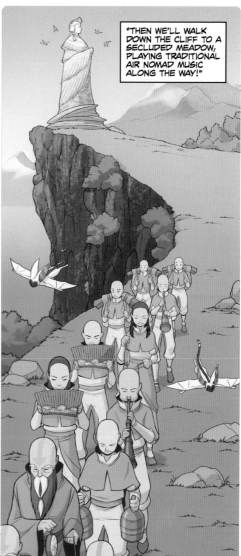

"THEN WE'LL WALK DOWN THE CLIFF TO A SECLUDED MEADOW, PLAYING TRADITIONAL AIR NOMAD MUSIC ALONG THE WAY!"

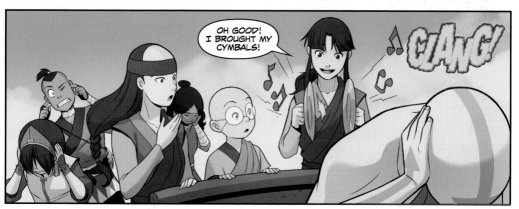

OH GOOD! I BROUGHT MY CYMBALS!

CLANG!

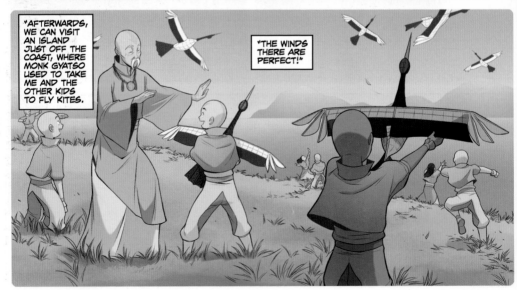

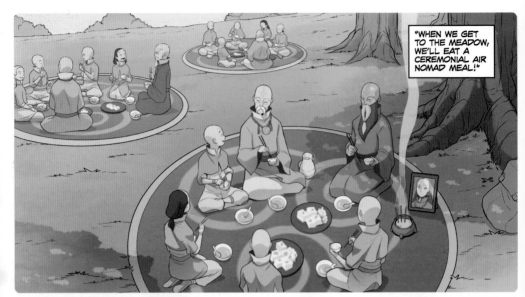

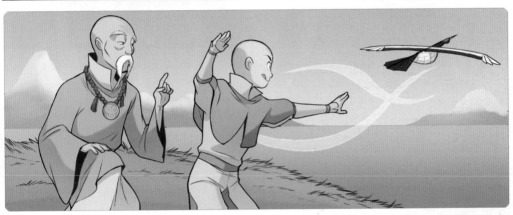

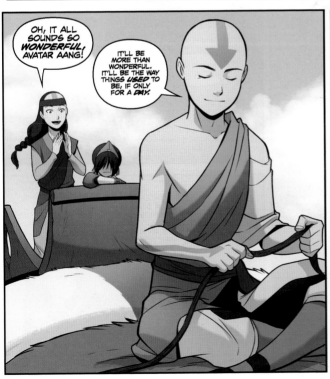

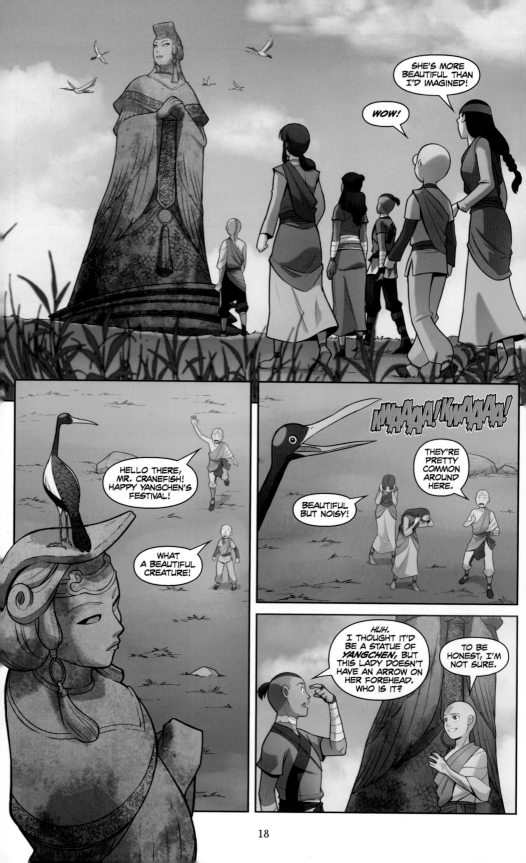

SHE'S MORE BEAUTIFUL THAN I'D IMAGINED!

WOW!

HELLO THERE, MR. CRANEFISH! HAPPY YANGCHEN'S FESTIVAL!

WHAT A BEAUTIFUL CREATURE!

KWAAAA! KWAAAA!

THEY'RE PRETTY COMMON AROUND HERE.

BEAUTIFUL BUT NOISY!

HUH. I THOUGHT IT'D BE A STATUE OF YANGCHEN, BUT THIS LADY DOESN'T HAVE AN ARROW ON HER FOREHEAD. WHO IS IT?

TO BE HONEST, I'M NOT SURE.

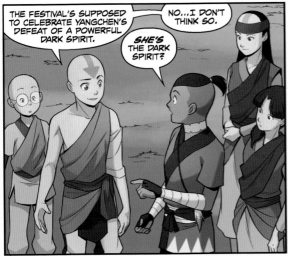

THE FESTIVAL'S SUPPOSED TO CELEBRATE YANGCHEN'S DEFEAT OF A POWERFUL DARK SPIRIT.

SHE'S THE DARK SPIRIT?

NO...I DON'T THINK SO.

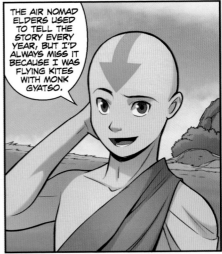

THE AIR NOMAD ELDERS USED TO TELL THE STORY EVERY YEAR, BUT I'D ALWAYS MISS IT BECAUSE I WAS FLYING KITES WITH MONK GYATSO.

YOU'LL HAVE PLENTY OF TIME TO LEARN THE INTRICACIES OF AIR NOMAD HISTORY WHEN YOU'RE OLDER.

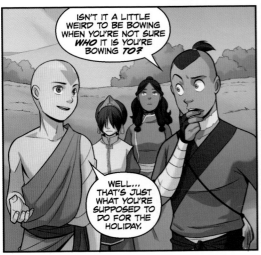

ISN'T IT A LITTLE WEIRD TO BE BOWING WHEN YOU'RE NOT SURE WHO IT IS YOU'RE BOWING TO?

WELL... THAT'S JUST WHAT YOU'RE SUPPOSED TO DO FOR THE HOLIDAY.

THAT'S JUST HOW IT'S DONE.

THAT'S JUST HOW IT'S DONE.

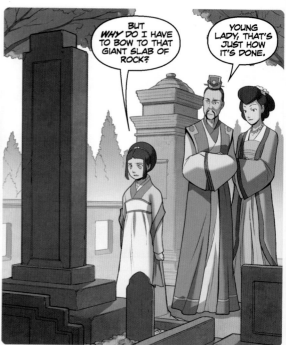

BUT *WHY* DO I HAVE TO BOW TO THAT GIANT SLAB OF ROCK?

YOUNG LADY, THAT'S JUST HOW IT'S DONE.

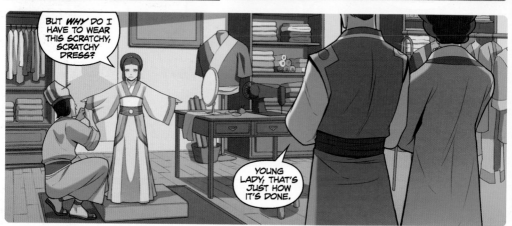

BUT *WHY* DO I HAVE TO WEAR THIS SCRATCHY, SCRATCHY DRESS?

YOUNG LADY, THAT'S JUST HOW IT'S DONE.

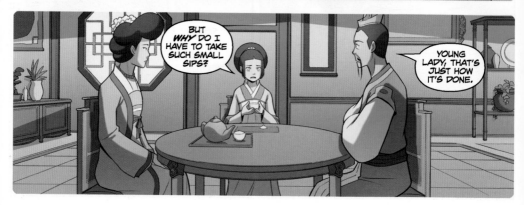

BUT *WHY* DO I HAVE TO TAKE SUCH SMALL SIPS?

YOUNG LADY, THAT'S JUST HOW IT'S DONE.

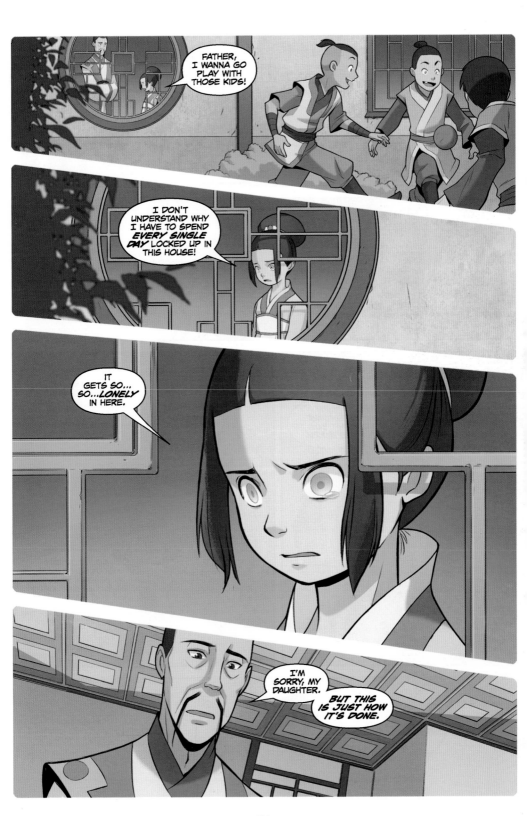

21

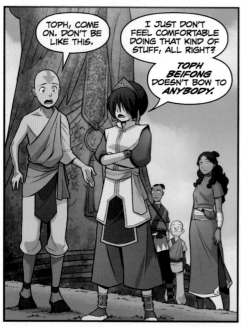

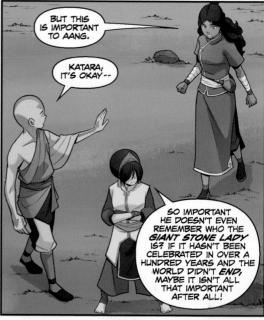

HEH HEH! DON'T MIND HER, AIR ACOLYTES! IN FACT, THIS IS A PERFECT LEARNING OPPORTUNITY!

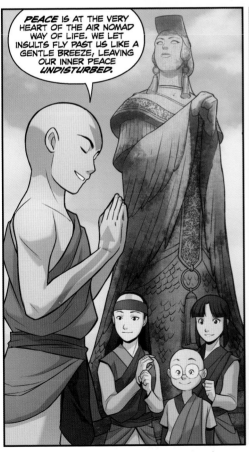

PEACE IS AT THE VERY HEART OF THE AIR NOMAD WAY OF LIFE. WE LET INSULTS FLY PAST US LIKE A GENTLE BREEZE, LEAVING OUR INNER PEACE *UNDISTURBED.*

COME. THOSE OF US WHO ARE *NOT* STUBBORN DUNDERHEADS WILL NOW DO OUR BOWS.

HARUMPH! BE MY *GUEST!*

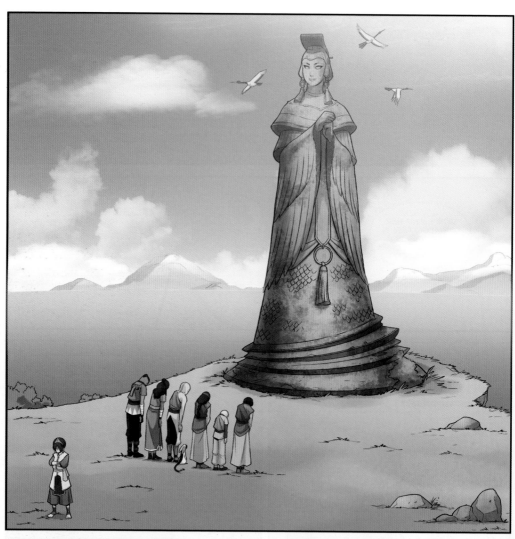

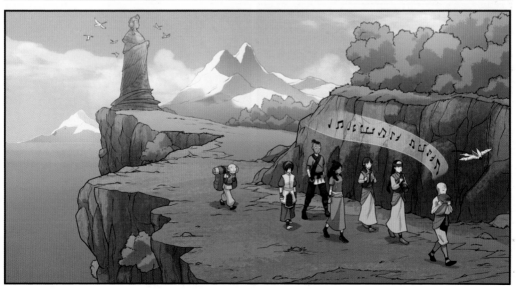

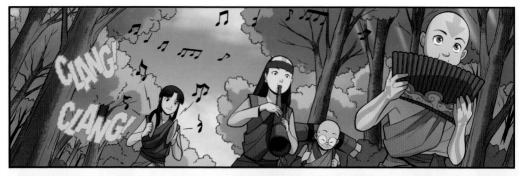

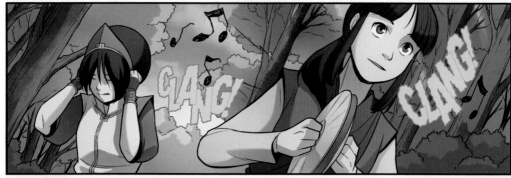

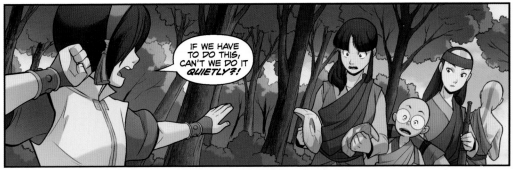

IF WE HAVE TO DO THIS, CAN'T WE DO IT *QUIETLY?!*

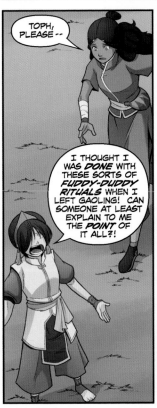

TOPH, PLEASE --

I THOUGHT I WAS *DONE* WITH THESE SORTS OF *FUDDY-DUDDY RITUALS* WHEN I LEFT GAOLING! CAN SOMEONE AT LEAST EXPLAIN TO ME THE *POINT* OF IT ALL?!

LET'S KEEP GOING, ACOLYTES. WE'RE ALMOST THERE.

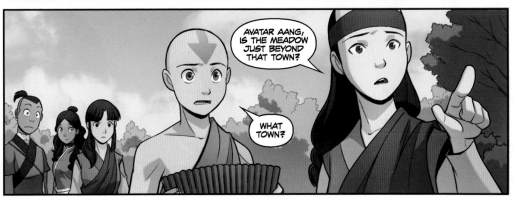

AVATAR AANG, IS THE MEADOW JUST BEYOND THAT TOWN?

WHAT TOWN?

27

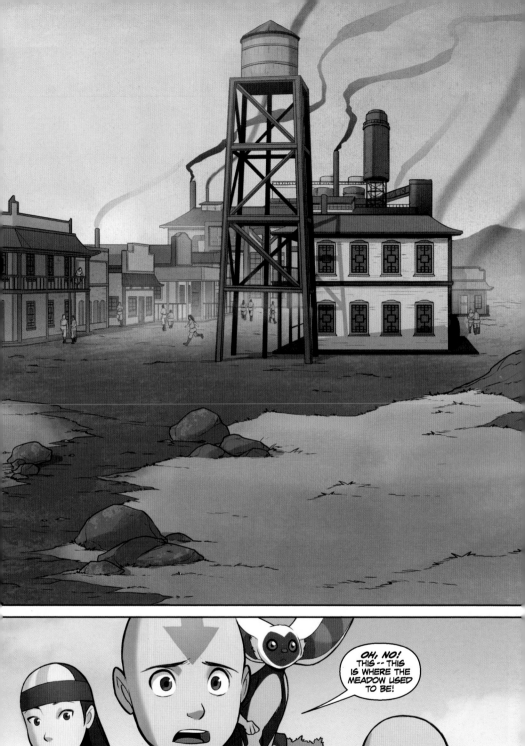

OH, NO! THIS -- THIS IS WHERE THE MEADOW USED TO BE!

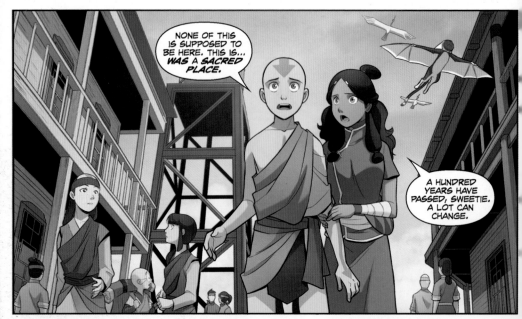

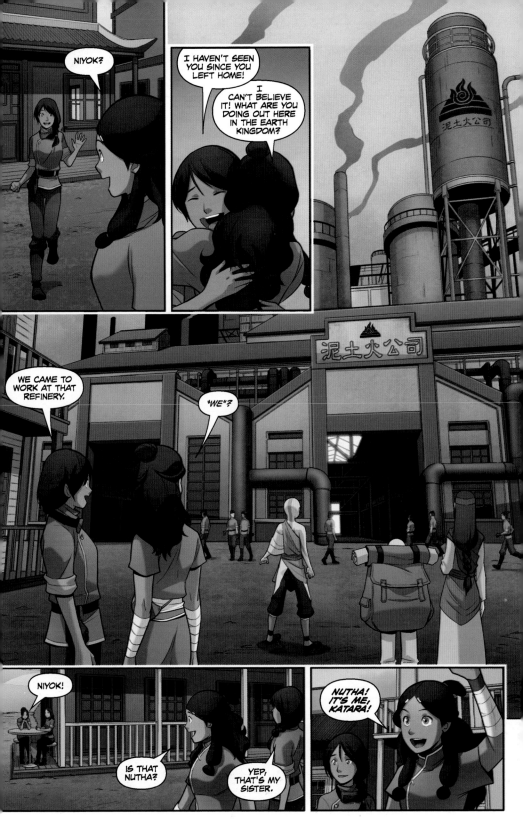

31

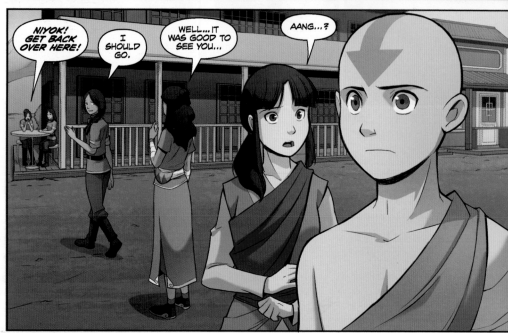

NIYOK! GET BACK OVER HERE!

I SHOULD GO.

WELL....IT WAS GOOD TO SEE YOU...

AANG...?

※

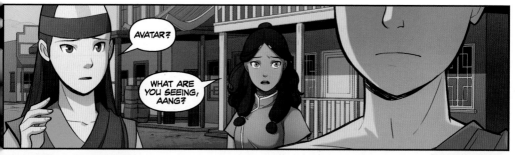

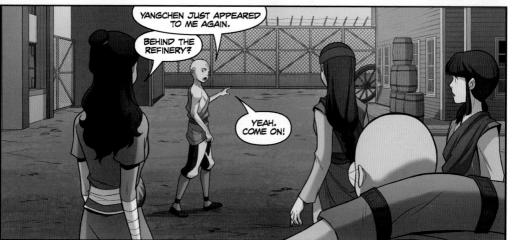

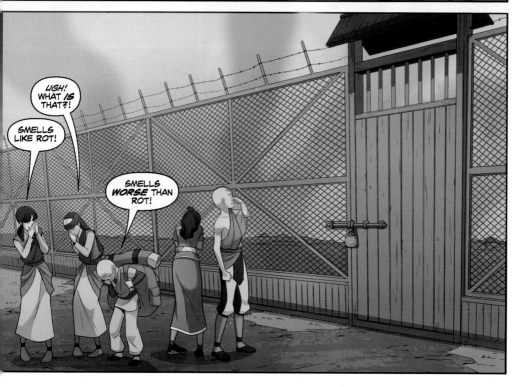

STOMP!

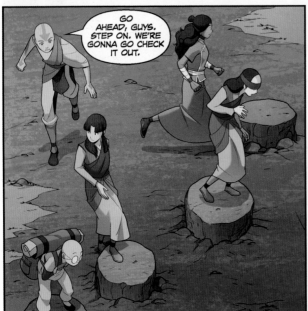

GO AHEAD, GUYS. STEP ON. WE'RE GONNA GO CHECK IT OUT.

BUT DOESN'T THE FENCE MEAN WE'RE NOT SUPPOSED TO BE HERE?

NO. THE *FENCE* ISN'T SUPPOSED TO BE HERE.

MAKE SURE YOU KEEP YOUR KNEES BENT.

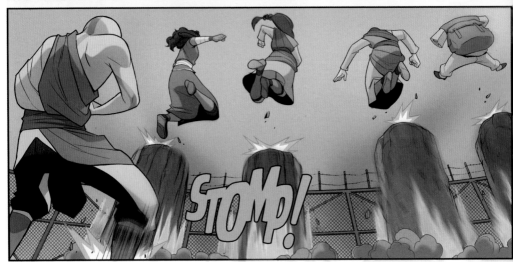

STOMP!

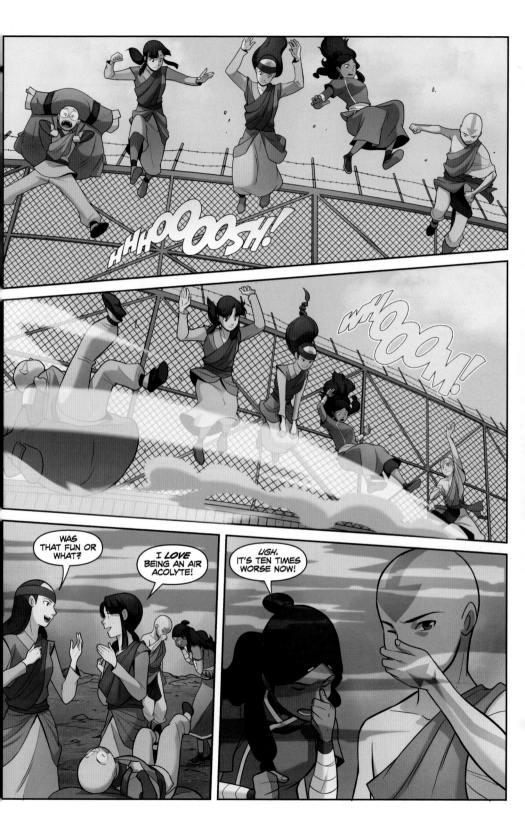

35

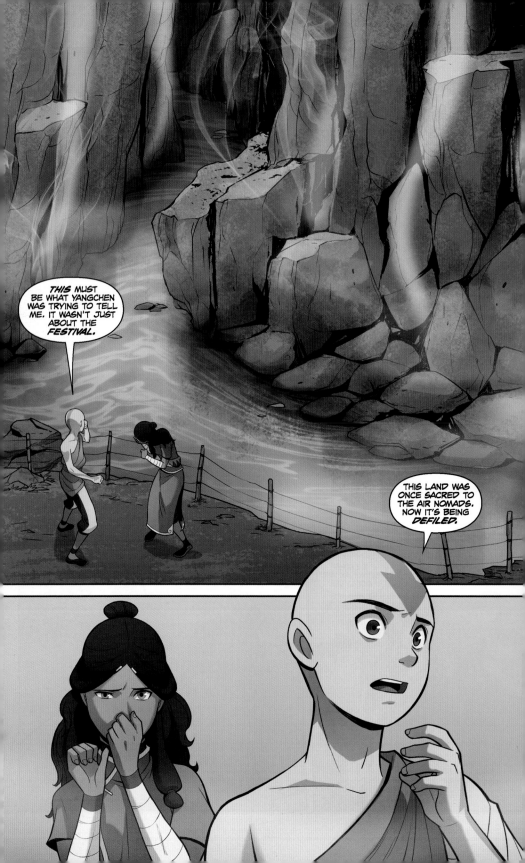

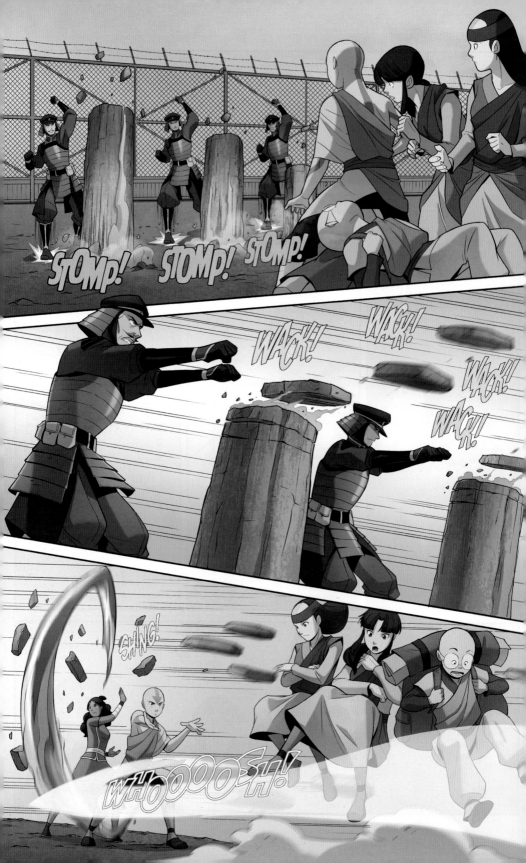

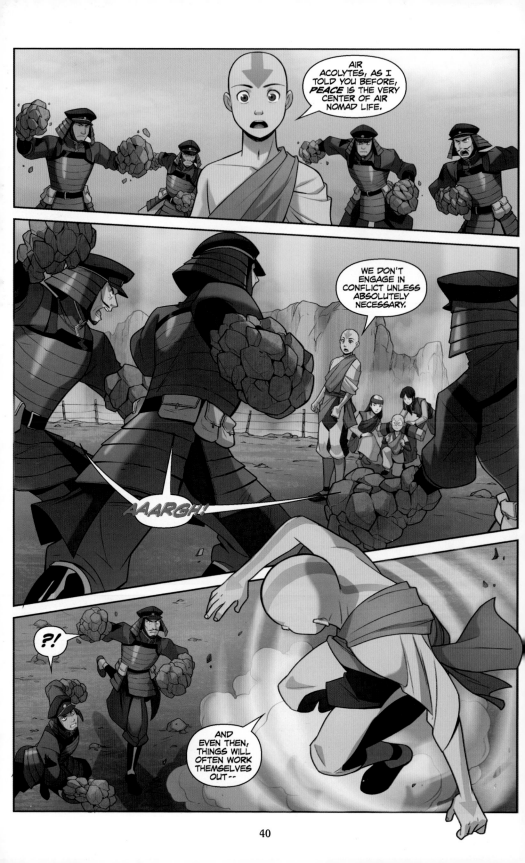

40

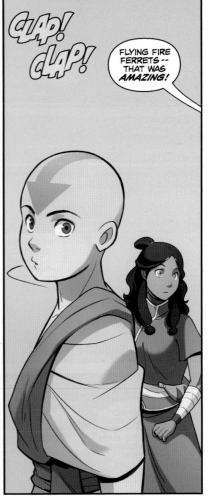

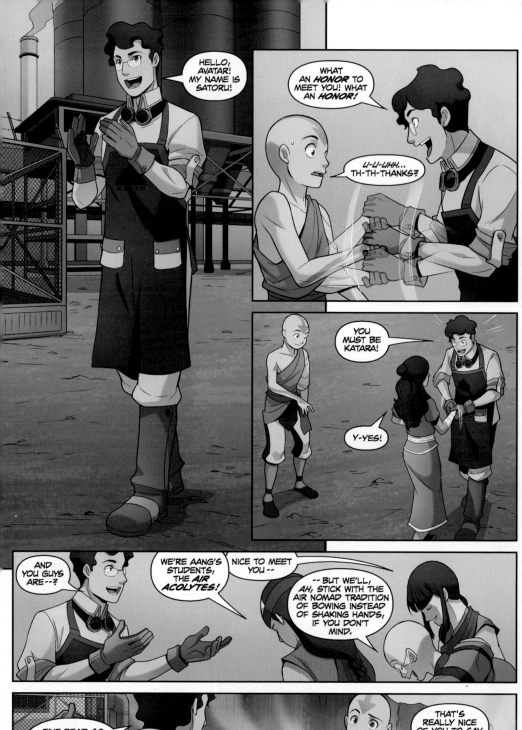

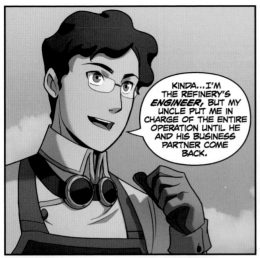

KINDA...I'M THE REFINERY'S **ENGINEER**, BUT MY UNCLE PUT ME IN CHARGE OF THE ENTIRE OPERATION UNTIL HE AND HIS BUSINESS PARTNER COME BACK.

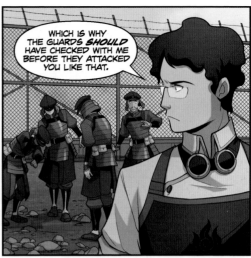

WHICH IS WHY THE GUARDS **SHOULD** HAVE CHECKED WITH ME BEFORE THEY ATTACKED YOU LIKE THAT.

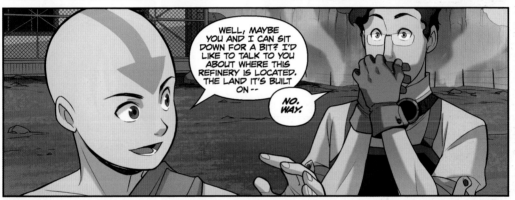

WELL, MAYBE YOU AND I CAN SIT DOWN FOR A BIT? I'D LIKE TO TALK TO YOU ABOUT WHERE THIS REFINERY IS LOCATED. THE LAND IT'S BUILT ON --

NO. WAY.

SATORU?

YOU OKAY?

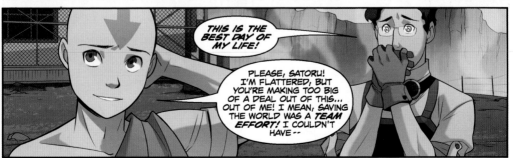

THIS IS THE BEST DAY OF MY LIFE!

PLEASE, SATORU! I'M FLATTERED, BUT YOU'RE MAKING TOO BIG OF A DEAL OUT OF THIS... OUT OF ME! I MEAN, SAVING THE WORLD WAS A **TEAM EFFORT**! I COULDN'T HAVE --

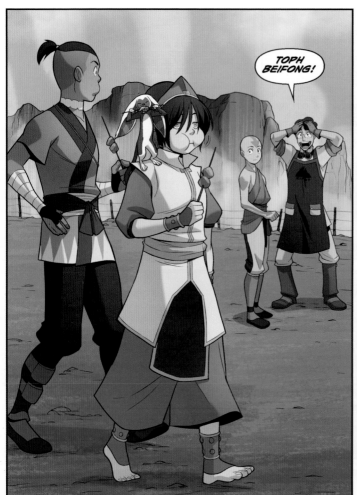

TOPH BEIFONG!

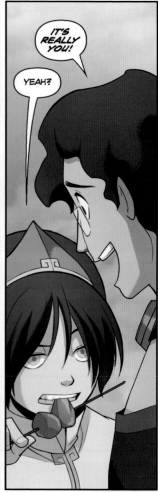

IT'S REALLY YOU!

YEAH?

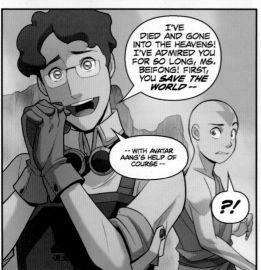

I'VE DIED AND GONE INTO THE HEAVENS! I'VE ADMIRED YOU FOR SO LONG, MS. BEIFONG! FIRST, YOU *SAVE THE WORLD* --

-- WITH AVATAR AANG'S HELP OF COURSE --

?!

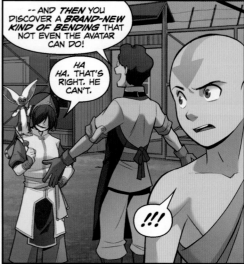

-- AND *THEN* YOU DISCOVER A *BRAND-NEW KIND OF BENDING* THAT NOT EVEN THE AVATAR CAN DO!

HA HA. THAT'S RIGHT. HE CAN'T.

!!!

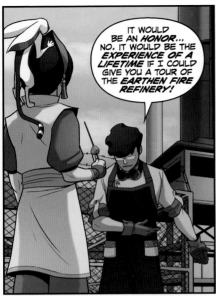

IT WOULD BE AN *HONOR...* NO. IT WOULD BE THE *EXPERIENCE OF A LIFETIME* IF I COULD GIVE YOU A TOUR OF THE *EARTHEN FIRE REFINERY!*

SATORU, WAS IT?

YOU SAID MY NAME!

SURE, SATORU. LEAD THE WAY.

OKAY IF MY FRIENDS TAG ALONG?

WHAT...? OH, YES! THEM!

OF COURSE YOUR FRIENDS CAN TAG ALONG!

SO GENEROUS OF TOPH TO LET US *"TAG ALONG."*

NO.

THIS MEAT IS SOOO GOOD. ANYONE WANT A BITE?

I'LL HAVE A BITE.

BY *"ANYONE,"* I MEANT ANYONE *VEGETARIAN.*

45

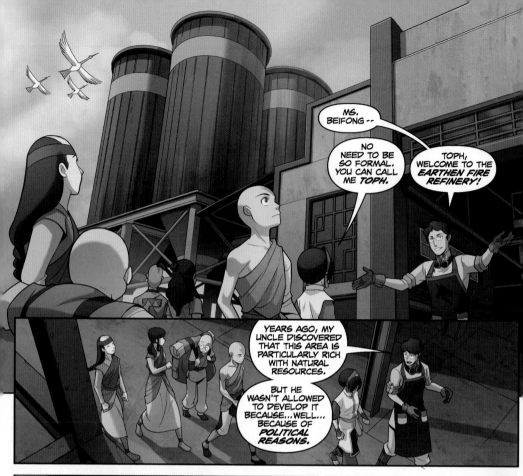

MS. BEIFONG --

NO NEED TO BE SO FORMAL. YOU CAN CALL ME *TOPH.*

TOPH, WELCOME TO THE *EARTHEN FIRE REFINERY!*

YEARS AGO, MY UNCLE DISCOVERED THAT THIS AREA IS PARTICULARLY RICH WITH NATURAL RESOURCES.

BUT HE WASN'T ALLOWED TO DEVELOP IT BECAUSE...WELL... BECAUSE OF *POLITICAL REASONS.*

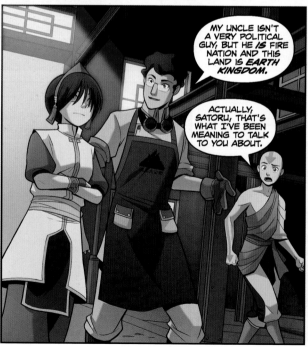

MY UNCLE ISN'T A VERY POLITICAL GUY, BUT HE *IS* FIRE NATION AND THIS LAND IS *EARTH KINGDOM.*

ACTUALLY, SATORU, THAT'S WHAT I'VE BEEN MEANING TO TALK TO YOU ABOUT.

THIS LAND MAY BE A PART OF THE EARTH KINGDOM CONTINENT, BUT HISTORICALLY THE *AIR NOMADS* HAVE ALWAYS --

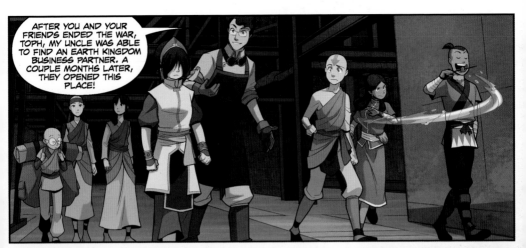

AFTER YOU AND YOUR FRIENDS ENDED THE WAR, TOPH, MY UNCLE WAS ABLE TO FIND AN EARTH KINGDOM BUSINESS PARTNER. A COUPLE MONTHS LATER, THEY OPENED THIS PLACE!

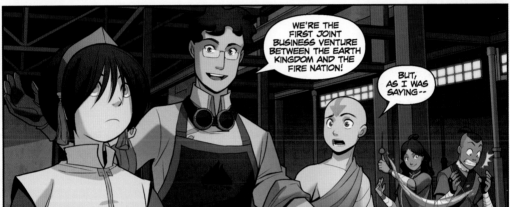

WE'RE THE FIRST JOINT BUSINESS VENTURE BETWEEN THE EARTH KINGDOM AND THE FIRE NATION!

BUT, AS I WAS SAYING--

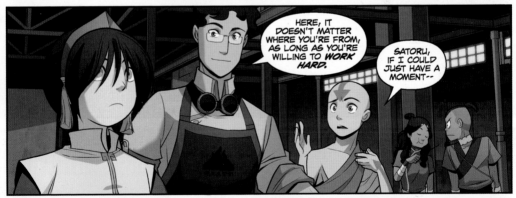

HERE, IT DOESN'T MATTER WHERE YOU'RE FROM, AS LONG AS YOU'RE WILLING TO *WORK HARD.*

SATORU, IF I COULD JUST HAVE A MOMENT--

PEOPLE FROM ALL OVER THE WORLD COME HERE--

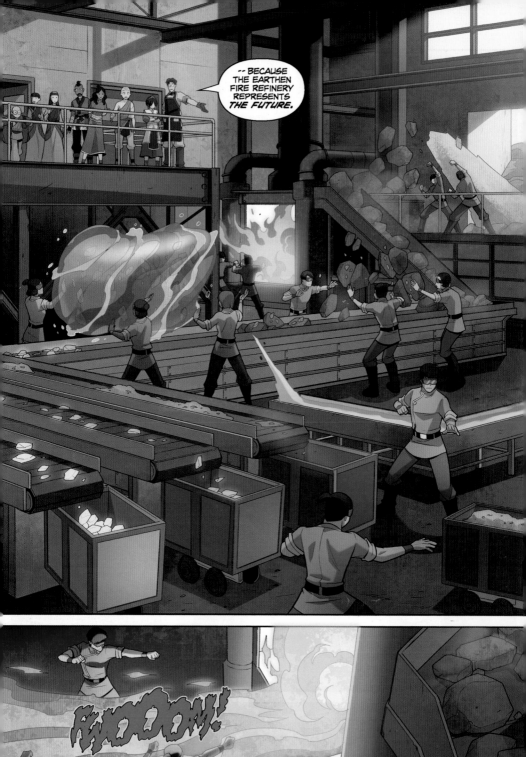

-- BECAUSE THE EARTHEN FIRE REFINERY REPRESENTS *THE FUTURE.*

FWOOM!

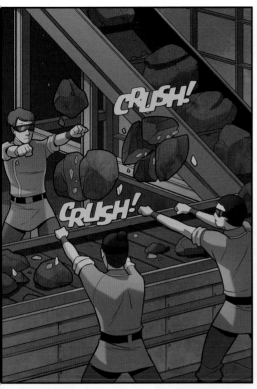

CRUSH!

CRUSH!

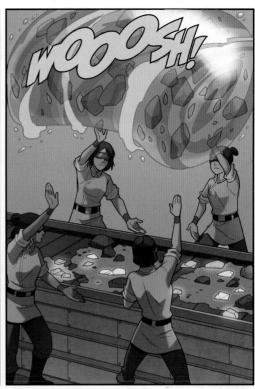

WOOOSH!

KCHUCK!

KCHUCK!

WOW.

YOU SAID IT, JINGBO.

IF YOU THINK *THIS* IS IMPRESSIVE, FOLLOW ME.

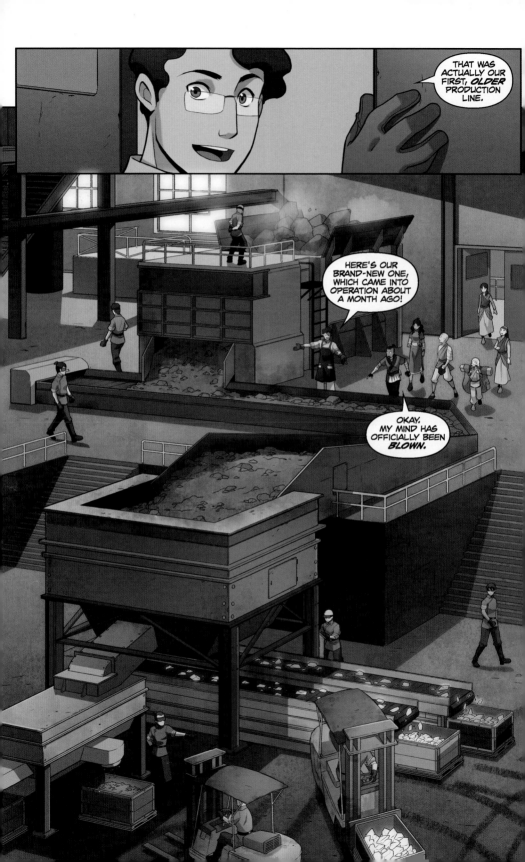

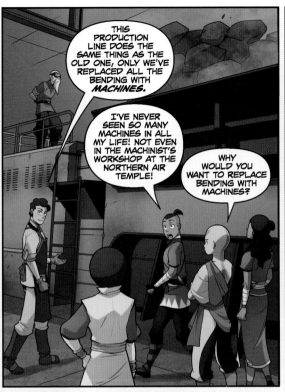

THIS PRODUCTION LINE DOES THE SAME THING AS THE OLD ONE, ONLY WE'VE REPLACED ALL THE BENDING WITH *MACHINES.*

I'VE NEVER SEEN SO MANY MACHINES IN ALL MY LIFE! NOT EVEN IN THE MACHINIST'S WORKSHOP AT THE NORTHERN AIR TEMPLE!

WHY WOULD YOU WANT TO REPLACE BENDING WITH MACHINES?

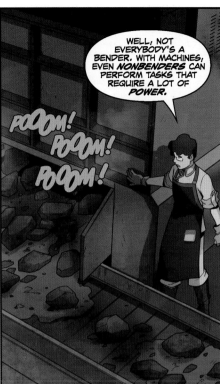

WELL, NOT EVERYBODY'S A BENDER. WITH MACHINES, EVEN *NONBENDERS* CAN PERFORM TASKS THAT REQUIRE A LOT OF *POWER.*

POOOM!
POOOM!
POOOM!

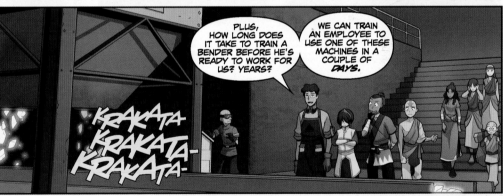

PLUS, HOW LONG DOES IT TAKE TO TRAIN A BENDER BEFORE HE'S READY TO WORK FOR US? YEARS?

WE CAN TRAIN AN EMPLOYEE TO USE ONE OF THESE MACHINES IN A COUPLE OF *DAYS.*

KRAKATA KRAKATA- KRAKATA-

BENDING JUST SEEMS SO MUCH MORE... *ELEGANT.*

KATA KATA-

THAT MAY BE TRUE. SO FAR THE BENDER LINE HAS BEEN MORE *EFFICIENT.*

BUT WE'RE FIGURING OUT WAYS TO IMPROVE THIS NEW LINE EVERY DAY.

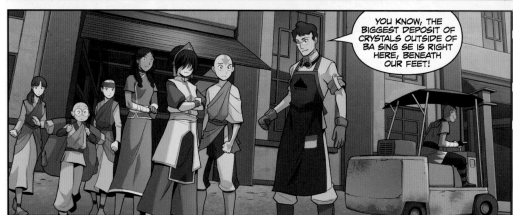

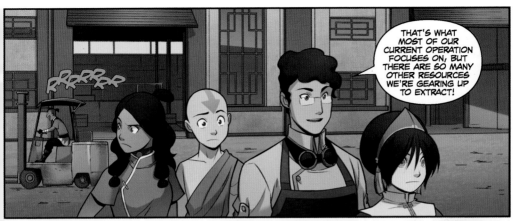

THAT'S WHAT MOST OF OUR CURRENT OPERATION FOCUSES ON, BUT THERE ARE SO MANY OTHER RESOURCES WE'RE GEARING UP TO EXTRACT!

RRRRR

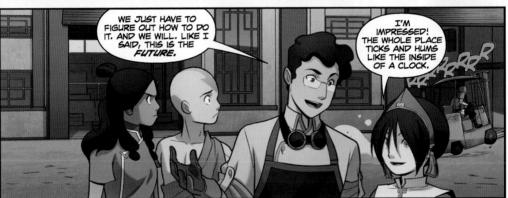

WE JUST HAVE TO FIGURE OUT HOW TO DO IT. AND WE WILL. LIKE I SAID, THIS IS THE *FUTURE.*

I'M IMPRESSED! THE WHOLE PLACE TICKS AND HUMS LIKE THE INSIDE OF A CLOCK.

RRRRR

HEY! HOW FAST CAN THIS THING GO?

RRRRRRRR

I'M NOT SURE. IT'S NOT REALLY BUILT FOR SPEED. IT'S MORE --

RRRR-- POP!

OOPS. SORRY ABOUT THAT.

NO, IT'S NOT YOUR FAULT. I'M STILL TINKERING WITH THE DESIGN.

Ffsss...

HE'S JUST BEING NICE, YOU KNOW. IT *IS* YOUR FAULT.

I KNOW.

YOU BUILT THIS?

YEAH.

≡TSK TSK≡ ≡SIGH≡

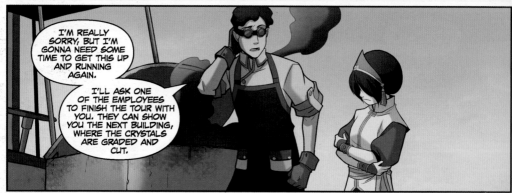

I'M REALLY SORRY, BUT I'M GONNA NEED SOME TIME TO GET THIS UP AND RUNNING AGAIN.

I'LL ASK ONE OF THE EMPLOYEES TO FINISH THE TOUR WITH YOU. THEY CAN SHOW YOU THE NEXT BUILDING, WHERE THE CRYSTALS ARE GRADED AND CUT.

STEP ASIDE.

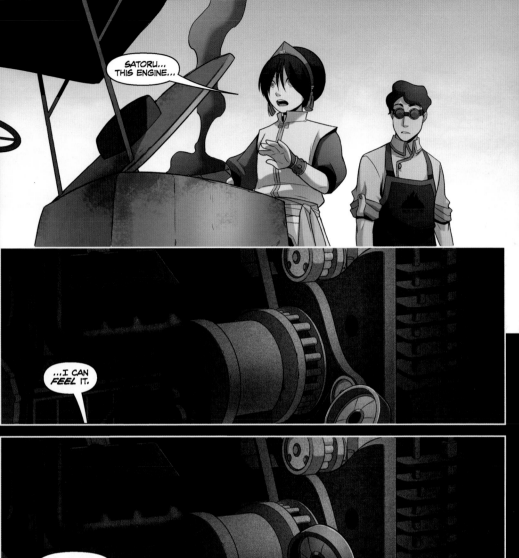

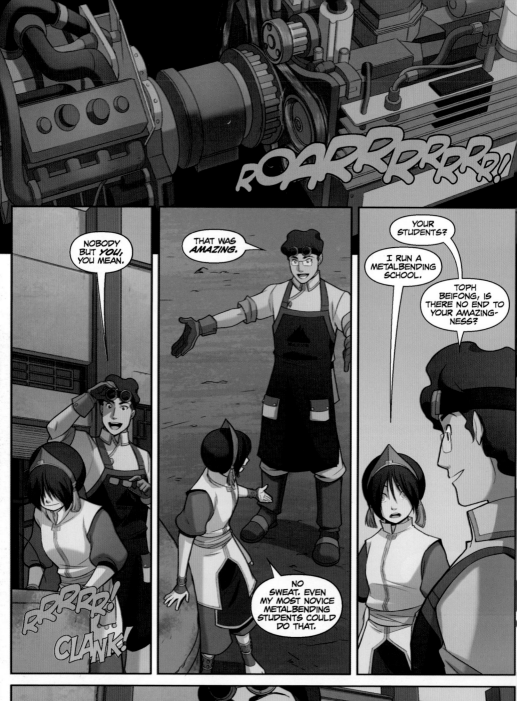

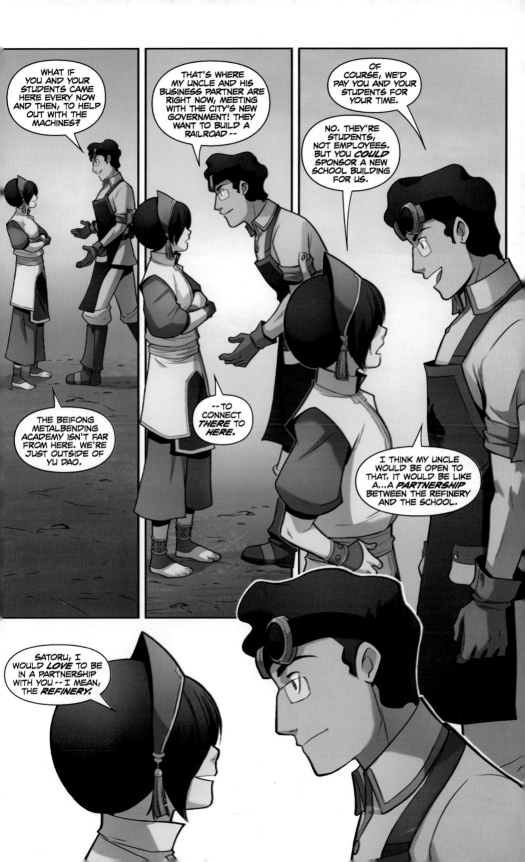

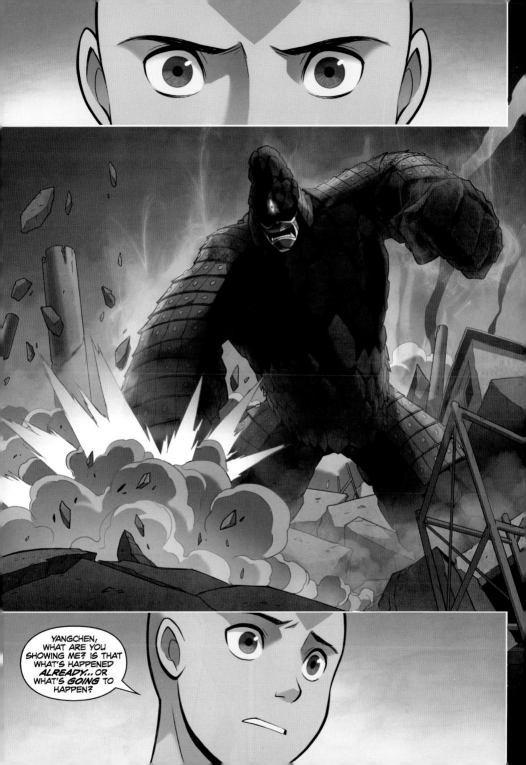

ARE YOU ALL RIGHT?

ANYTHING WE CAN DO TO HELP?

I -- I'M *OKAY.* I JUST NEED TO GET HIM TO LISTEN TO ME.

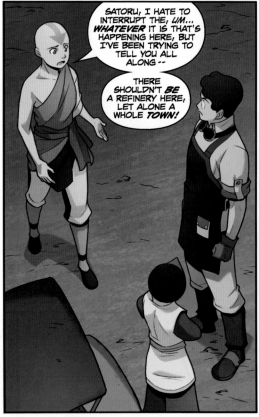

SATORU, I HATE TO INTERRUPT THE, *UM... WHATEVER* IT IS THAT'S HAPPENING HERE, BUT I'VE BEEN TRYING TO TELL YOU ALL ALONG --

THERE SHOULDN'T *BE* A REFINERY HERE, LET ALONE A WHOLE *TOWN!*

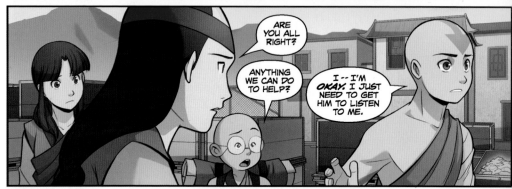

THIS LAND WAS -- *IS* SACRED TO THE AIR NOMADS! YOU AREN'T SUPPOSED TO BUILD ON SACRED LAND!

AVATAR, I --

NO OFFENSE, TWINKLE TOES, BUT WHAT IS THAT, A RULE FROM THE OLDEN DAYS?

NO ONE'S BEEN HERE FOR A HUNDRED YEARS! IF SATORU AND HIS UNCLE CAN FIGURE OUT A WAY TO MAKE THIS PLACE USEFUL, I SAY *GOOD FOR THEM!*

BUT YANGCHEN'S BEEN TRYING TO WARN ME... SHE JUST GAVE ME A *VISION.* I THINK *SOMETHING BAD* IS GOING TO HAPPEN.

LIKE WHAT?

I'M...I'M NOT SURE...I CAN'T HEAR HER FOR SOME REASON. AND THE VISION WASN'T ALL THAT CLEAR.

HERE WE GO AGAIN! MORE STUFF THAT'S SO IMPORTANT, YOU DON'T EVEN KNOW THE *DETAILS!*

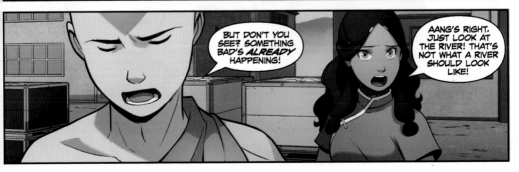

BUT DON'T YOU SEE? SOMETHING BAD'S *ALREADY* HAPPENING!

AANG'S RIGHT. JUST LOOK AT THE RIVER! THAT'S NOT WHAT A RIVER SHOULD LOOK LIKE!

--ISN'T BECAUSE OF THE REFINERY.

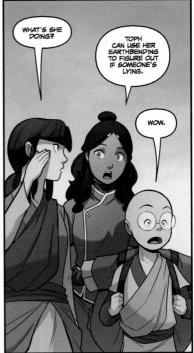

WHAT'S SHE DOING?

TOPH CAN USE HER EARTHBENDING TO FIGURE OUT IF SOMEONE'S LYING.

WOW.

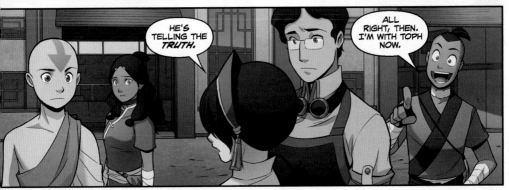

HE'S TELLING THE *TRUTH.*

ALL RIGHT, THEN. I'M WITH TOPH NOW.

MIND IF WE TALK ALONE FOR A MOMENT?

EXCUSE US!

63

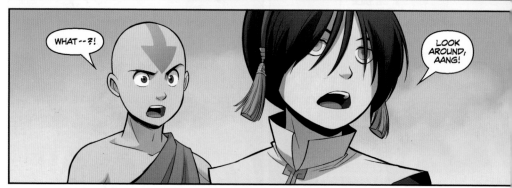

PEOPLE FROM ALL OVER THE WORLD ARE HERE, WORKING SIDE BY SIDE! ISN'T THAT EXACTLY WHAT YOU'VE BEEN WANTING FOR YU DAO?

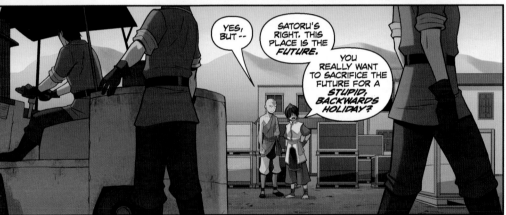

YES, BUT --

SATORU'S RIGHT. THIS PLACE IS THE *FUTURE.*

YOU REALLY WANT TO SACRIFICE THE FUTURE FOR A *STUPID, BACKWARDS HOLIDAY?*

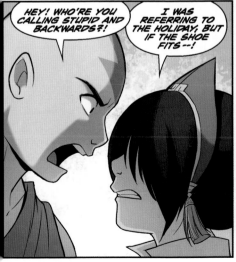

HEY! WHO'RE YOU CALLING STUPID AND BACKWARDS?!

I WAS REFERRING TO THE HOLIDAY, BUT IF THE SHOE FITS --!

?!

RUMBLE! RUMBLE!

?!

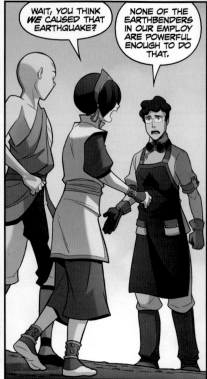

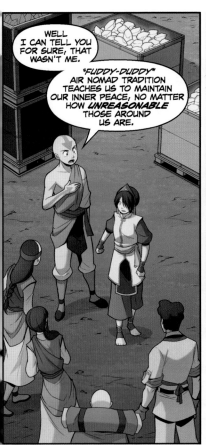

WELL I CAN TELL YOU FOR SURE, THAT WASN'T ME.

"FUDDY-DUDDY" AIR NOMAD TRADITION TEACHES US TO MAINTAIN OUR INNER PEACE, NO MATTER HOW *UNREASONABLE* THOSE AROUND US ARE.

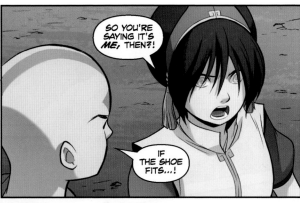

SO YOU'RE SAYING IT'S *ME*, THEN?!

IF THE SHOE FITS...!

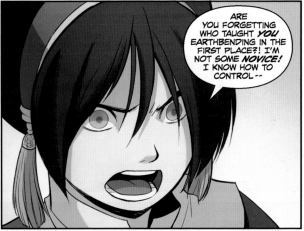

ARE YOU FORGETTING WHO TAUGHT *YOU* EARTHBENDING IN THE FIRST PLACE?! I'M NOT SOME *NOVICE!* I KNOW HOW TO CONTROL--

!!!

!!!

RUMBLE! RUMBLE! RUMBLE!

CRASH!

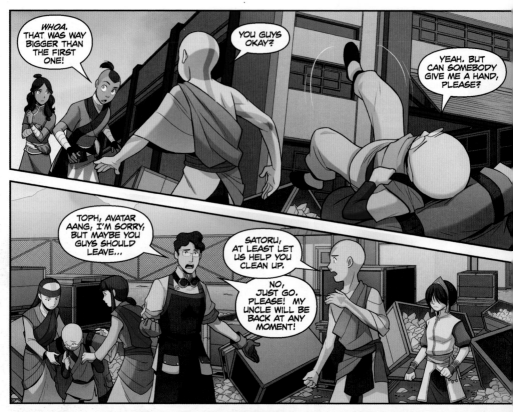

WHOA. THAT WAS WAY BIGGER THAN THE FIRST ONE!

YOU GUYS OKAY?

YEAH. BUT CAN SOMEBODY GIVE ME A HAND, PLEASE?

TOPH, AVATAR AANG, I'M SORRY, BUT MAYBE YOU GUYS SHOULD LEAVE...

SATORU, AT LEAST LET US HELP YOU CLEAN UP.

NO, JUST GO. PLEASE! MY UNCLE WILL BE BACK AT ANY MOMENT!

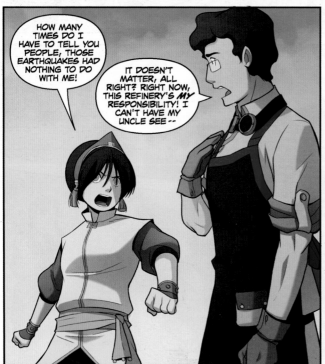

HOW MANY TIMES DO I HAVE TO TELL YOU PEOPLE, THOSE EARTHQUAKES HAD NOTHING TO DO WITH ME!

IT DOESN'T MATTER, ALL RIGHT? RIGHT NOW, THIS REFINERY'S *MY* RESPONSIBILITY! I CAN'T HAVE MY UNCLE SEE --

HELP! HELP!

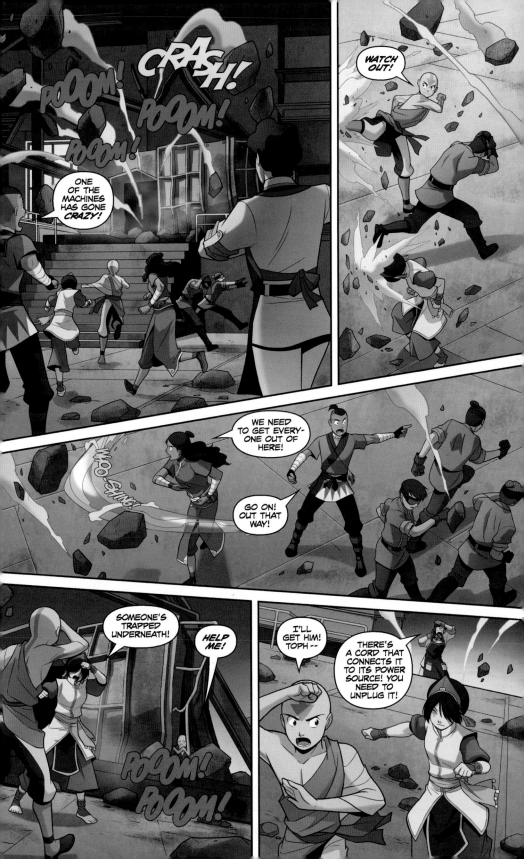

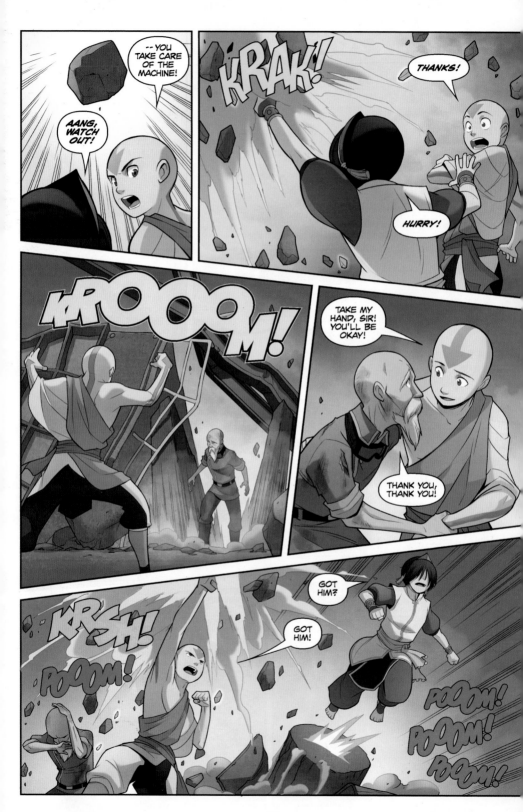

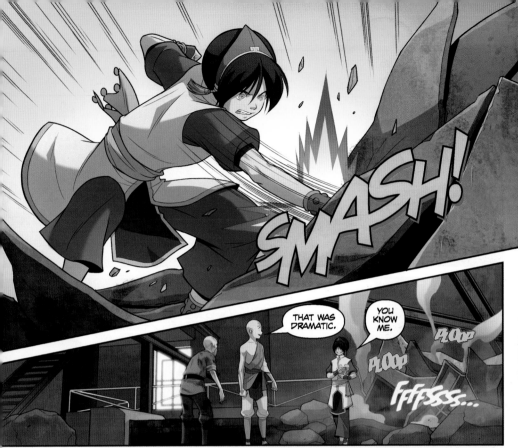

SMASH!

THAT WAS DRAMATIC.

YOU KNOW ME.

FLOOP

FLOOP

Fffffssss...

TOPH, ABOUT THOSE THINGS I SAID EARLIER --

I KNOW. ME TOO. I GUESS I WAS JUST TRYING TO SAY...

DON'T YOU THINK YOU'RE TRYING A LITTLE TOO HARD TO HOLD ON TO *THE PAST?*

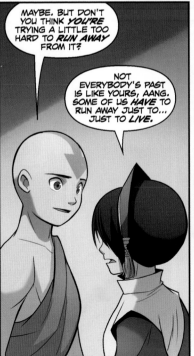

MAYBE. BUT DON'T YOU THINK *YOU'RE* TRYING A LITTLE TOO HARD TO *RUN AWAY* FROM IT?

NOT EVERYBODY'S PAST IS LIKE YOURS, AANG. SOME OF US *HAVE* TO RUN AWAY JUST TO... JUST TO *LIVE.*

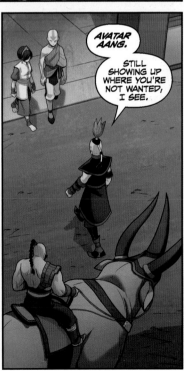

AVATAR AANG.

STILL SHOWING UP WHERE YOU'RE NOT WANTED, I SEE.

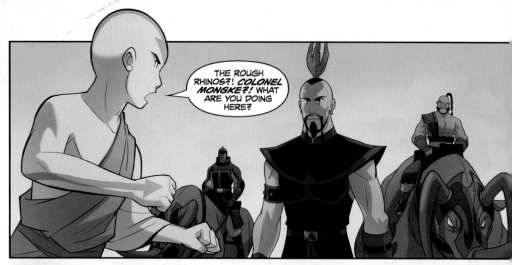

THE ROUGH RHINOS?! *COLONEL MONGKE?!* WHAT ARE YOU DOING HERE?

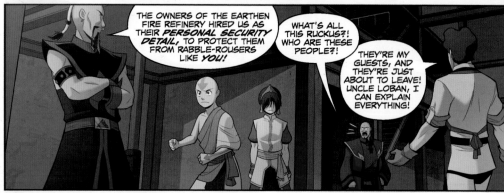

THE OWNERS OF THE EARTHEN FIRE REFINERY HIRED US AS THEIR *PERSONAL SECURITY DETAIL,* TO PROTECT THEM FROM RABBLE-ROUSERS LIKE *YOU!*

WHAT'S ALL THIS RUCKUS?! WHO ARE THESE PEOPLE?!

THEY'RE MY GUESTS, AND THEY'RE JUST ABOUT TO LEAVE! UNCLE LOBAN, I CAN EXPLAIN EVERYTHING!

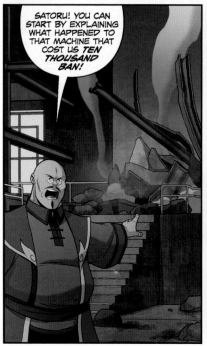

SATORU! YOU CAN START BY EXPLAINING WHAT HAPPENED TO THAT MACHINE THAT COST US *TEN THOUSAND BAN!*

FFFSSSS....

PLOOP!

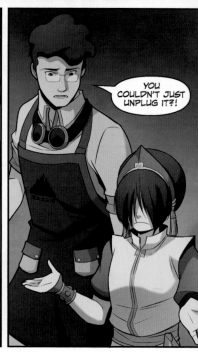

YOU COULDN'T JUST UNPLUG IT?!

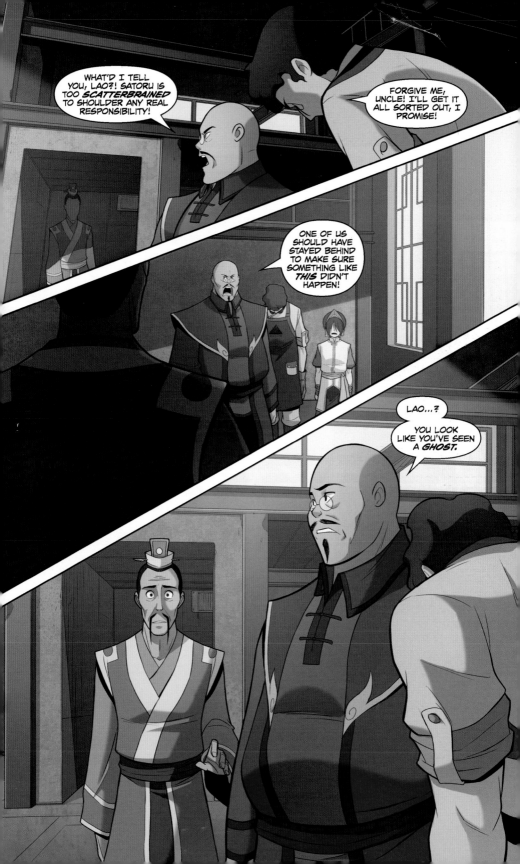

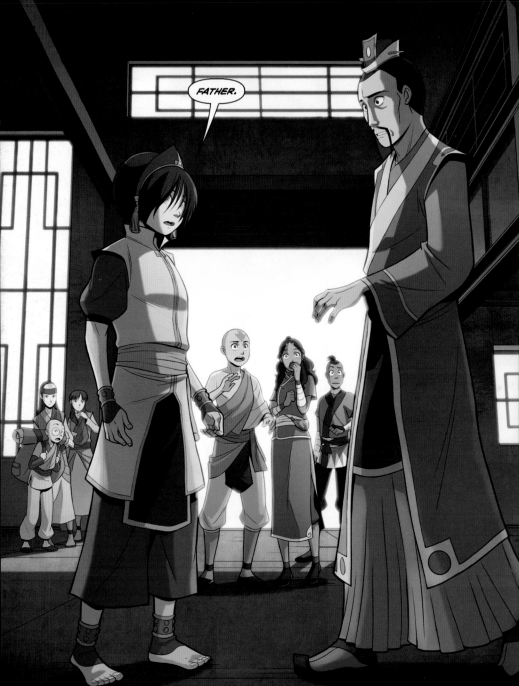

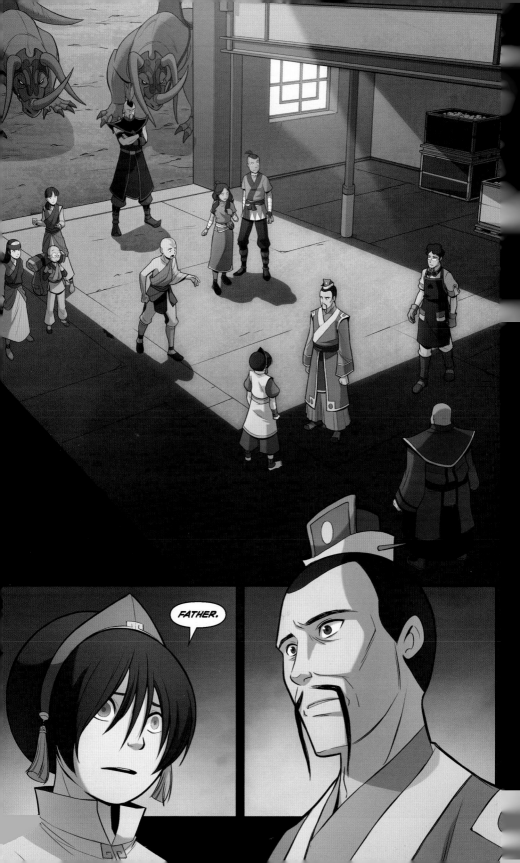

FATHER.

BOSS MAN LAO? YOU TOLD ME THAT YOU DIDN'T HAVE A FAMILY.

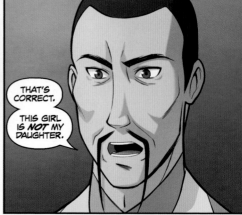

THAT'S CORRECT.

THIS GIRL IS *NOT* MY DAUGHTER.

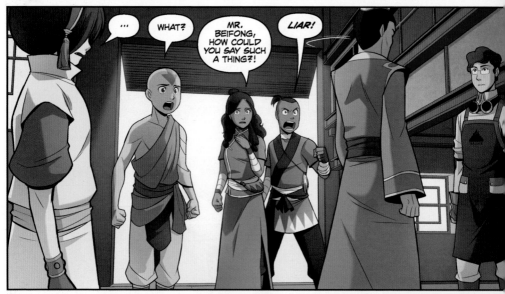

...

WHAT?

MR. BEIFONG, HOW COULD YOU SAY SUCH A THING?!

LIAR!

WAIT. SO HE REALLY *IS* YOUR DAD?

SATORU! MIND YOUR OWN BUSINESS!

76

HAVEN'T YOU SCREWED UP ENOUGH FOR ONE DAY?! GET EVERYBODY BACK TO WORK!

THAT *"EVERYBODY"* YOU'RE REFERRING TO? THEY FLED THE BUILDING. WE JUST HAD AN EARTHQUAKE, REMEMBER? *EVERYBODY'S SCARED.*

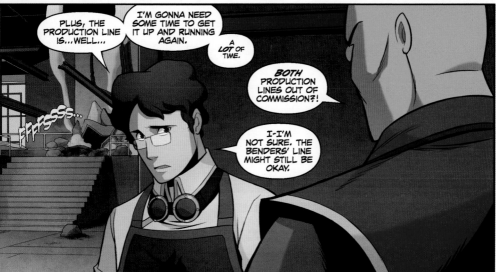

PLUS, THE PRODUCTION LINE IS...WELL...

I'M GONNA NEED SOME TIME TO GET IT UP AND RUNNING AGAIN. A *LOT* OF TIME.

BOTH PRODUCTION LINES OUT OF COMMISSION?!

I-I'M NOT SURE. THE BENDERS' LINE MIGHT STILL BE OKAY.

FFFFSSSS...

THEN YOU TELL THOSE COWARDS OUTSIDE IF THEY WANT THEIR JOBS, THEY WILL *GET BACK TO WORK!* I CAN REPLACE EVERY SINGLE ONE OF THEM WITHIN THE HOUR!

YES, UNCLE.

WE'VE GOT DEADLINES TO MEET!

AVATAR AANG, AREN'T WE LEAVING?

THE MAN IN CHARGE SAID WE HAVE TO GO AND NOT COME BACK!

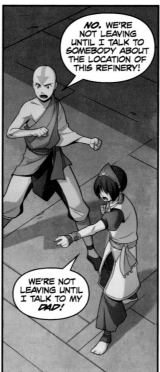

NO. WE'RE NOT LEAVING UNTIL I TALK TO SOMEBODY ABOUT THE LOCATION OF THIS REFINERY!

WE'RE NOT LEAVING UNTIL I TALK TO MY *DAD!*

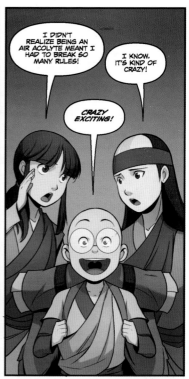

I DIDN'T REALIZE BEING AN AIR ACOLYTE MEANT I HAD TO BREAK SO MANY RULES!

I KNOW. IT'S KIND OF CRAZY!

CRAZY EXCITING!

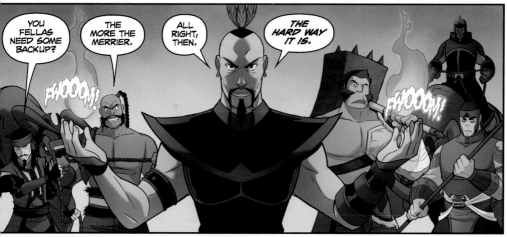

YOU FELLAS NEED SOME BACKUP?

THE MORE THE MERRIER.

ALL RIGHT, THEN.

THE HARD WAY IT IS.

FWOOOM!

FWOOOM!

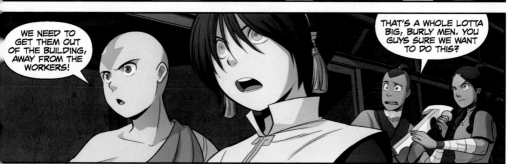

WE NEED TO GET THEM OUT OF THE BUILDING, AWAY FROM THE WORKERS!

THAT'S A WHOLE LOTTA BIG, BURLY MEN. YOU GUYS SURE WE WANT TO DO THIS?

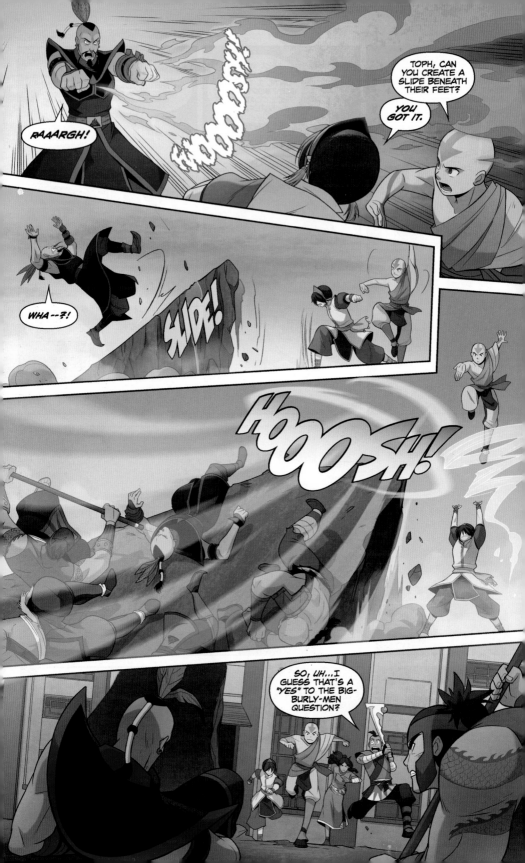

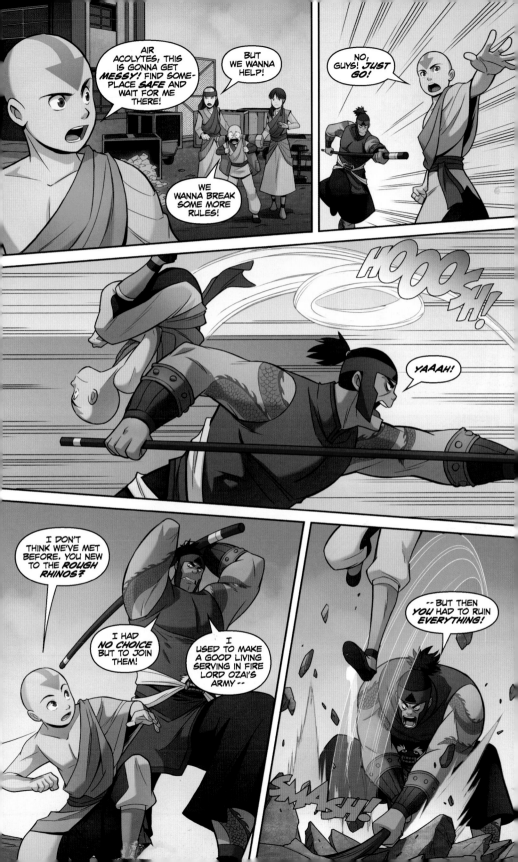

KRUNK!

WHAT THE --?!

SO WHAT'S YOUR NAME?

UTOR.

NICE TO MEET YOU, UTOR! A LITTLE ADVICE? FIND SOME OTHER GROUP TO JOIN. THE ROUGH RHINOS ARE *BAD NEWS.*

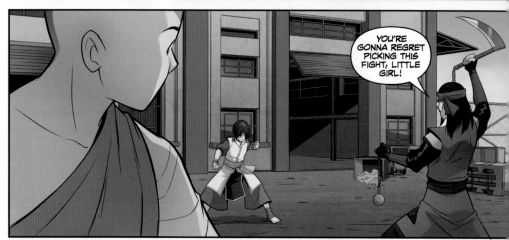

YOU'RE GONNA REGRET PICKING THIS FIGHT, LITTLE GIRL!

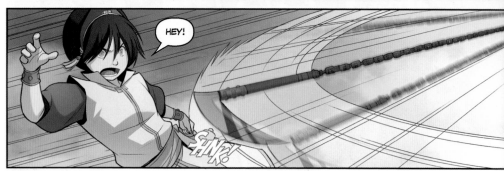

HEY!

SHNK!

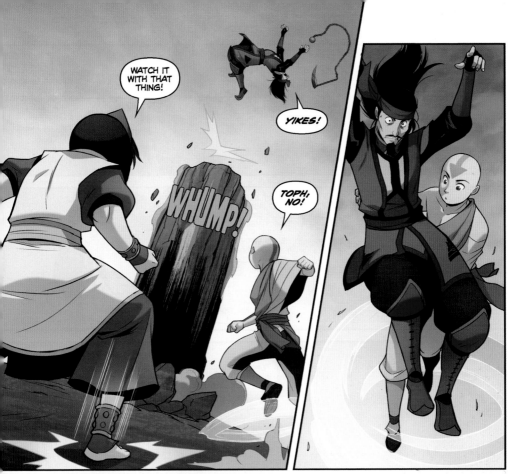

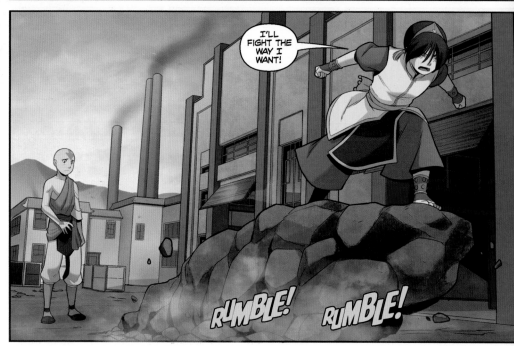

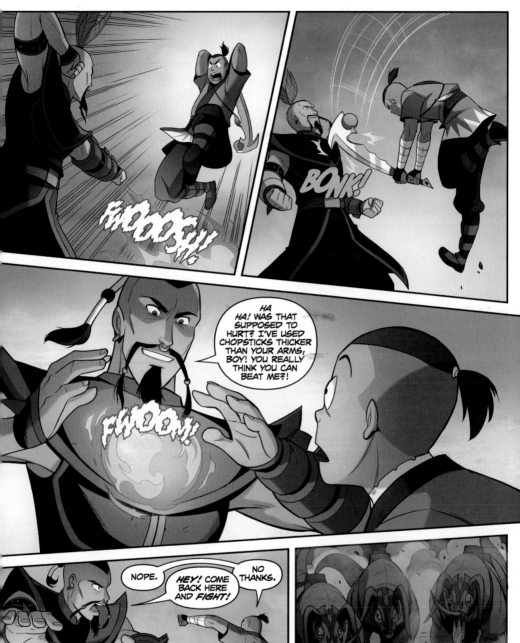

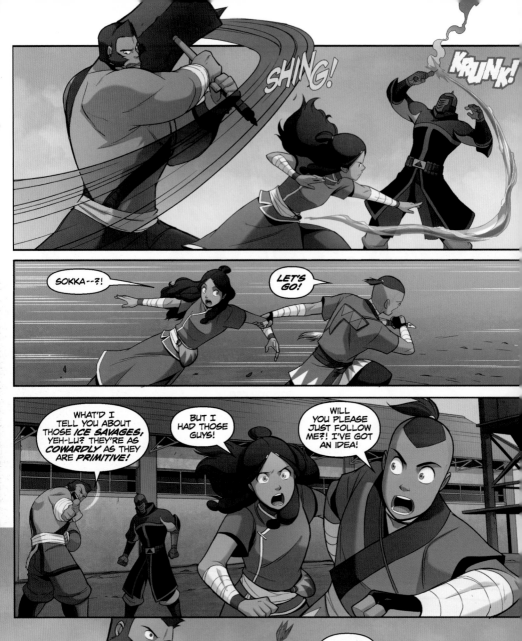

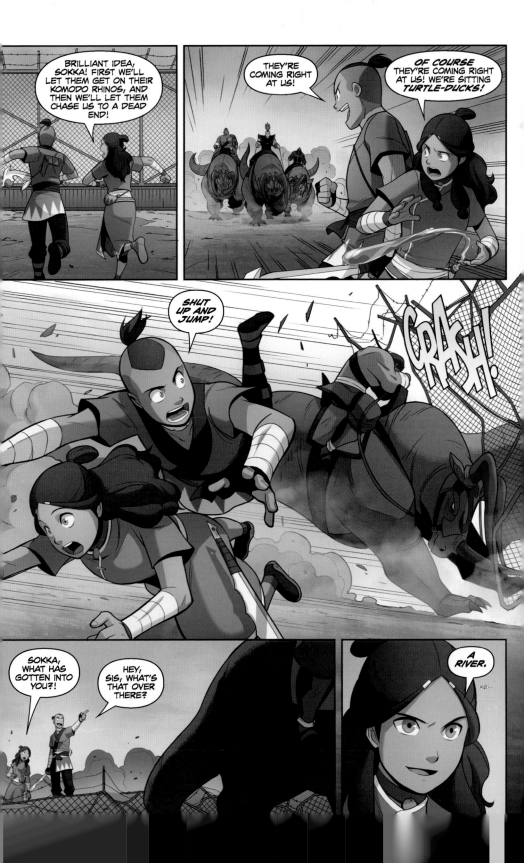

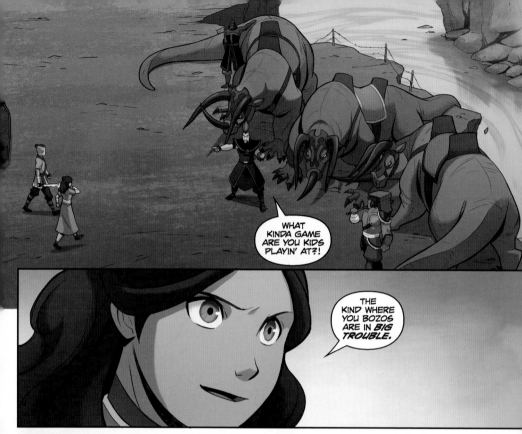

WHAT KINDA GAME ARE YOU KIDS PLAYIN' AT?!

THE KIND WHERE YOU BOZOS ARE IN *BIG TROUBLE.*

WHOOOOOSH!

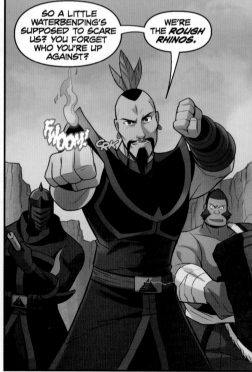

SO A LITTLE WATERBENDING'S SUPPOSED TO SCARE US? YOU FORGET WHO YOU'RE UP AGAINST?

WE'RE THE *ROUGH RHINOS.*

FWOOM! CRK!

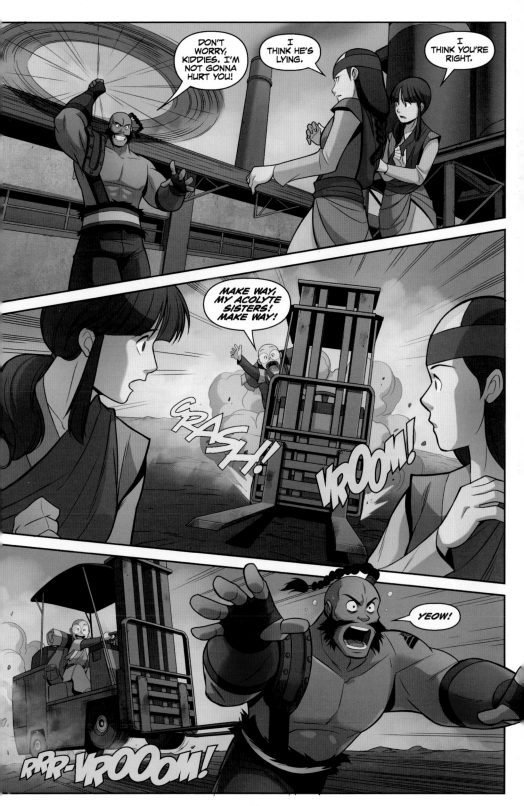

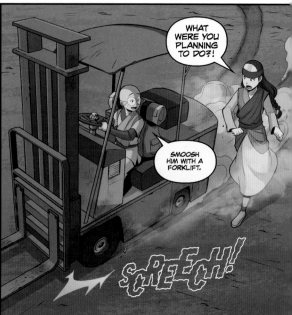

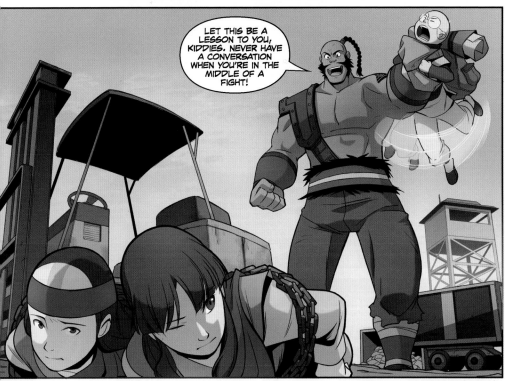

LET THIS BE A LESSON TO YOU, KIDDIES. NEVER HAVE A CONVERSATION WHEN YOU'RE IN THE MIDDLE OF A FIGHT!

WHAT--?!

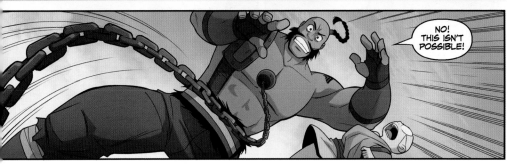

NO! THIS ISN'T POSSIBLE!

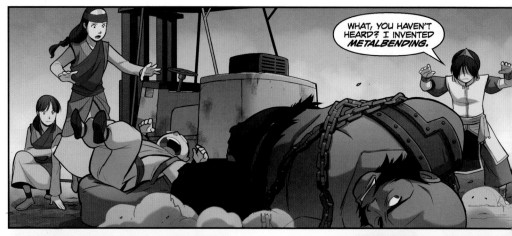

WHAT, YOU HAVEN'T HEARD?! I INVENTED *METALBENDING*.

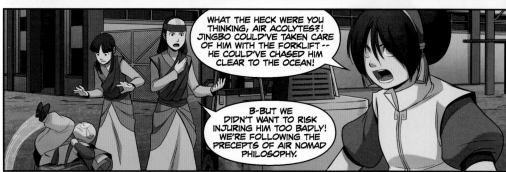

WHAT THE HECK WERE YOU THINKING, AIR ACOLYTES?! JINGBO COULD'VE TAKEN CARE OF HIM WITH THE FORKLIFT -- HE COULD'VE CHASED HIM CLEAR TO THE OCEAN!

B-BUT WE DIDN'T WANT TO RISK INJURING HIM TOO BADLY! WE'RE FOLLOWING THE PRECEPTS OF AIR NOMAD PHILOSOPHY.

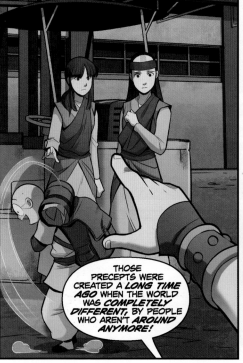

YOU GUYS HAVE GOT TO STOP WORSHIPING THE *PAST* AND START WORRYING ABOUT *RIGHT NOW!* OTHERWISE, YOU'RE NOT GONNA *HAVE* A RIGHT NOW TO WORRY *ABOUT!*

THOSE PRECEPTS WERE CREATED A *LONG TIME AGO* WHEN THE WORLD WAS *COMPLETELY DIFFERENT,* BY PEOPLE WHO AREN'T *AROUND ANYMORE!*

ACOLYTES!

I'M SO CONFUSED.

I THOUGHT I TOLD YOU TO LEAVE!

WE...WE WERE GOING TO, BUT...

AVATAR AANG, WE CAME TODAY BECAUSE WE WANT TO LEARN THE AIR NOMAD TRADITIONS.

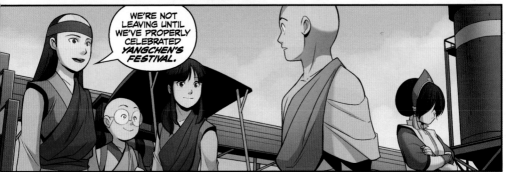

WE'RE NOT LEAVING UNTIL WE'VE PROPERLY CELEBRATED *YANGCHEN'S FESTIVAL.*

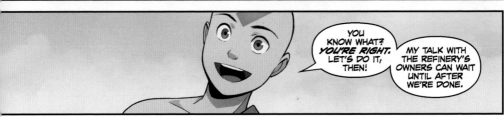

YOU KNOW WHAT? *YOU'RE RIGHT.* LET'S DO IT, THEN!

MY TALK WITH THE REFINERY'S OWNERS CAN WAIT UNTIL AFTER WE'RE DONE.

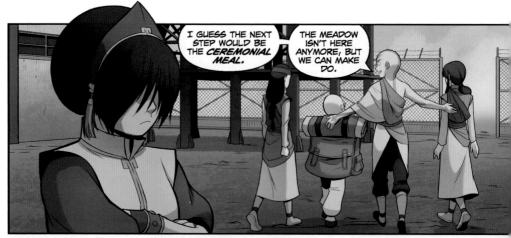

I GUESS THE NEXT STEP WOULD BE THE *CEREMONIAL MEAL.*

THE MEADOW ISN'T HERE ANYMORE, BUT WE CAN MAKE DO.

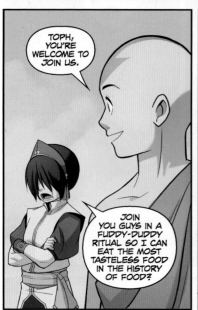

TOPH, YOU'RE WELCOME TO JOIN US.

JOIN YOU GUYS IN A FUDDY-DUDDY RITUAL SO I CAN EAT THE MOST TASTELESS FOOD IN THE HISTORY OF FOOD?

I CAN THINK OF ABOUT *A MILLION THINGS* I'D RATHER DO.

KRMK!

DON'T MIND HER, AIR ACOLYTES --

DON'T WORRY. WE WON'T.

RR-RR-RUMBLE!

94

I'M SORRY, EVERYBODY, BUT WE NEED TO PICK UP THE PACE TO MAKE UP FOR THE OTHER PRODUCTION LINE'S LOSSES.

AFTER EVERYTHING THAT'S HAPPENED, IT'S HARD TO CONCENTRATE.

I KNOW. BUT MY UNCLE'S REALLY WORRIED ABOUT DEADLINES.

JUST DO YOUR BEST, OKAY?

I THINK WE'RE PAST THE *WORST* OF IT.

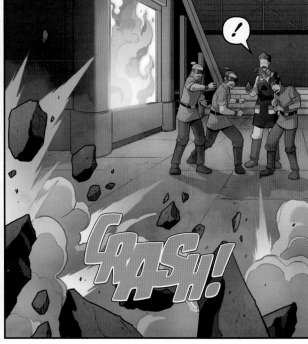

!

CRASH!

I'M HERE TO TALK TO MY DAD.

THAT WAY.

HEY, MOMO! YOU'RE JUST IN TIME FOR THE FOOD!

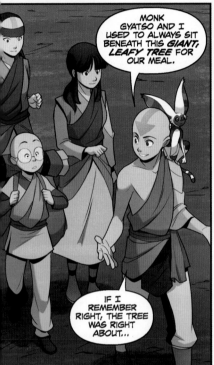

MONK GYATSO AND I USED TO ALWAYS SIT BENEATH THIS *GIANT, LEAFY TREE* FOR OUR MEAL.

IF I REMEMBER RIGHT, THE TREE WAS RIGHT ABOUT...

...HERE.

I'M SORRY, AVATAR AANG.

NO, IT'S...I MEAN, WHAT'D I EXPECT? IT WAS SUCH A LONG TIME AGO.

AND MAYBE WE CAN STILL CELEBRATE IN THE SAME SPOT, EVEN IF THE SPOT'S NOW *INDOORS.*

包心美食小館

LOOKS LIKE THIS IS A RESTAURANT. LET'S GO IN AND ASK.

THE MENU'S KINDA WEIRD. CABBAGE SOUP? CABBAGE NOODLES? CABBAGE COOKIES?

YUCK! WHO'D WANT TO EAT A CABBAGE COOKIE?

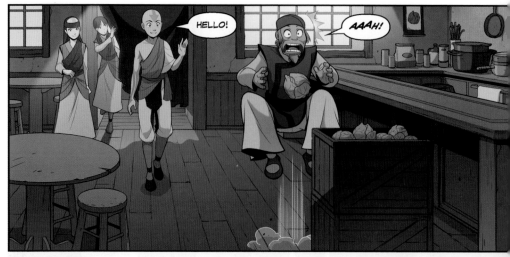

HELLO!

AAAH!

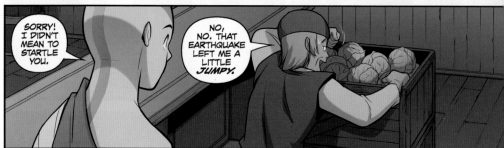

SORRY! I DIDN'T MEAN TO STARTLE YOU.

NO, NO. THAT EARTHQUAKE LEFT ME A LITTLE *JUMPY*.

BUT LUCKILY, MY LOVELY CABBAGES WERE *UNHARMED!*

I TOLD YOU A *RESTAURANT* WOULD BE SAFER THAN A *CART*, DIDN'T I, MY LOVELY --

AHEM.

OH! YES! HOW CAN I --?

≥GASP!≤ IT'S *YOU*!

BAD THINGS ALWAYS HAPPEN TO MY POOR CABBAGES WHEN YOU'RE AROUND!

REALLY? YOU SURE YOU DON'T HAVE ME CONFUSED WITH SOMEONE ELSE?

NO!

WOULD IT BE ALL RIGHT IF MY FRIENDS AND I ATE A MEAL IN HERE?

WELL... BUSINESS HAS BEEN SLOW...

I SUPPOSE SO. BUT YOU MUST KEEP ALL BAD THINGS FAR, FAR AWAY FROM MY CABBAGES!

I'LL DO MY BEST.

JUST ONE MORE REQUEST. WOULD YOU MIND IF WE ATE THE FOOD WE BROUGHT?

TA-DA!

UNCONSCIONABLE! I'M TRYING TO RUN A BUSINESS HERE! YOU'RE GOING TO HAVE TO ORDER AT LEAST ONE DISH!

THAT'S FAIR. GIVE US YOUR HOUSE SPECIAL!

A PLATE OF *CABBAGE COOKIES* COMING RIGHT UP!

HERE YOU GO, FRESH FROM THE OVEN! ENJOY!

HM. NOT BAD. TASTES KINDA LIKE A SUGAR COOKIE --

-- ONLY MORE *CABBAGEY*.

SNIFF SNIFF

TOPH! *WAIT UP!*

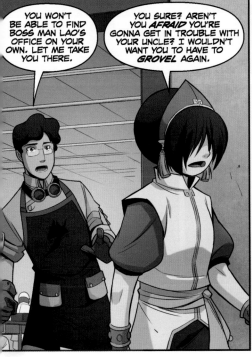

YOU WON'T BE ABLE TO FIND BOSS MAN LAO'S OFFICE ON YOUR OWN. LET ME TAKE YOU THERE.

YOU SURE? AREN'T YOU *AFRAID* YOU'RE GONNA GET IN TROUBLE WITH YOUR UNCLE? I WOULDN'T WANT YOU TO HAVE TO *GROVEL* AGAIN.

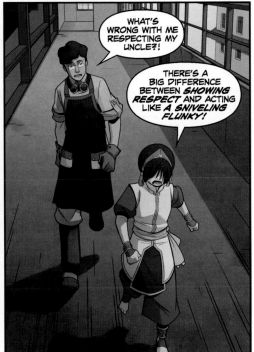

WHAT'S WRONG WITH ME RESPECTING MY UNCLE?!

THERE'S A BIG DIFFERENCE BETWEEN *SHOWING RESPECT* AND ACTING LIKE *A SNIVELING FLUNKY!*

YOU -- YOU -- YOU DON'T KNOW *ANYTHING*, TOPH! YOU THINK YOU DO, BUT YOU *DON'T!*

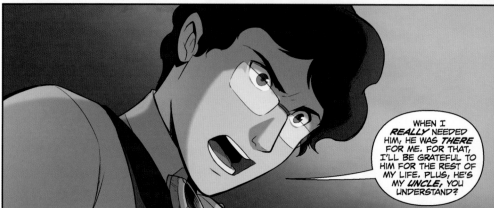

WHEN I *REALLY* NEEDED HIM, HE WAS *THERE* FOR ME. FOR THAT, I'LL BE GRATEFUL TO HIM FOR THE REST OF MY LIFE. PLUS, HE'S MY *UNCLE*, YOU UNDERSTAND?

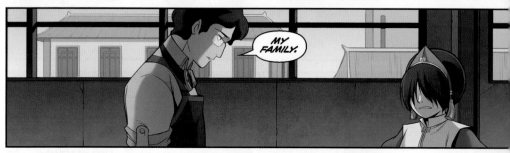

MY FAMILY.

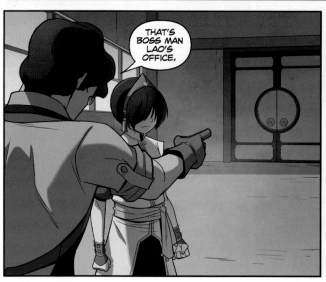

THAT'S BOSS MAN LAO'S OFFICE.

SEE YOU AROUND.

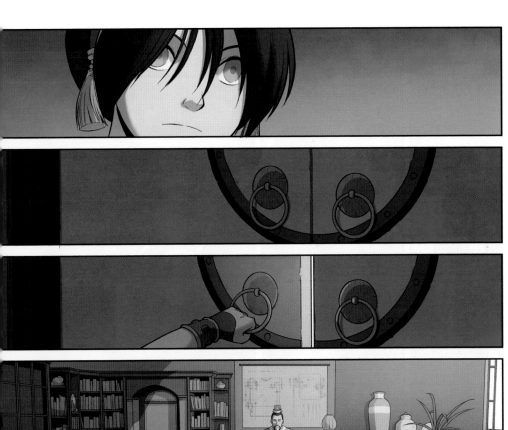

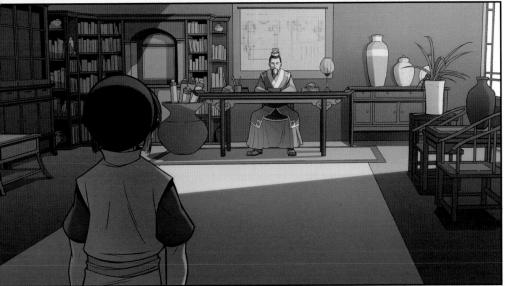

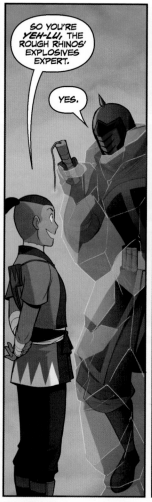 SO YOU'RE *YEH-LU,* THE ROUGH RHINOS' EXPLOSIVES EXPERT.

YES.

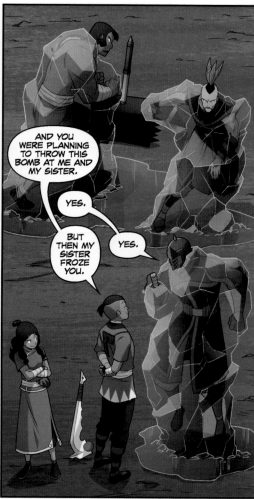 AND YOU WERE PLANNING TO THROW THIS BOMB AT ME AND MY SISTER.

YES.

YES.

BUT THEN MY SISTER FROZE YOU.

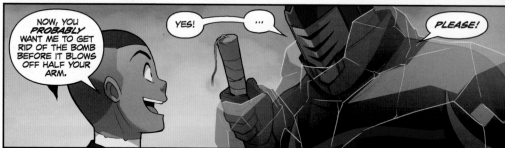 NOW, YOU *PROBABLY* WANT ME TO GET RID OF THE BOMB BEFORE IT BLOWS OFF HALF YOUR ARM.

YES!

...

PLEASE!

 EVEN THOUGH YOU WERE TRYING TO KILL US NOT *TEN MINUTES AGO?!*

...Y-YES...?

FINE.

YEOWCH!

‹HUFF! HUFF!›

‹HUFF HUFFHUFF HUFFHUFF!›

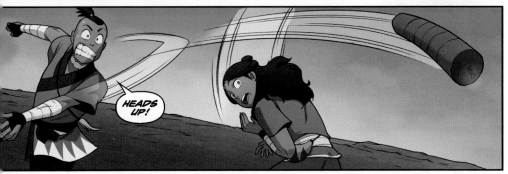

HEADS UP!

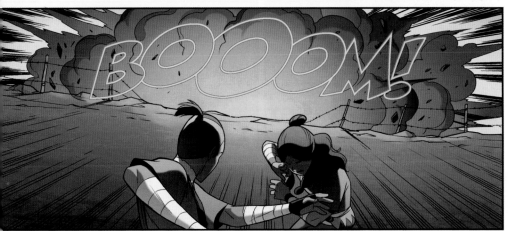

BOOOM!

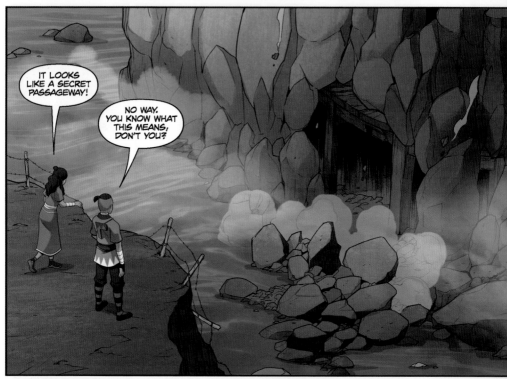

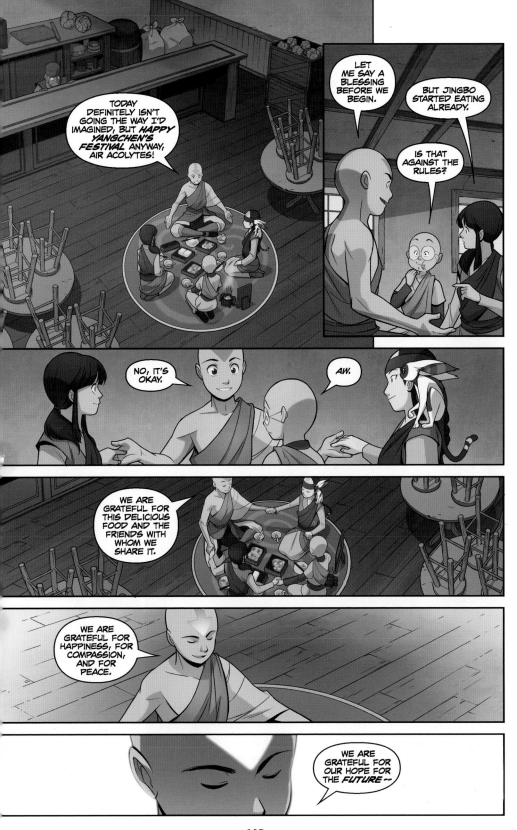

107

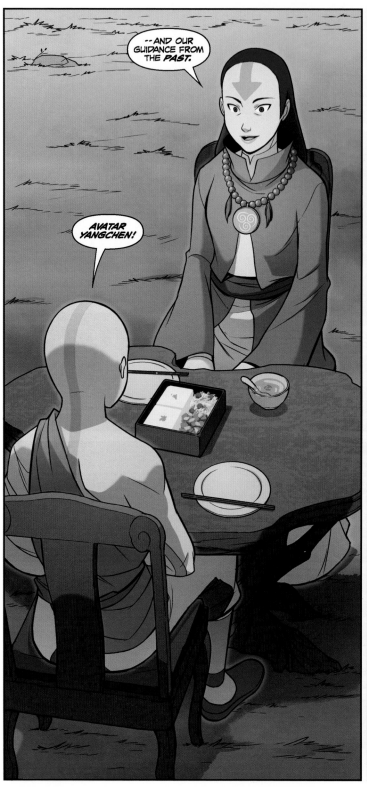

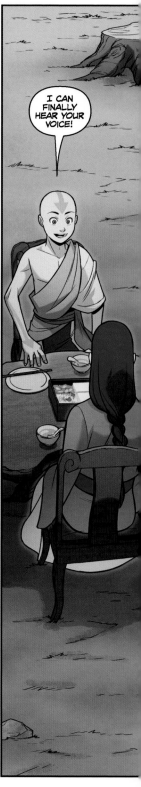

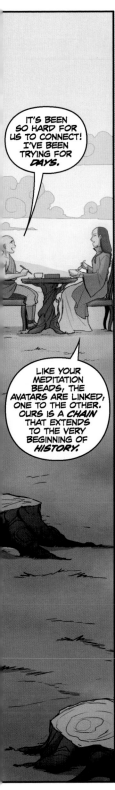

IT'S BEEN SO HARD FOR US TO CONNECT! I'VE BEEN TRYING FOR *DAYS.*

LIKE YOUR MEDITATION BEADS, THE AVATARS ARE LINKED, ONE TO THE OTHER. OURS IS A *CHAIN* THAT EXTENDS TO THE VERY BEGINNING OF *HISTORY.*

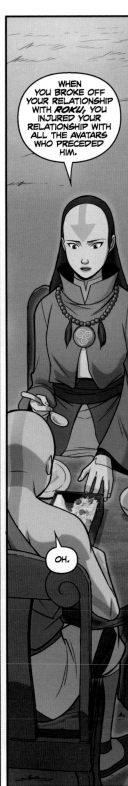

WHEN YOU BROKE OFF YOUR RELATIONSHIP WITH *ROKU,* YOU INJURED YOUR RELATIONSHIP WITH ALL THE AVATARS WHO PRECEDED HIM.

OH.

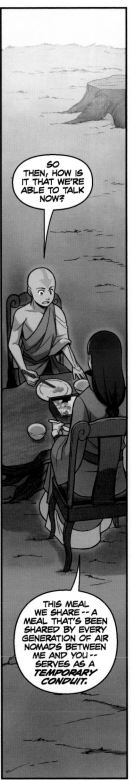

SO THEN, HOW IS IT THAT WE'RE ABLE TO TALK NOW?

THIS MEAL WE SHARE -- A MEAL THAT'S BEEN SHARED BY EVERY GENERATION OF AIR NOMADS BETWEEN ME AND YOU -- SERVES AS A *TEMPORARY CONDUIT.*

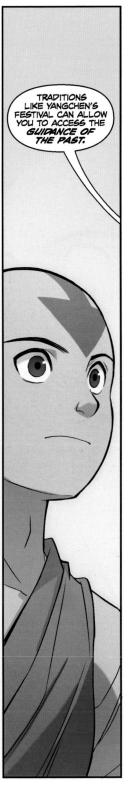

TRADITIONS LIKE YANGCHEN'S FESTIVAL CAN ALLOW YOU TO ACCESS THE *GUIDANCE OF THE PAST.*

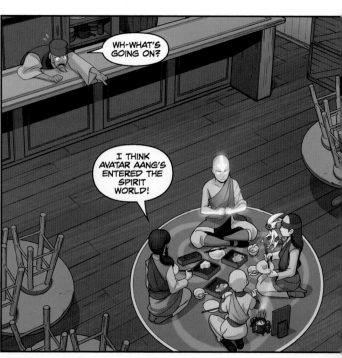

WH-WHAT'S GOING ON?

I THINK AVATAR AANG'S ENTERED THE SPIRIT WORLD!

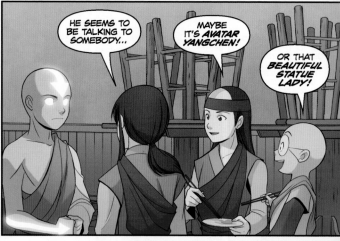

HE SEEMS TO BE TALKING TO SOMEBODY...

MAYBE IT'S *AVATAR YANGCHEN!*

OR THAT *BEAUTIFUL STATUE LADY!*

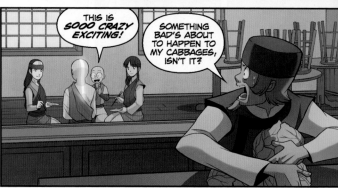

THIS IS *SOOO CRAZY EXCITING!*

SOMETHING BAD'S ABOUT TO HAPPEN TO MY CABBAGES, ISN'T IT?

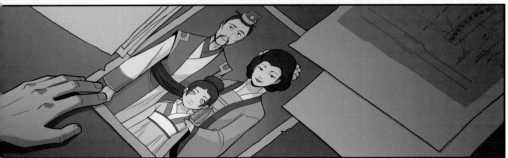

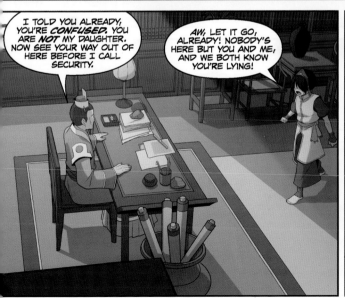

I TOLD YOU ALREADY, YOU'RE *CONFUSED.* YOU ARE *NOT* MY DAUGHTER. NOW SEE YOUR WAY OUT OF HERE BEFORE I CALL SECURITY.

AW, LET IT GO, ALREADY! NOBODY'S HERE BUT YOU AND ME, AND WE BOTH KNOW YOU'RE LYING!

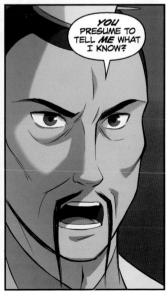

YOU PRESUME TO TELL *ME* WHAT I KNOW?

LET *ME* TELL *YOU* WHAT I KNOW.

I SPENT COUNTLESS HOURS OF MY *LIFE* -- NOT TO MENTION A SUBSTANTIAL PORTION OF MY *FORTUNE* -- RAISING MY DAUGHTER TO BE A *POISED, DEMURE, OBEDIENT YOUNG WOMAN!*

I DID EVERYTHING I COULD TO PROTECT HER FROM THE *CORROSIVE DANGERS* OF THE OUTSIDE WORLD!

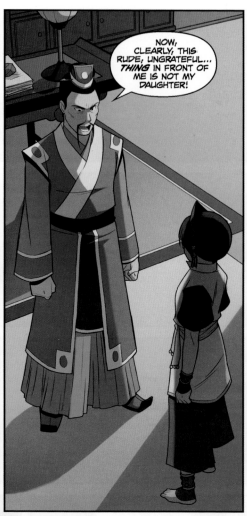

NOW, CLEARLY, THIS RUDE, UNGRATEFUL... *THING* IN FRONT OF ME IS NOT MY DAUGHTER!

...

I KNOW I'VE PUT YOU THROUGH *A LOT...*

...BUT YOU'VE GOT NO RIGHT TO TALK TO ME LIKE THAT.

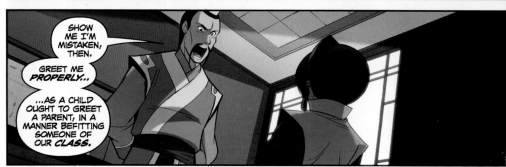

SHOW ME I'M MISTAKEN, THEN.

GREET ME *PROPERLY...*

...AS A CHILD OUGHT TO GREET A PARENT, IN A MANNER BEFITTING SOMEONE OF OUR *CLASS.*

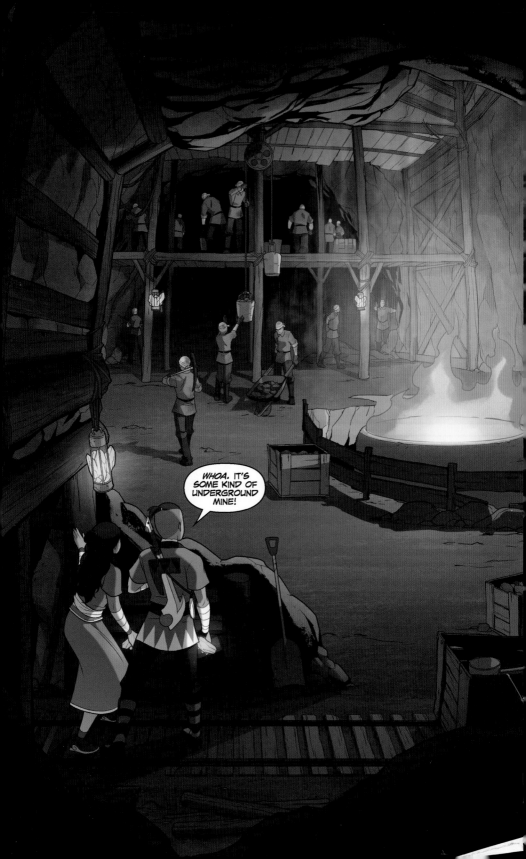

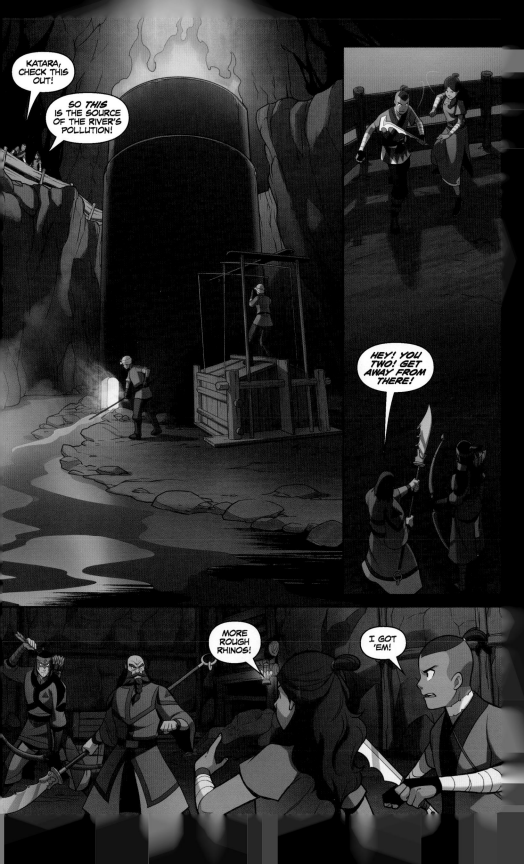

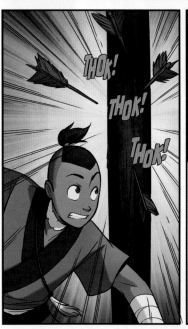

THOK!

THOK!

THOK!

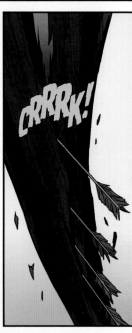

CRRRK!

RRR!

RRR!

!

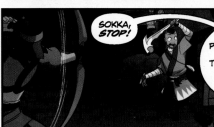

SOKKA, STOP!

THIS PLACE ISN'T JUST THE SOURCE OF THE POLLUTION--IT'S THE SOURCE OF THE *EARTHQUAKES!* THOSE SUPPORTS LOOK LIKE THEY COULD GIVE WAY AT ANY MOMENT...AND WE'RE RIGHT BENEATH THE TOWN!

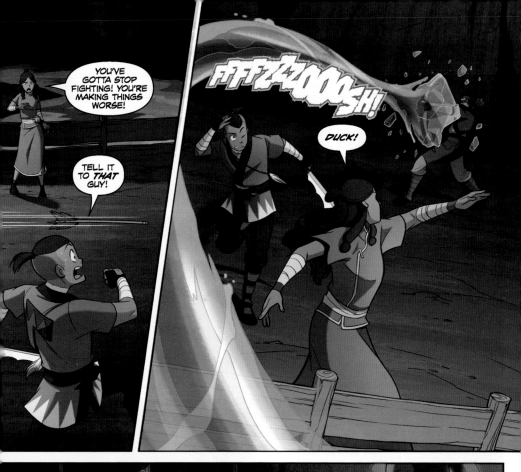

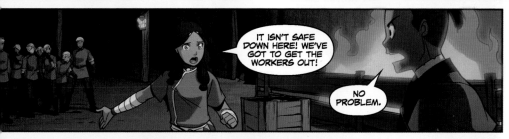

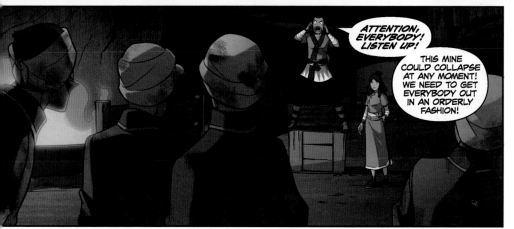

SO IF YOU'LL ALL FOLLOW ME IN A SINGLE-FILE LINE--

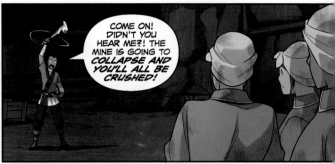

COME ON! DIDN'T YOU HEAR ME?! THE MINE IS GOING TO *COLLAPSE* AND YOU'LL ALL BE *CRUSHED!*

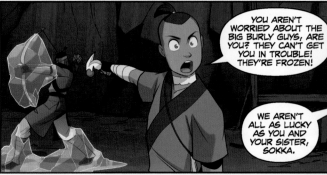

YOU AREN'T WORRIED ABOUT THE BIG BURLY GUYS, ARE YOU? THEY CAN'T GET YOU IN TROUBLE! THEY'RE FROZEN!

WE AREN'T ALL AS LUCKY AS YOU AND YOUR SISTER, SOKKA.

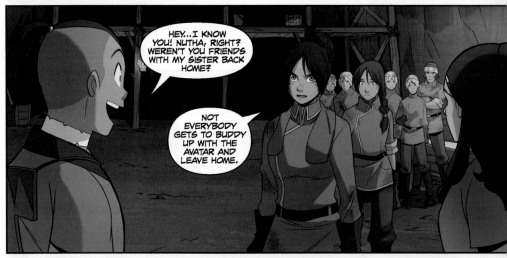

HEY...I KNOW YOU! NUTHA, RIGHT? WEREN'T YOU FRIENDS WITH MY SISTER BACK HOME?

NOT EVERYBODY GETS TO BUDDY UP WITH THE AVATAR AND LEAVE HOME.

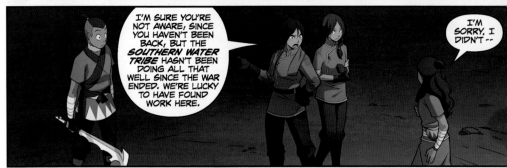

I'M SURE YOU'RE NOT AWARE, SINCE YOU HAVEN'T BEEN BACK, BUT THE *SOUTHERN WATER TRIBE* HASN'T BEEN DOING ALL THAT WELL SINCE THE WAR ENDED. WE'RE LUCKY TO HAVE FOUND WORK HERE.

I'M SORRY, I DIDN'T--

SORRY FOR WHAT? WE KNOW YOU'VE GOT OTHER PRIORITIES THESE DAYS. THE *WHOLE WORLD* NEEDS YOU NOW, RIGHT?

THIS JOB IS ALL WE'VE GOT, KATARA. WITHOUT IT, WE DON'T EAT. SO UNLESS THE BOSS MAN ORDERS US TO LEAVE, WE HAVE TO STAY.

SOKKA, WHERE ARE YOU GOING?

I'M GONNA GET THE *"BOSS MAN"* TO ORDER THEM TO LEAVE!

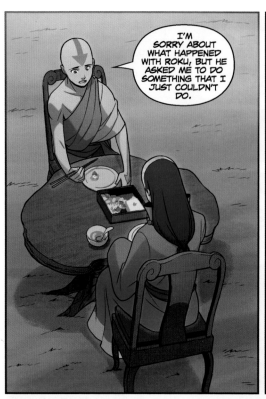

I'M SORRY ABOUT WHAT HAPPENED WITH ROKU, BUT HE ASKED ME TO DO SOMETHING THAT I JUST COULDN'T DO.

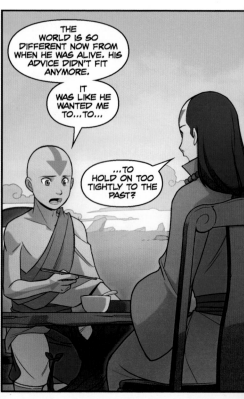

THE WORLD IS SO DIFFERENT NOW FROM WHEN HE WAS ALIVE. HIS ADVICE DIDN'T FIT ANYMORE.

IT WAS LIKE HE WANTED ME TO...TO...

...TO HOLD ON TOO TIGHTLY TO THE PAST?

EXACTLY!

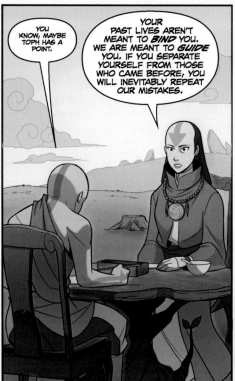

YOU KNOW, MAYBE TOPH HAS A POINT.

YOUR PAST LIVES AREN'T MEANT TO *BIND* YOU. WE ARE MEANT TO *GUIDE* YOU. IF YOU SEPARATE YOURSELF FROM THOSE WHO CAME BEFORE, YOU WILL INEVITABLY REPEAT OUR MISTAKES.

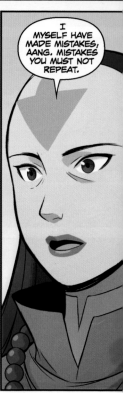

I MYSELF HAVE MADE MISTAKES, AANG. MISTAKES YOU MUST NOT REPEAT.

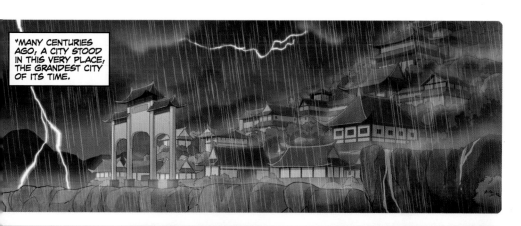

"MANY CENTURIES AGO, A CITY STOOD IN THIS VERY PLACE, THE GRANDEST CITY OF ITS TIME.

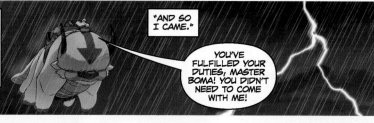

"ONE STORMY EVENING, THE CITY'S KING SENT FOR MY HELP. THOUGH I WAS YOUNG AND INEXPERIENCED, I WAS EAGER TO MAKE A DIFFERENCE IN THE WORLD.

"AND SO I CAME."

YOU'VE FULFILLED YOUR DUTIES, MASTER BOMA! YOU DIDN'T NEED TO COME WITH ME!

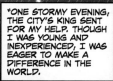

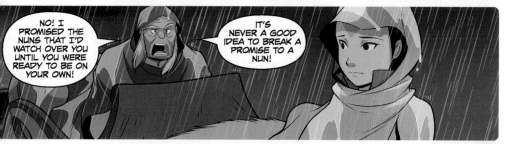

NO! I PROMISED THE NUNS THAT I'D WATCH OVER YOU UNTIL YOU WERE READY TO BE ON YOUR OWN!

IT'S NEVER A GOOD IDEA TO BREAK A PROMISE TO A NUN!

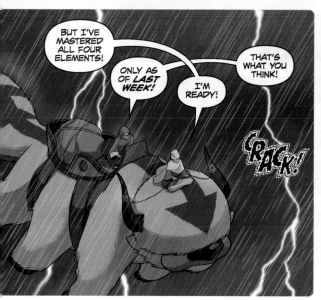

BUT I'VE MASTERED ALL FOUR ELEMENTS!

ONLY AS OF *LAST WEEK!*

I'M READY!

THAT'S WHAT YOU THINK!

CRACK!

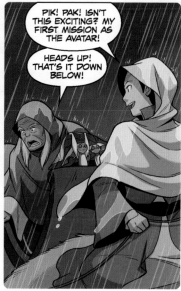

PIK! PAK! ISN'T THIS EXCITING? MY FIRST MISSION AS THE AVATAR!

HEADS UP! THAT'S IT DOWN BELOW!

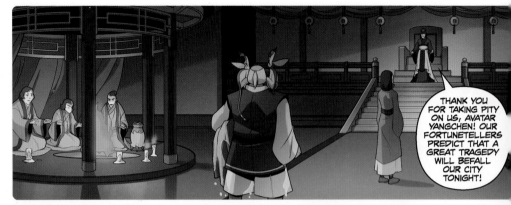

THANK YOU FOR TAKING PITY ON US, AVATAR YANGCHEN! OUR FORTUNETELLERS PREDICT THAT A GREAT TRAGEDY WILL BEFALL OUR CITY TONIGHT!

SEDUCED BY THE *NEW*, SHE FORSOOK HER OWN KIND! THE *NEW* USED HER!

THE *NEW* DESTROYED HER! NOW ALL THAT IS LEFT--

--IS *VENGEANCE*. *VENGEANCE FROM THE SEAS*.

I KNOW. THOSE LADIES GIVE ME THE WILLIES, TOO.

WHAT ARE THEY TALKING ABOUT, YOUR MAJESTY?

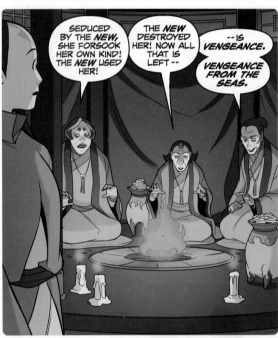

I...I'M NOT SURE.

"I WAS VERY YOUNG AND NOT YET FULLY ATTUNED TO THE SPIRIT WORLD, BUT I COULD TELL THAT THE FORTUNETELLERS WERE *RIGHT*.

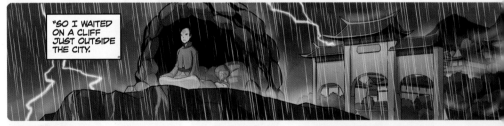

"SO I WAITED ON A CLIFF JUST OUTSIDE THE CITY.

"THEN, JUST PAST MIDNIGHT --

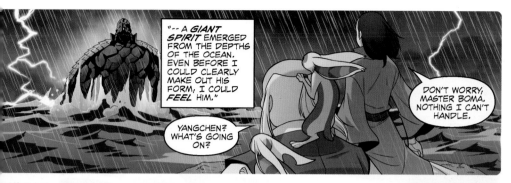

"-- A *GIANT SPIRIT* EMERGED FROM THE DEPTHS OF THE OCEAN. EVEN BEFORE I COULD CLEARLY MAKE OUT HIS FORM, I COULD *FEEL* HIM."

YANGCHEN? WHAT'S GOING ON?

DON'T WORRY, MASTER BOMA. NOTHING I CAN'T HANDLE.

"I WAS LYING, OF COURSE. THE SPIRIT'S GRIEF OVERWHELMED ME. I'D NEVER FELT ANYTHING SO DEEP, SO INTENSE. I WAS *AFRAID*."

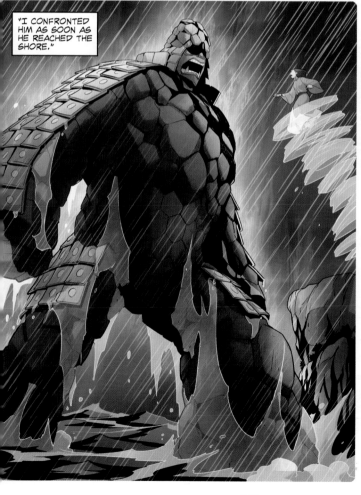

"I CONFRONTED HIM AS SOON AS HE REACHED THE SHORE."

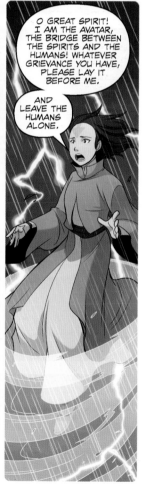

O GREAT SPIRIT! I AM THE AVATAR, THE BRIDGE BETWEEN THE SPIRITS AND THE HUMANS! WHATEVER GRIEVANCE YOU HAVE, PLEASE LAY IT BEFORE ME.

AND LEAVE THE HUMANS ALONE.

123

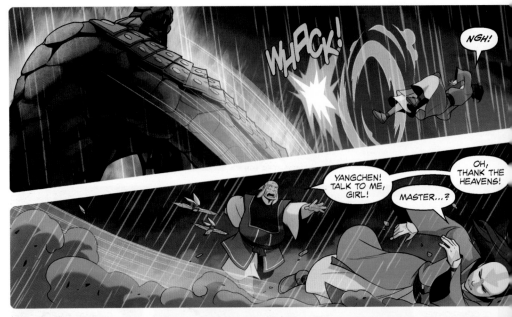

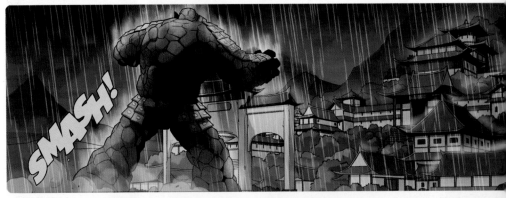

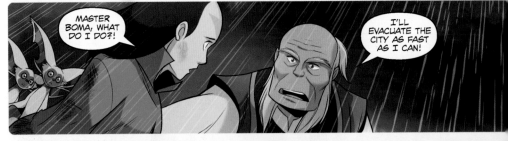

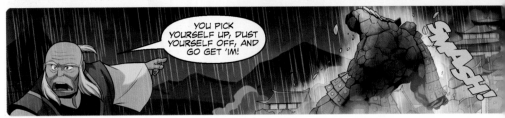

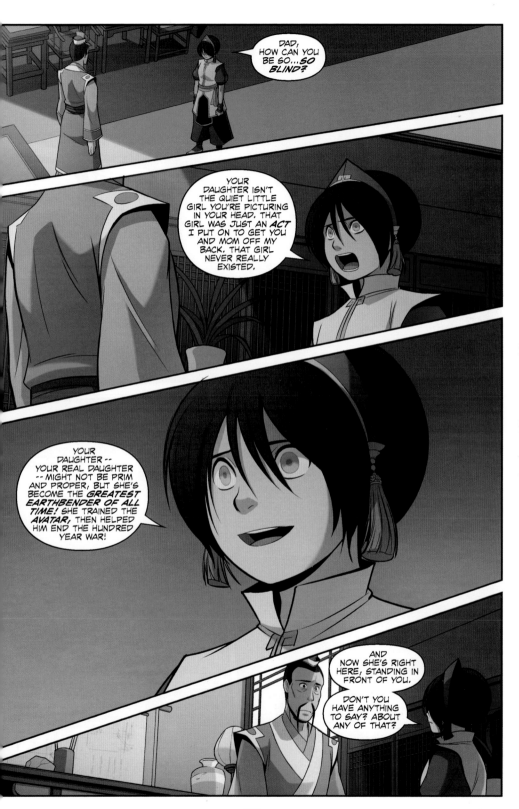

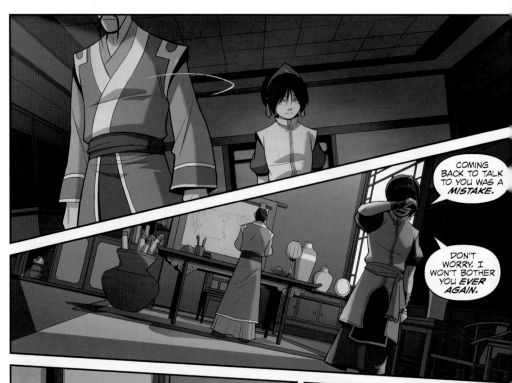

COMING BACK TO TALK TO YOU WAS A *MISTAKE.*

DON'T WORRY. I WON'T BOTHER YOU *EVER AGAIN.*

CRASH!

!

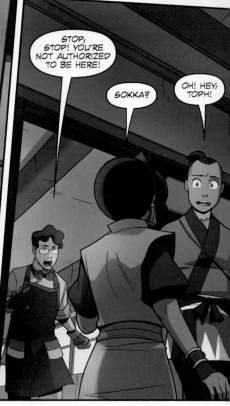

STOP, STOP! YOU'RE NOT AUTHORIZED TO BE HERE!

SOKKA?

OH! HEY, TOPH!

SATORU?!

WILL YOU PEOPLE STOP BREAKING INTO THIS PLACE?! HOW AM I SUPPOSED TO GET THINGS BACK TO NORMAL?!

YOU! YOU'RE THE GUY I'M LOOKING FOR, "BOSS MAN LAO"!

YOU GOTTA ORDER YOUR EMPLOYEES OUT OF THAT MINE! IT LOOKS LIKE IT COULD COLLAPSE AT ANY MOMENT!

I ASSURE YOU, OUR CRYSTAL MINE IS COMPLETELY SAFE! WE INSPECT IT ON A REGULAR BASIS!

NO, NOT THE CRYSTAL MINE! THE *IRON MINE* RIGHT BENEATH THE TOWN!

WHAT ARE YOU TALKING ABOUT, YOUNG MAN? EARTHEN FIRE ONLY PROCESSES *CRYSTALS.* THERE IS NO IRON MINE.

FOLLOW ME.

MASTER BOMA DID WHAT HE SAID HE WOULD.

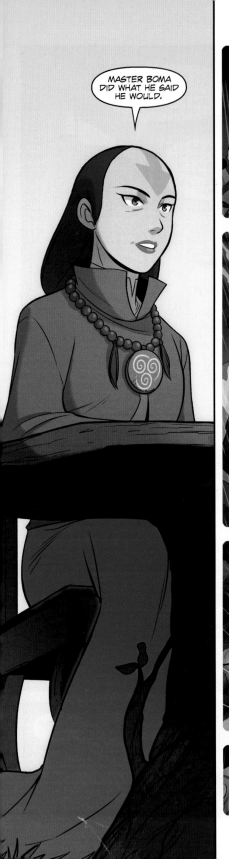

"HE EVACUATED THE PEOPLE OF THE CITY TO A NEARBY CLEARING.

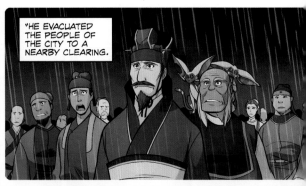

"I TRIED TO STOP THE GREAT SPIRIT. WE FOUGHT THROUGH THE NIGHT.

"NEITHER OF US COULD GAIN THE UPPER HAND, AND OUR BATTLE LEFT THE CITY IN *RUINS.*

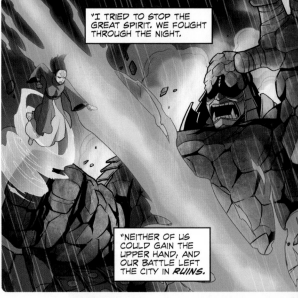

"FINALLY, AS DAWN BROKE--"

JUST...

≤HUFF HUFF≥

...JUST TELL ME WHAT YOU *WANT.*

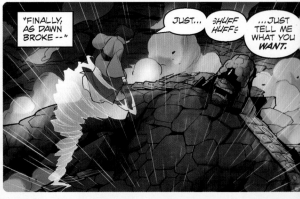

128

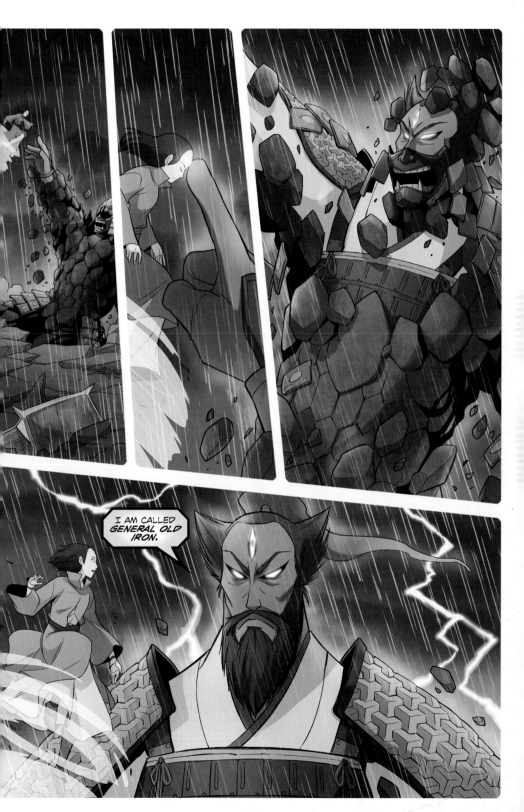

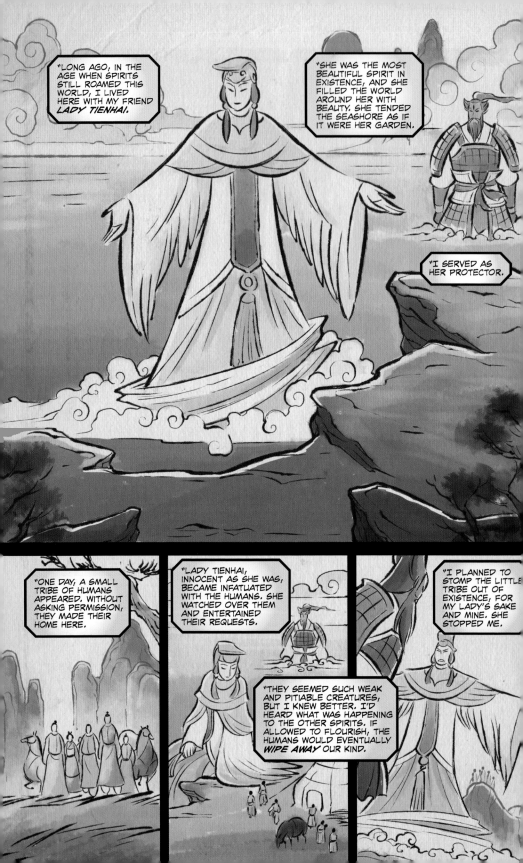

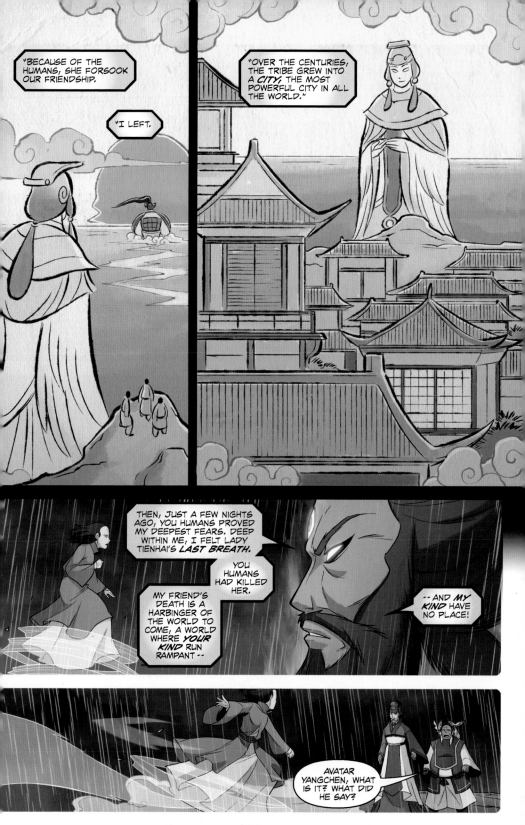

"BECAUSE OF THE HUMANS, SHE FORSOOK OUR FRIENDSHIP.

"I LEFT.

"OVER THE CENTURIES, THE TRIBE GREW INTO A *CITY*, THE MOST POWERFUL CITY IN ALL THE WORLD."

THEN, JUST A FEW NIGHTS AGO, YOU HUMANS PROVED MY DEEPEST FEARS. DEEP WITHIN ME, I FELT LADY TIENHAI'S *LAST BREATH.*

YOU HUMANS HAD KILLED HER.

MY FRIEND'S DEATH IS A HARBINGER OF THE WORLD TO COME, A WORLD WHERE *YOUR KIND* RUN RAMPANT --

-- AND *MY KIND* HAVE NO PLACE!

AVATAR YANGCHEN, WHAT IS IT? WHAT DID HE SAY?

131

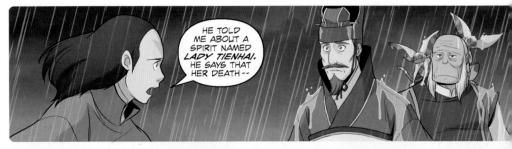

HE TOLD ME ABOUT A SPIRIT NAMED *LADY TIENHAI*. HE SAYS THAT HER DEATH --

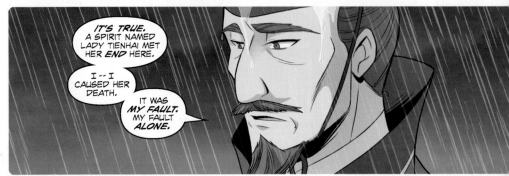

IT'S TRUE. A SPIRIT NAMED LADY TIENHAI MET HER *END* HERE.

I -- I CAUSED HER DEATH.

IT WAS *MY FAULT.* MY FAULT *ALONE.*

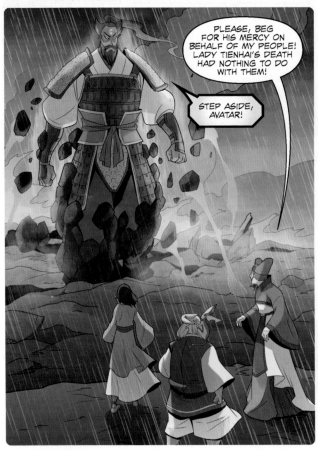

PLEASE, BEG FOR HIS MERCY ON BEHALF OF MY PEOPLE! LADY TIENHAI'S DEATH HAD NOTHING TO DO WITH THEM!

STEP ASIDE, AVATAR!

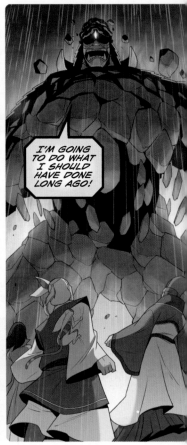

I'M GOING TO DO WHAT I SHOULD HAVE DONE LONG AGO!

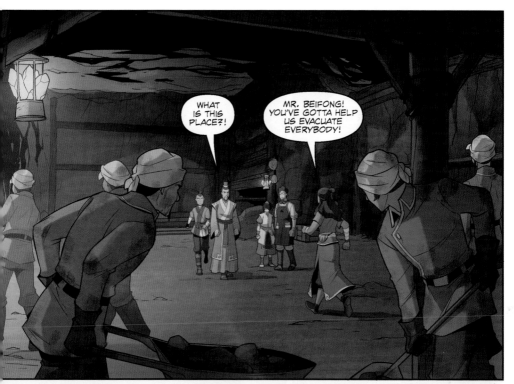

WHAT IS THIS PLACE?!

MR. BEIFONG! YOU'VE GOTTA HELP US EVACUATE EVERYBODY!

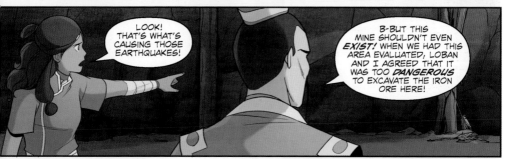

LOOK! THAT'S WHAT'S CAUSING THOSE EARTHQUAKES!

B-BUT THIS MINE SHOULDN'T EVEN *EXIST!* WHEN WE HAD THIS AREA EVALUATED, LOBAN AND I AGREED THAT IT WAS TOO *DANGEROUS* TO EXCAVATE THE IRON ORE HERE!

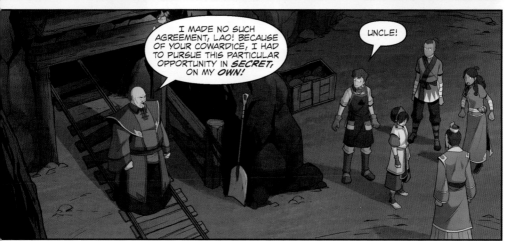

I MADE NO SUCH AGREEMENT, LAO! BECAUSE OF YOUR COWARDICE, I HAD TO PURSUE THIS PARTICULAR OPPORTUNITY IN *SECRET,* ON MY *OWN!*

UNCLE!

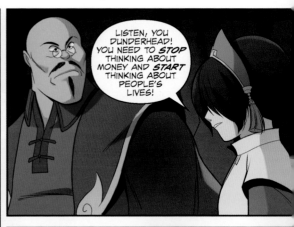

THIS IS THE RICHEST DEPOSIT OF *IRON ORE* I'VE EVER SEEN! IT'S -- IT'S ALMOST *UNNATURALLY* RICH! AND YOU JUST WANTED TO LEAVE IT HERE, BURIED BENEATH THE DIRT!

LISTEN, YOU DUNDERHEAD! YOU NEED TO *STOP* THINKING ABOUT MONEY AND *START* THINKING ABOUT PEOPLE'S LIVES!

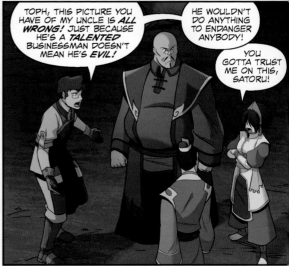

TOPH, THIS PICTURE YOU HAVE OF MY UNCLE IS *ALL WRONG!* JUST BECAUSE HE'S A *TALENTED* BUSINESSMAN DOESN'T MEAN HE'S *EVIL!*

HE WOULDN'T DO ANYTHING TO ENDANGER ANYBODY!

YOU GOTTA TRUST ME ON THIS, SATORU!

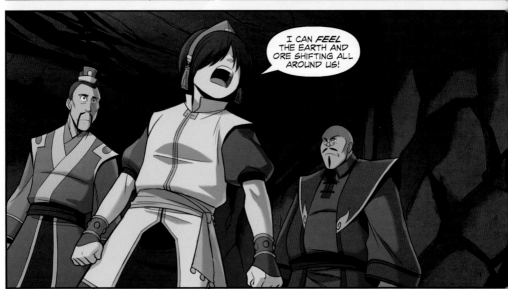

I CAN *FEEL* THE EARTH AND ORE SHIFTING ALL AROUND US!

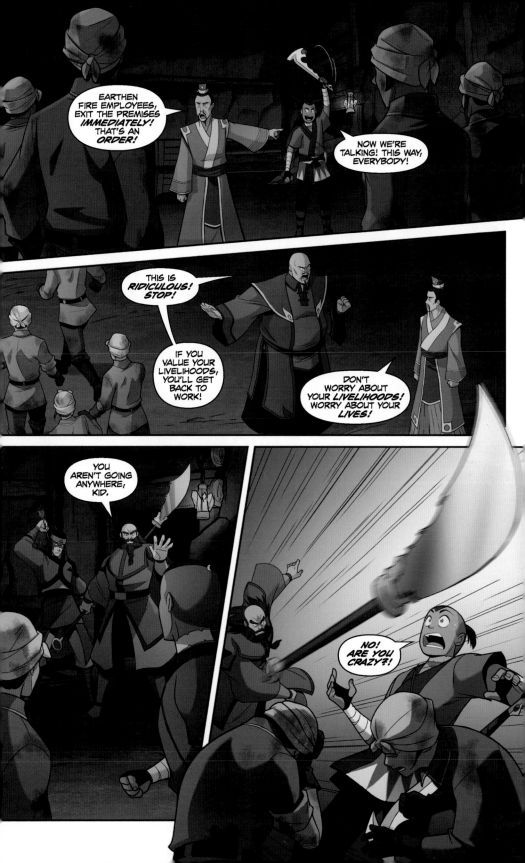

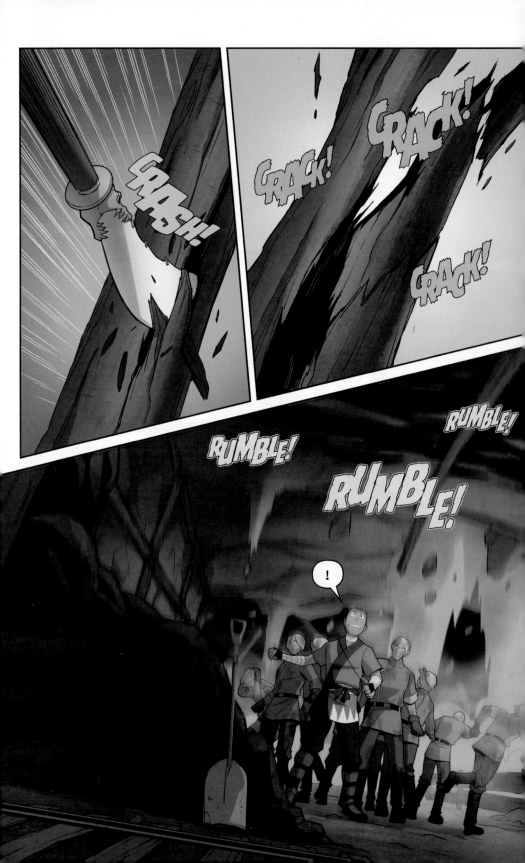

I TOLD YOU, I WAS VERY YOUNG THEN. THE AVATAR STATE COULD STILL BE ELUSIVE AT TIMES.

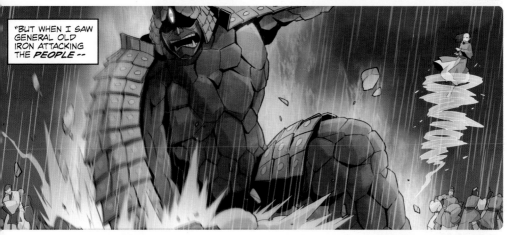

"BUT WHEN I SAW GENERAL OLD IRON ATTACKING THE *PEOPLE* --

"-- THE AVATAR STATE WELLED UP WITHIN ME, UNBIDDEN."

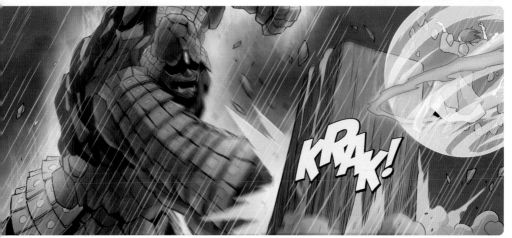

KRAK!

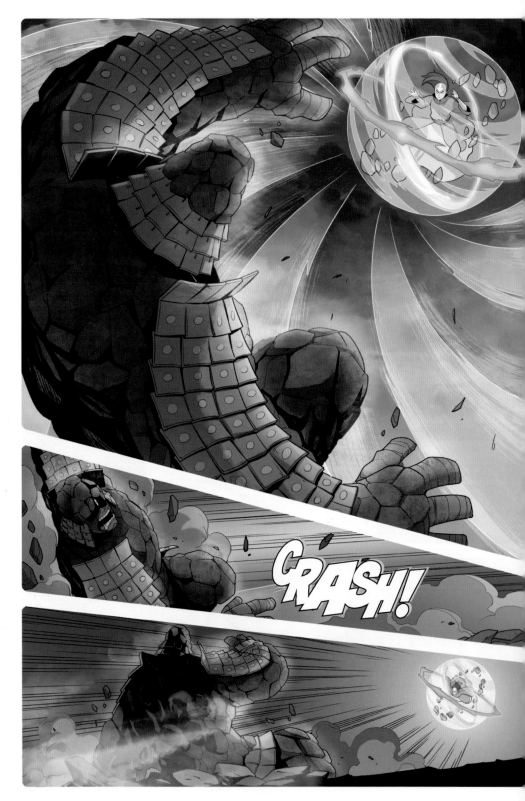

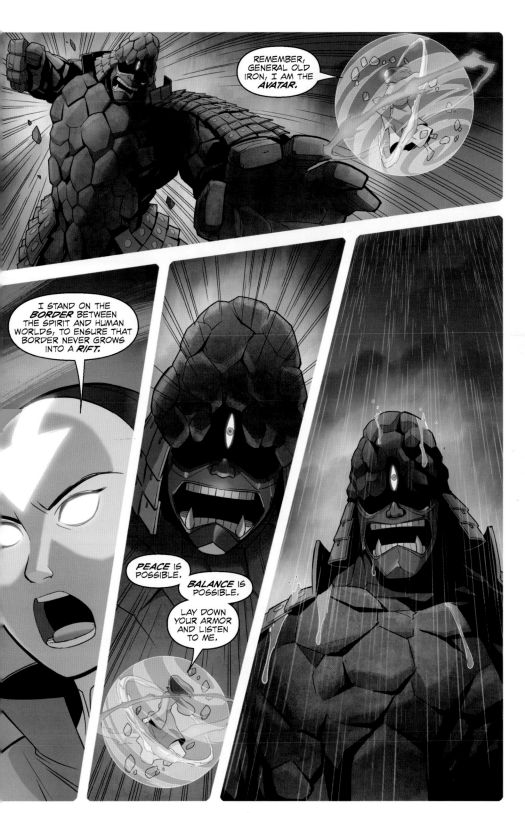

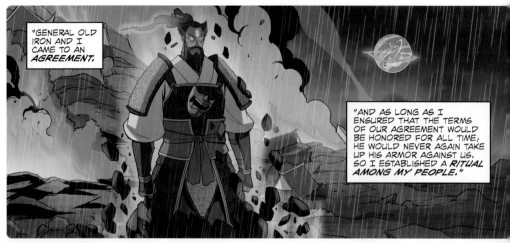

"GENERAL OLD IRON AND I CAME TO AN *AGREEMENT*.

"AND AS LONG AS I ENSURED THAT THE TERMS OF OUR AGREEMENT WOULD BE HONORED FOR ALL TIME, HE WOULD NEVER AGAIN TAKE UP HIS ARMOR AGAINST US. SO I ESTABLISHED A *RITUAL AMONG MY PEOPLE*."

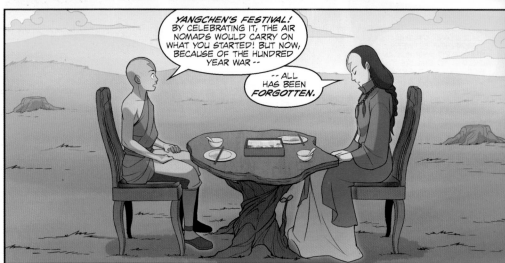

YANGCHEN'S FESTIVAL! BY CELEBRATING IT, THE AIR NOMADS WOULD CARRY ON WHAT YOU STARTED! BUT NOW, BECAUSE OF THE HUNDRED YEAR WAR --

-- ALL HAS BEEN *FORGOTTEN*.

TELL ME, THEN, WHAT ARE THE TERMS OF YOUR AGREEMENT?

FIRST --

RUMBLE! RUMBLE! RUMBLE!

AVATAR YANGCHEN? WHAT'S GOING ON?!

RUMBLE!

RUMBLE!

RUMBLE!

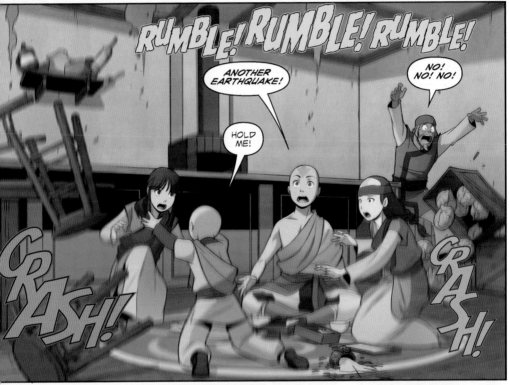

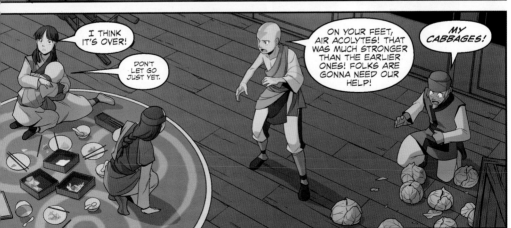

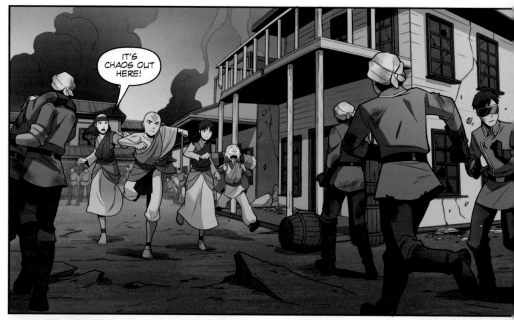

IT'S CHAOS OUT HERE!

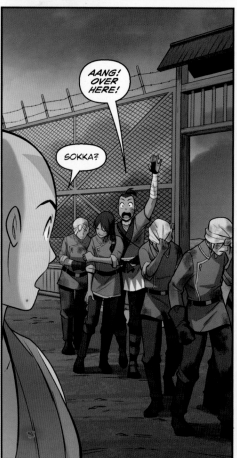

AANG! OVER HERE!

SOKKA?

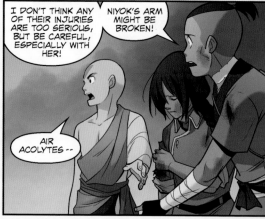

I DON'T THINK ANY OF THEIR INJURIES ARE TOO SERIOUS, BUT BE CAREFUL, ESPECIALLY WITH HER!

NIYOK'S ARM MIGHT BE BROKEN!

AIR ACOLYTES --

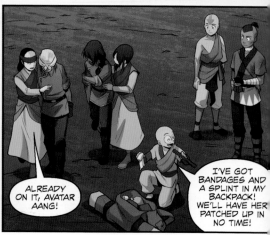

ALREADY ON IT, AVATAR AANG!

I'VE GOT BANDAGES AND A SPLINT IN MY BACKPACK! WE'LL HAVE HER PATCHED UP IN NO TIME!

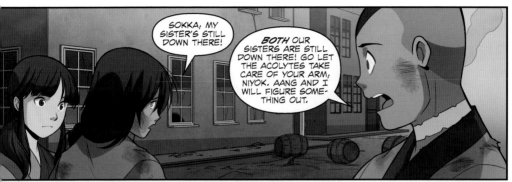

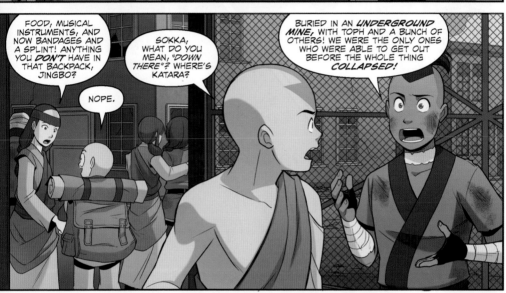

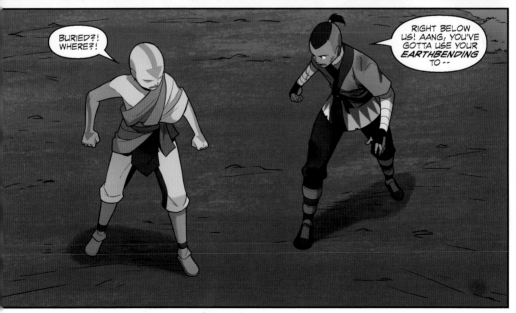

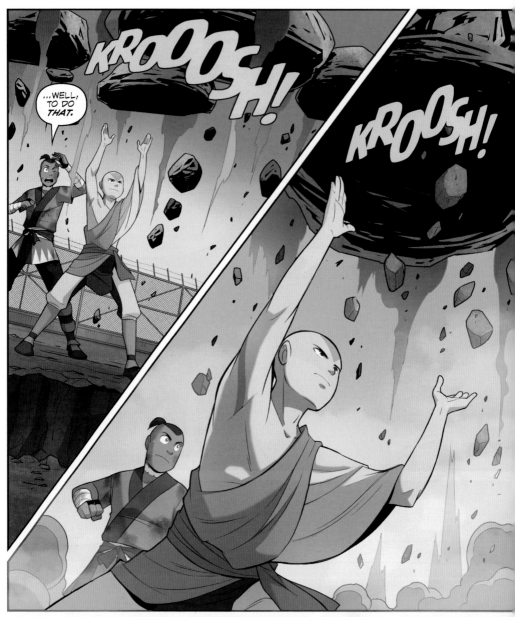

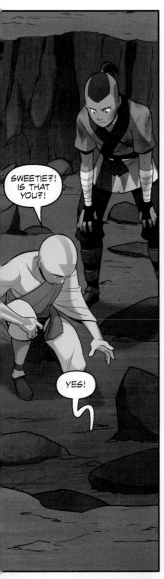

SWEETIE?! IS THAT YOU?!

YES!

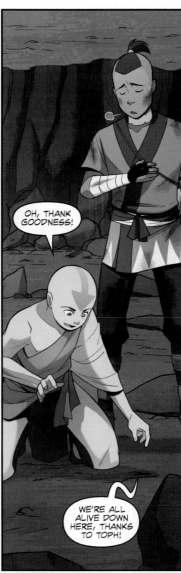

OH, THANK GOODNESS!

WE'RE ALL ALIVE DOWN HERE, THANKS TO TOPH!

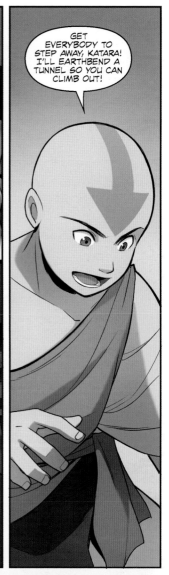

GET EVERYBODY TO STEP AWAY, KATARA! I'LL EARTHBEND A TUNNEL SO YOU CAN CLIMB OUT!

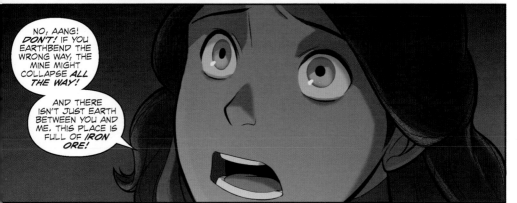

NO, AANG! *DON'T!* IF YOU EARTHBEND THE WRONG WAY, THE MINE MIGHT COLLAPSE *ALL THE WAY!*

AND THERE ISN'T JUST EARTH BETWEEN YOU AND ME. THIS PLACE IS FULL OF *IRON ORE!*

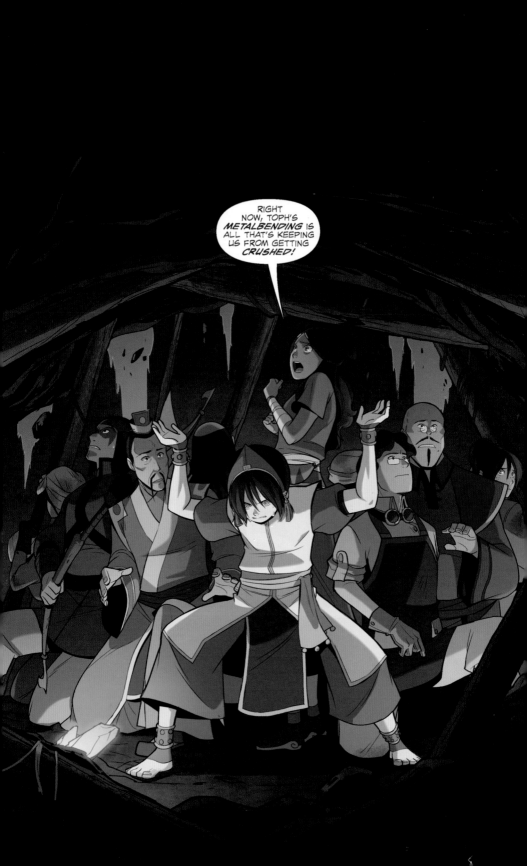

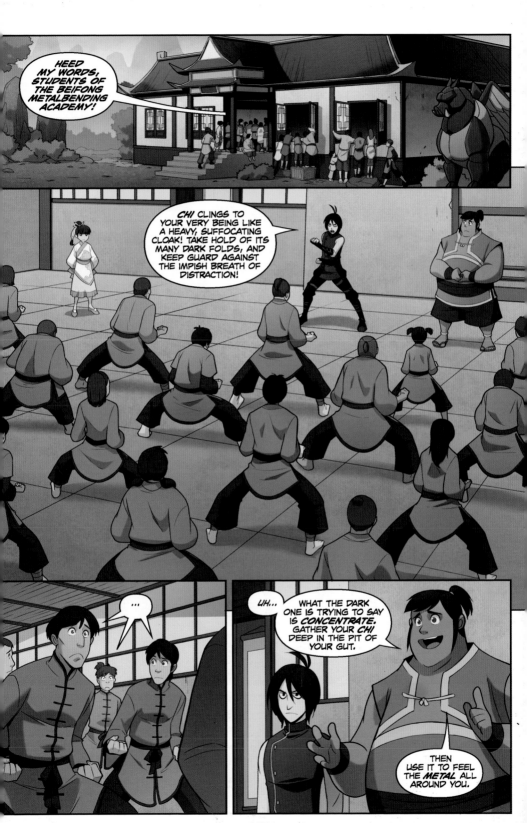

TELL EVERYBODY DOWN THERE TO HANG ON JUST A WHILE LONGER. THE METALBENDERS WILL BE HERE IN NO TIME, I'M SURE OF IT!

KATARA?

SOKKA'S BACK?

NO, NOT YET. I JUST WANTED TO HEAR YOUR VOICE.

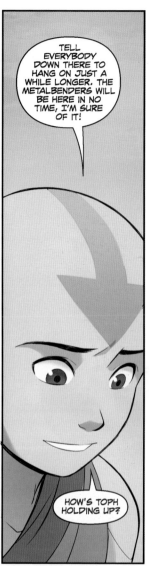

HOW'S TOPH HOLDING UP?

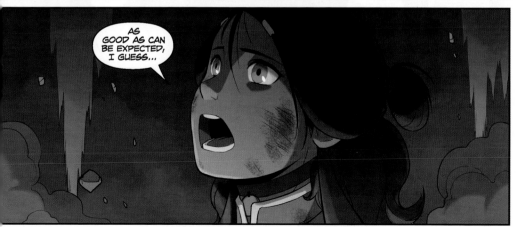

AS GOOD AS CAN BE EXPECTED, I GUESS...

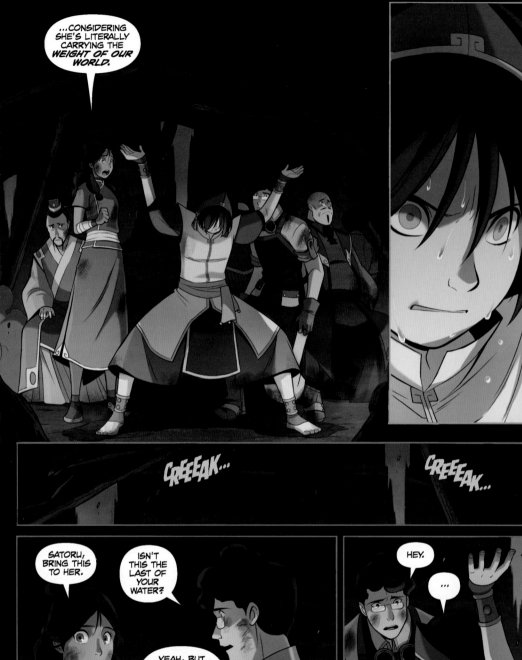

...CONSIDERING SHE'S LITERALLY CARRYING THE **WEIGHT OF OUR WORLD.**

CREEEAK...

CREEEAK...

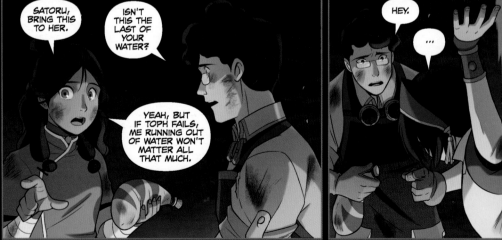

SATORU, BRING THIS TO HER.

ISN'T THIS THE LAST OF YOUR WATER?

YEAH, BUT IF TOPH FAILS, ME RUNNING OUT OF WATER WON'T MATTER ALL THAT MUCH.

HEY.

...

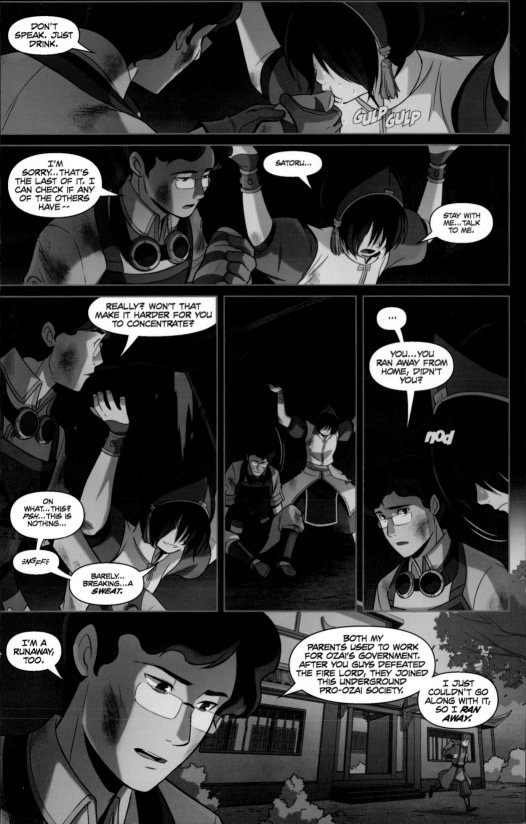

"I SPENT MONTHS ON THE STREETS OF BA SING SE'S LOWER RING, BEGGING FOR FOOD.

"WHEN MY UNCLE HEARD WHAT'D HAPPENED, HE CAME TO FIND ME. HE FED ME, HOUSED ME, GAVE ME A JOB.

"I ADMIRED HIM SO MUCH. UNLIKE MY PARENTS, HE DOESN'T CARE ABOUT *POLITICS* AT ALL."

BUT NOW I REALIZE THAT'S BECAUSE HE ONLY CARES ABOUT *MONEY.*

I GUESS I WAS TOO SCARED OF GETTING THROWN BACK OUT ON THE STREETS TO SEE IT EARLIER.

YOU'RE RIGHT, TOPH. I'M A *SNIVELING FLUNKY.*

NHH... NO...YOU'RE *NOT.*

I WISH I WERE BRAVE LIKE YOU. YOU CONFRONTED YOUR DAD, EVEN AFTER ALL THOSE TERRIBLE THINGS HE SAID.

THERE REALLY IS NO END TO YOUR AMAZINGNESS, TOPH BEIFONG.

≥AHEM≤

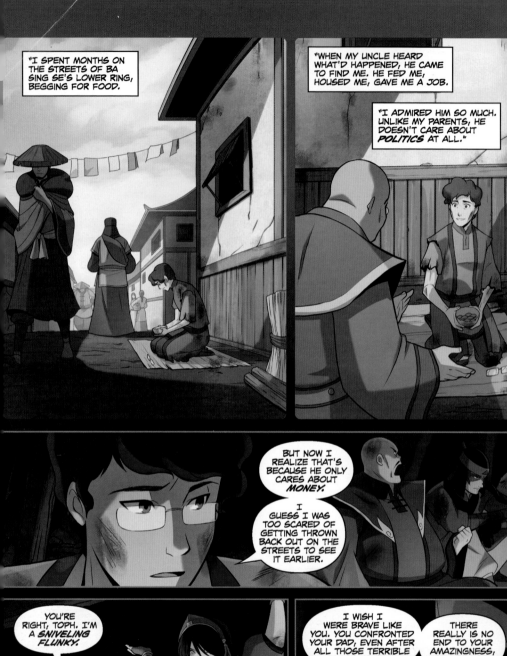

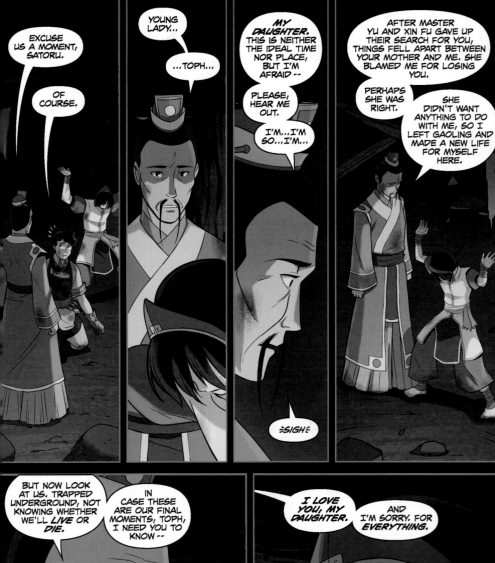

EXCUSE US A MOMENT, SATORU.

OF COURSE.

YOUNG LADY...

...TOPH...

MY DAUGHTER. THIS IS NEITHER THE IDEAL TIME NOR PLACE, BUT I'M AFRAID --

PLEASE, HEAR ME OUT.

I'M...I'M SO...I'M...

≷SIGH≷

AFTER MASTER YU AND XIN FU GAVE UP THEIR SEARCH FOR YOU, THINGS FELL APART BETWEEN YOUR MOTHER AND ME. SHE BLAMED ME FOR LOSING YOU.

PERHAPS SHE WAS RIGHT.

SHE DIDN'T WANT ANYTHING TO DO WITH ME, SO I LEFT GAOLING AND MADE A NEW LIFE FOR MYSELF HERE.

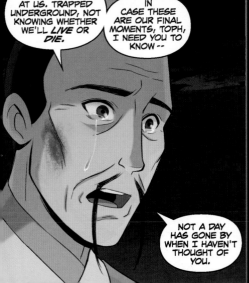

BUT NOW LOOK AT US. TRAPPED UNDERGROUND, NOT KNOWING WHETHER WE'LL LIVE OR *DIE.*

IN CASE THESE ARE OUR FINAL MOMENTS, TOPH, I NEED YOU TO KNOW --

NOT A DAY HAS GONE BY WHEN I HAVEN'T THOUGHT OF YOU.

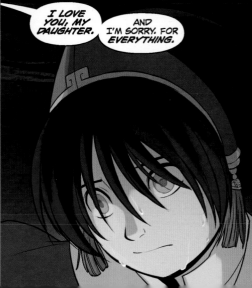

I LOVE YOU, MY DAUGHTER.

AND I'M SORRY. FOR *EVERYTHING.*

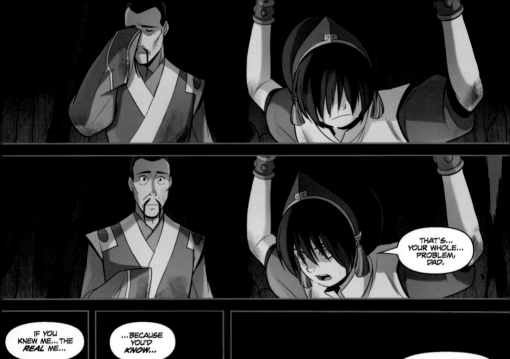

THAT'S... YOUR WHOLE... PROBLEM, DAD.

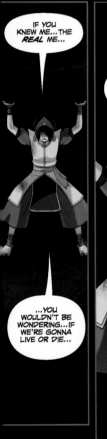

IF YOU KNEW ME...THE *REAL* ME...

...YOU WOULDN'T BE WONDERING...IF WE'RE GONNA LIVE OR DIE...

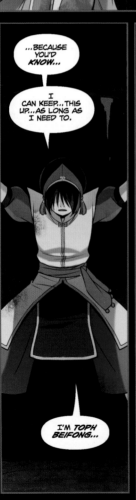

...BECAUSE YOU'D *KNOW*...

I CAN KEEP...THIS UP...AS LONG AS I NEED TO.

I'M *TOPH BEIFONG*...

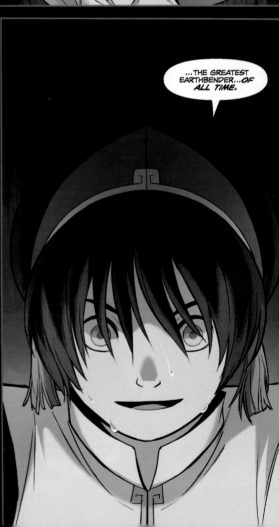

...THE GREATEST EARTHBENDER...*OF ALL TIME.*

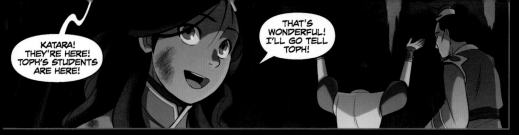

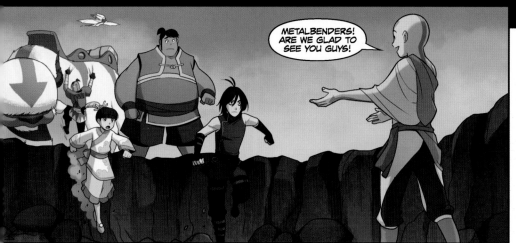

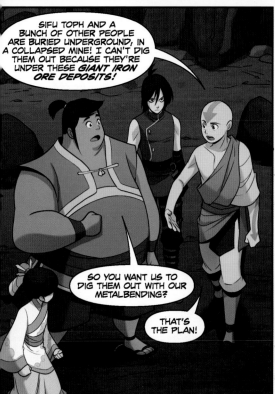

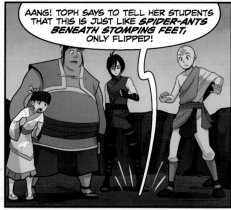

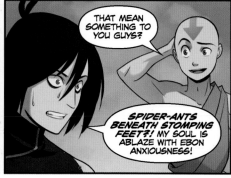

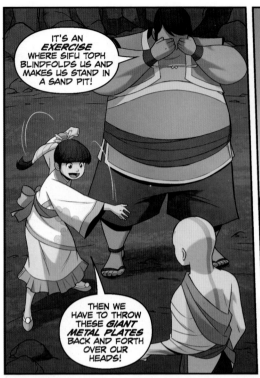

IT'S AN *EXERCISE* WHERE SIFU TOPH BLINDFOLDS US AND MAKES US STAND IN A SAND PIT!

THEN WE HAVE TO THROW THESE *GIANT METAL PLATES* BACK AND FORTH OVER OUR HEADS!

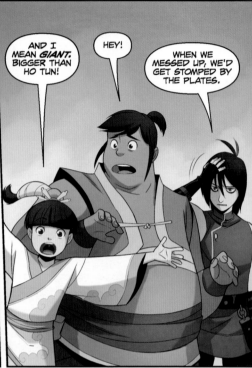

AND I MEAN *GIANT.* BIGGER THAN HO TUN!

HEY!

WHEN WE MESSED UP, WE'D GET STOMPED BY THE PLATES.

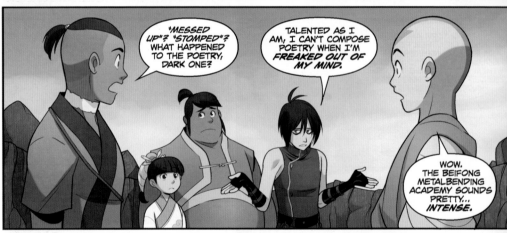

"MESSED UP"? "STOMPED"? WHAT HAPPENED TO THE POETRY, DARK ONE?

TALENTED AS I AM, I CAN'T COMPOSE POETRY WHEN I'M *FREAKED OUT OF MY MIND.*

WOW. THE BEIFONG METALBENDING ACADEMY SOUNDS PRETTY... *INTENSE.*

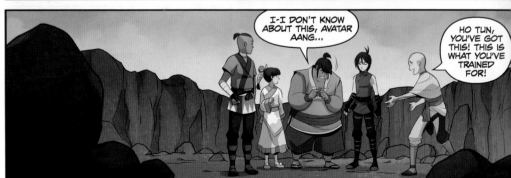

I-I DON'T KNOW ABOUT THIS, AVATAR AANG...

HO TUN, YOU'VE GOT THIS! THIS IS WHAT YOU'VE TRAINED FOR!

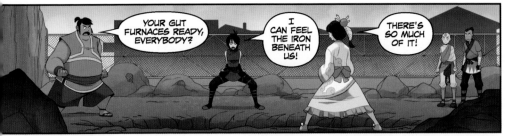

YOUR GUT FURNACES READY, EVERYBODY?

I CAN FEEL THE IRON BENEATH US!

THERE'S SO MUCH OF IT!

ALL RIGHT THEN, TEAM BEIFONG! *LET'S METALBEND!*

KRK!

KRK!

KRK! KRK!

KEEP GOING, KEEP GOING!

KRK!

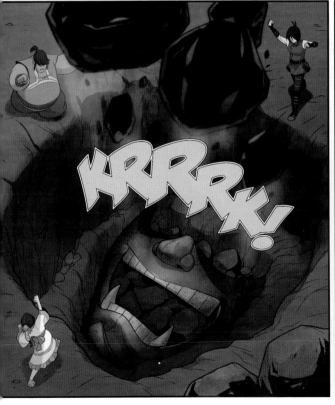

KRRRK!

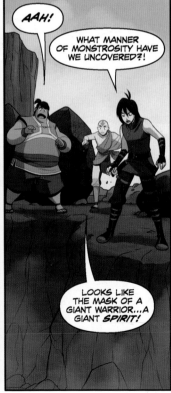

AAH!

WHAT MANNER OF MONSTROSITY HAVE WE UNCOVERED?!

LOOKS LIKE THE MASK OF A GIANT WARRIOR...A GIANT *SPIRIT!*

157

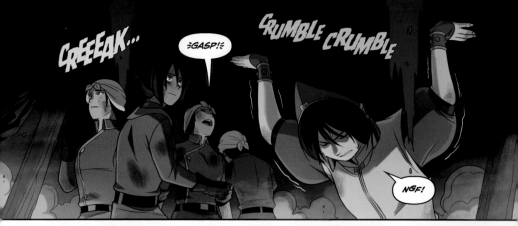

CREEEAK... ⸵GASP!⸴ CRUMBLE CRUMBLE

NGF!

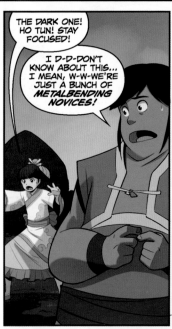

THE DARK ONE! HO TUN! STAY FOCUSED!

I D-D-DON'T KNOW ABOUT THIS... I MEAN, W-W-WE'RE JUST A BUNCH OF *METALBENDING NOVICES!*

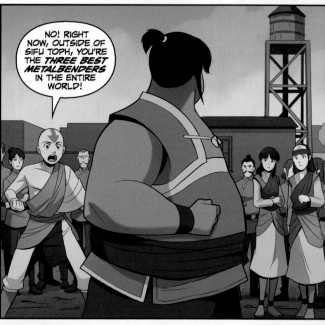

NO! RIGHT NOW, OUTSIDE OF SIFU TOPH, YOU'RE THE *THREE BEST METALBENDERS* IN THE ENTIRE WORLD!

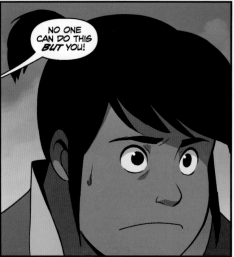

NO ONE CAN DO THIS *BUT* YOU!

XING YING, WHO ARE THOSE GUYS?

TOPH'S METALBENDING STUDENTS. THEY'RE PRETTY GREAT, HUH?

HEY! I CAN FEEL THE SPACE WHERE SIFU TOPH AND THE OTHERS ARE!

YEAH, PRETTY GREAT.

AVATAR AANG, WE NEED YOU FOR THIS LAST PART! AS WE PULL UP THE LAST FEW PIECES OF IRON, DON'T LET ANY OF THE DIRT COLLAPSE BACK INTO THE MINE!

GOT IT.

THIS IS IT! ONE LAST HEAVE, TEAM BEIFONG!

COME ON...GUYS... ALMOST THERE...

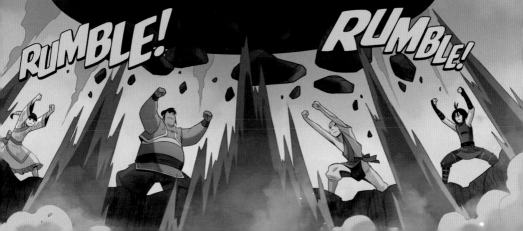

RUMBLE!

RUMBLE!

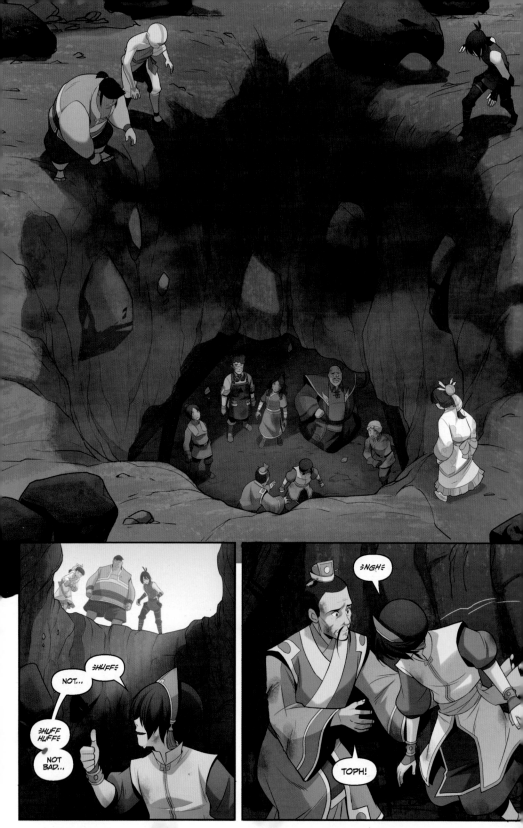

NOT...

≶HUFF≶

≶HUFF
HUFF≶

NOT
BAD...

≶NGH≶

TOPH!

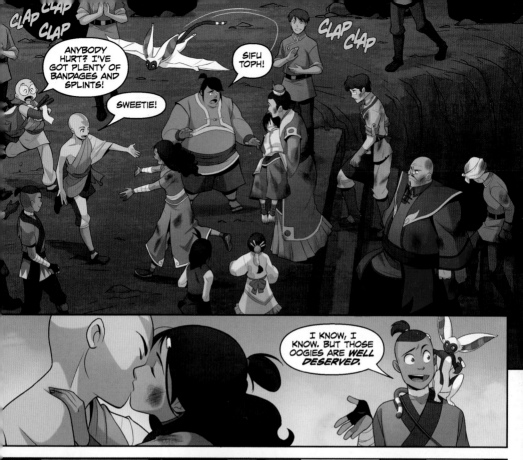

CLAP CLAP
CLAP

CLAP CLAP

ANYBODY HURT? I'VE GOT PLENTY OF BANDAGES AND SPLINTS!

SWEETIE!

SIFU TOPH!

I KNOW, I KNOW. BUT THOSE OOGIES ARE WELL DESERVED.

I'M SO GLAD YOU'RE OUT OF THERE.

ME TOO.

OH NO! IS SHE--?

DREAD UPON DREAD! LO, HOW THE DARK FOG OF DESPAIR ROLLS RELENTLESSLY THROUGH MY HEART!

SHE'S JUST EXHAUSTED. SHE'LL BE FINE.

SHE LOOKS SO...SMALL. FRAGILE, ALMOST.

SSSH! ARE YOU CRAZY?! YOU'LL GET PUMMELED IF SHE HEARS YOU TALKING LIKE THAT!

161

STRANGER, KEEP NOT YOUR IDENTITY HIDDEN AWAY FROM US, LIKE A SECRET TREASURE IN AN ANCIENT CHEST!

I'M... TOPH'S *FATHER*.

SIFU TOPH HAS A *DAD*?

WHAT'D YOU THINK, SHE POPPED OUT OF A ROCK?

IT'D MAKE SENSE, WOULDN'T IT?

NUTHA, LET ONE OF THE AIR ACOLYTES CHECK YOU OVER, TO MAKE SURE YOU'RE OKAY.

KATARA... I, UH...

THANKS.

YEAH. NO PROBLEM.

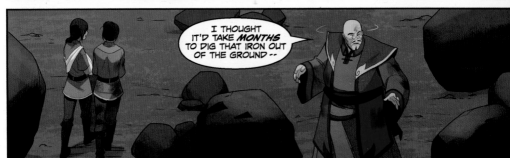

I THOUGHT IT'D TAKE *MONTHS* TO DIG THAT IRON OUT OF THE GROUND --

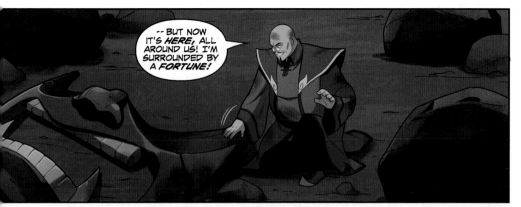

-- BUT NOW IT'S *HERE*, ALL AROUND US! I'M SURROUNDED BY A *FORTUNE!*

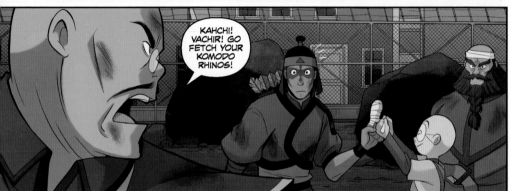

KAHCHI! VACHIR! GO FETCH YOUR KOMODO RHINOS!

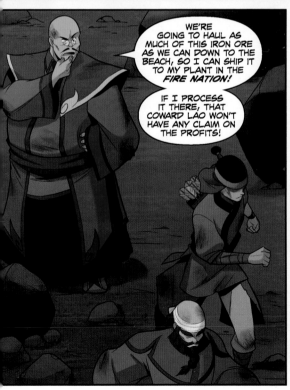

WE'RE GOING TO HAUL AS MUCH OF THIS IRON ORE AS WE CAN DOWN TO THE BEACH, SO I CAN SHIP IT TO MY PLANT IN THE *FIRE NATION!*

IF I PROCESS IT THERE, THAT COWARD LAO WON'T HAVE ANY CLAIM ON THE PROFITS!

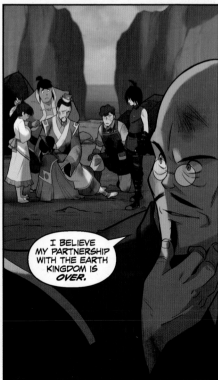

I BELIEVE MY PARTNERSHIP WITH THE EARTH KINGDOM IS *OVER.*

WHOOO...

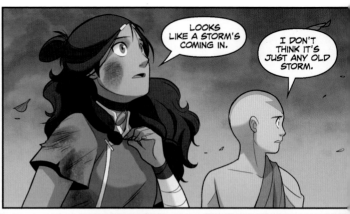

LOOKS LIKE A STORM'S COMING IN.

I DON'T THINK IT'S JUST ANY OLD STORM.

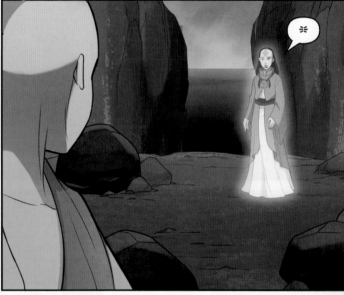

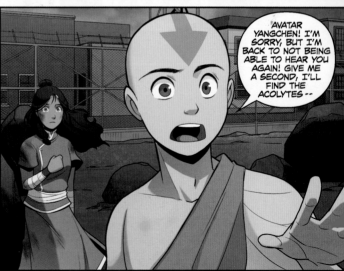

AVATAR YANGCHEN! I'M SORRY, BUT I'M BACK TO NOT BEING ABLE TO HEAR YOU AGAIN! GIVE ME A SECOND, I'LL FIND THE ACOLYTES --

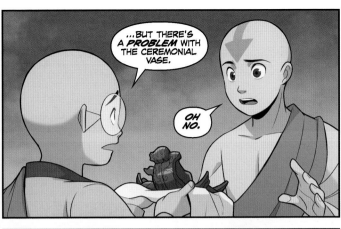

GUYS, I NEED TO FINISH THE *CEREMONIAL MEAL!* YOU STILL HAVE THE FOOD AND THE INCENSE AND THE OTHER STUFF?

...BUT THERE'S A *PROBLEM* WITH THE CEREMONIAL VASE.

OH NO.

KIND OF...

THERE'S GOTTA BE ANOTHER WAY...

LIKE YOUR MEDITATION BEADS, THE AVATARS ARE LINKED, ONE TO THE OTHER.

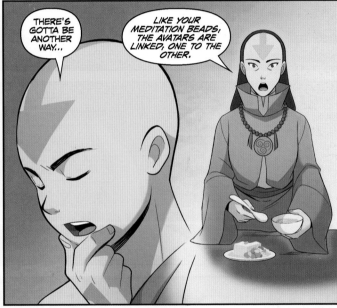

ANYTHING I CAN DO TO HELP?

NO, I GOT THIS. I JUST NEED SOME PEACE, QUIET, AND A *GOOD-SIZED ROCK.*

KRK!

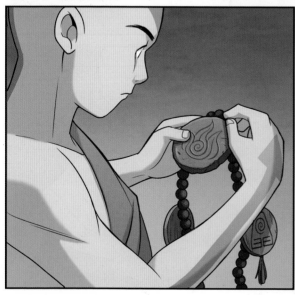

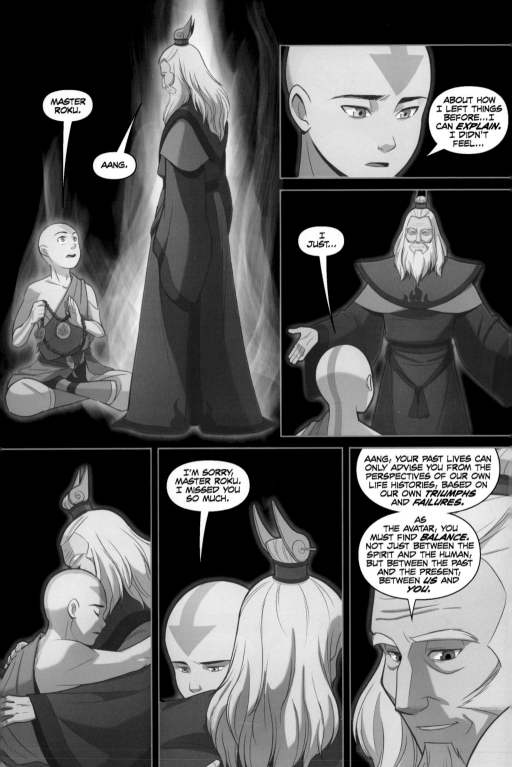

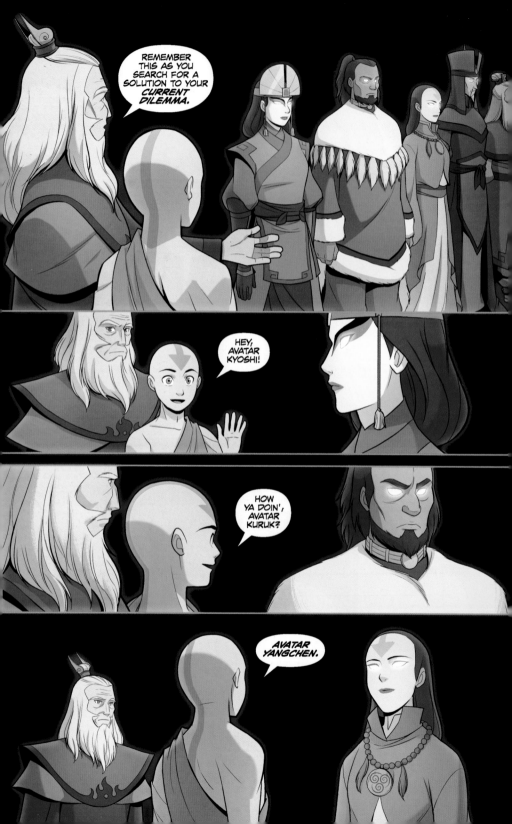

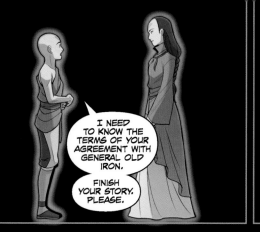

I NEED TO KNOW THE TERMS OF YOUR AGREEMENT WITH GENERAL OLD IRON.

FINISH YOUR STORY. PLEASE.

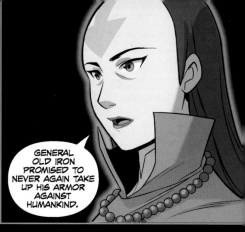

GENERAL OLD IRON PROMISED TO NEVER AGAIN TAKE UP HIS ARMOR AGAINST HUMANKIND.

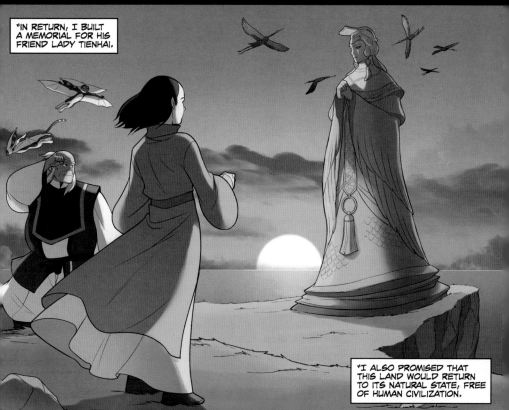

"IN RETURN, I BUILT A MEMORIAL FOR HIS FRIEND LADY TIENHAI.

"I ALSO PROMISED THAT THIS LAND WOULD RETURN TO ITS NATURAL STATE, FREE OF HUMAN CIVILIZATION.

"IT WOULD BE A SIGN THAT HUMANS ARE CAPABLE OF *PRESERVING* AND *PROTECTING*, THAT BALANCE CAN BE ACHIEVED BETWEEN THE SPIRIT AND HUMAN WORLDS.

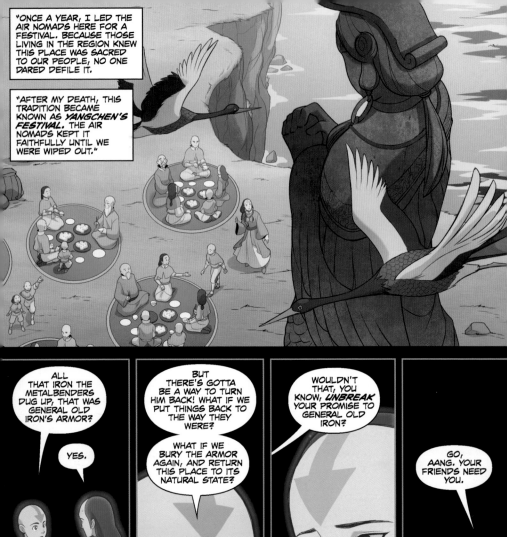

"ONCE A YEAR, I LED THE AIR NOMADS HERE FOR A FESTIVAL. BECAUSE THOSE LIVING IN THE REGION KNEW THIS PLACE WAS SACRED TO OUR PEOPLE, NO ONE DARED DEFILE IT.

"AFTER MY DEATH, THIS TRADITION BECAME KNOWN AS *YANGCHEN'S FESTIVAL.* THE AIR NOMADS KEPT IT FAITHFULLY UNTIL WE WERE WIPED OUT."

ALL THAT IRON THE METALBENDERS DUG UP, THAT WAS GENERAL OLD IRON'S ARMOR?

YES.

MY PROMISE HAS BEEN *BROKEN.* NOW, IT'S ONLY A MATTER OF TIME BEFORE GENERAL OLD IRON RETURNS.

BUT THERE'S GOTTA BE A WAY TO TURN HIM BACK! WHAT IF WE PUT THINGS BACK TO THE WAY THEY WERE?

WHAT IF WE BURY THE ARMOR AGAIN, AND RETURN THIS PLACE TO ITS NATURAL STATE?

WOULDN'T THAT, YOU KNOW, *UNBREAK* YOUR PROMISE TO GENERAL OLD IRON?

...

GO, AANG. YOUR FRIENDS NEED YOU.

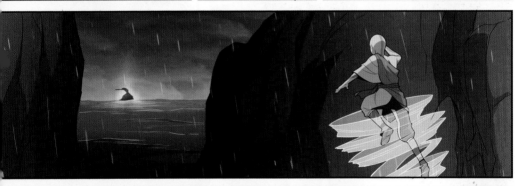

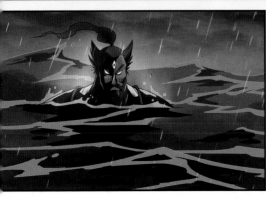

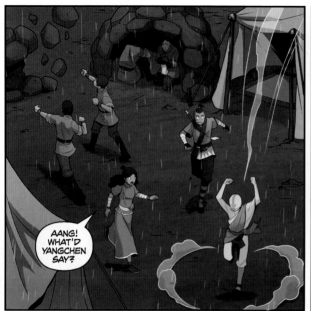

ALL THIS IRON IS ACTUALLY THE ARMOR OF AN *ANCIENT SPIRIT.* WE NEED TO PUT IT BACK IN THE GROUND.

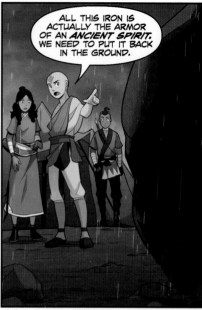

AANG! WHAT'D YANGCHEN SAY?

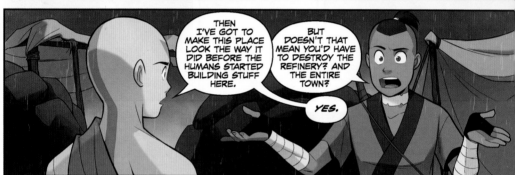

THEN I'VE GOT TO MAKE THIS PLACE LOOK THE WAY IT DID BEFORE THE HUMANS STARTED BUILDING STUFF HERE.

BUT DOESN'T THAT MEAN YOU'D HAVE TO DESTROY THE REFINERY? AND THE ENTIRE TOWN?

YES.

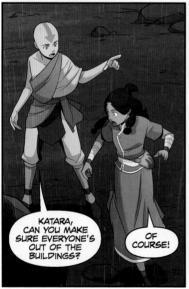

KATARA, CAN YOU MAKE SURE EVERYONE'S OUT OF THE BUILDINGS?

OF COURSE!

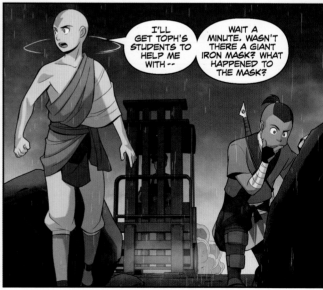

I'LL GET TOPH'S STUDENTS TO HELP ME WITH --

WAIT A MINUTE. WASN'T THERE A GIANT IRON MASK? WHAT HAPPENED TO THE MASK?

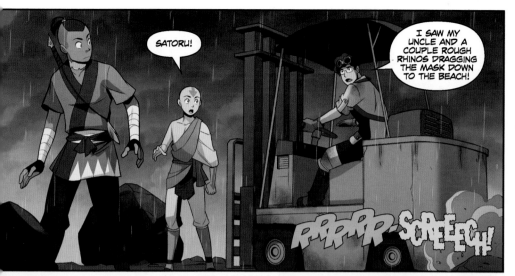

173

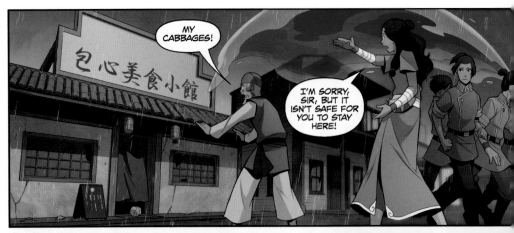

174

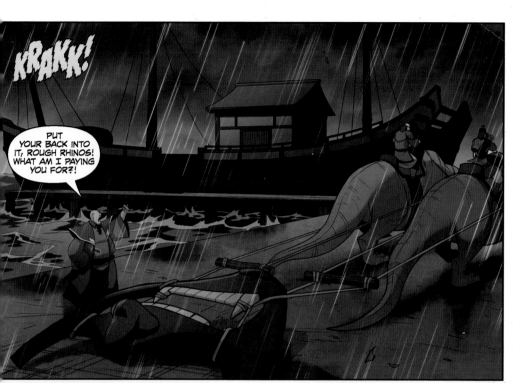

175

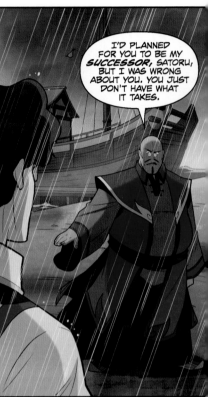

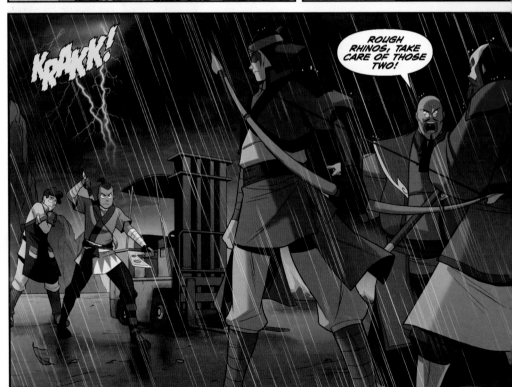

176

EVERYONE'S OUT OF THE BUILDINGS?

EVERYONE'S OUT.

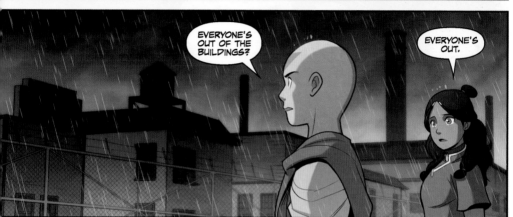

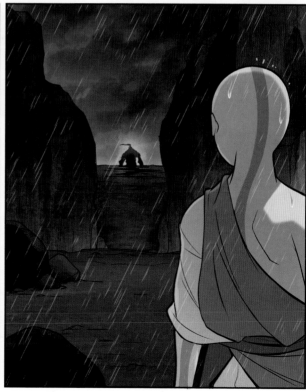

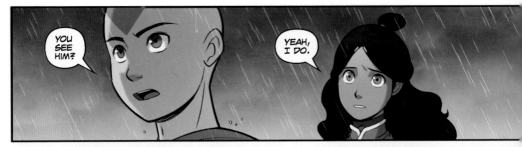

YOU SEE HIM?

YEAH, I DO.

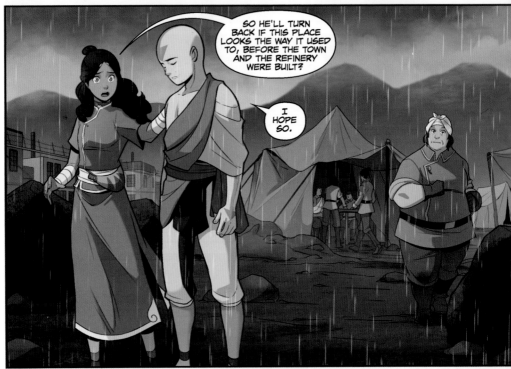

SO HE'LL TURN BACK IF THIS PLACE LOOKS THE WAY IT USED TO, BEFORE THE TOWN AND THE REFINERY WERE BUILT?

I HOPE SO.

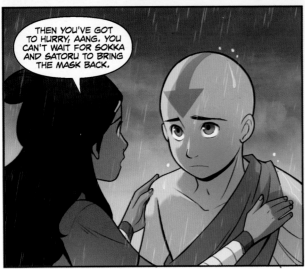

THEN YOU'VE GOT TO HURRY, AANG. YOU CAN'T WAIT FOR SOKKA AND SATORU TO BRING THE MASK BACK.

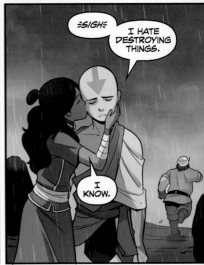

≶SIGH≶ I HATE DESTROYING THINGS.

I KNOW.

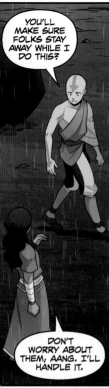

YOU'LL MAKE SURE FOLKS STAY AWAY WHILE I DO THIS?

DON'T WORRY ABOUT THEM, AANG. I'LL HANDLE IT.

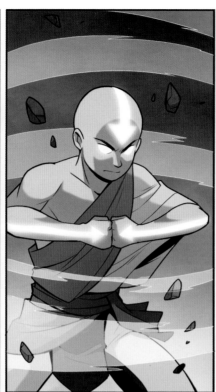

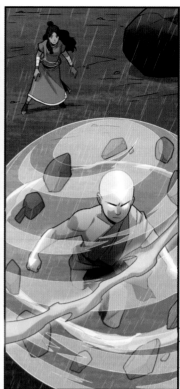

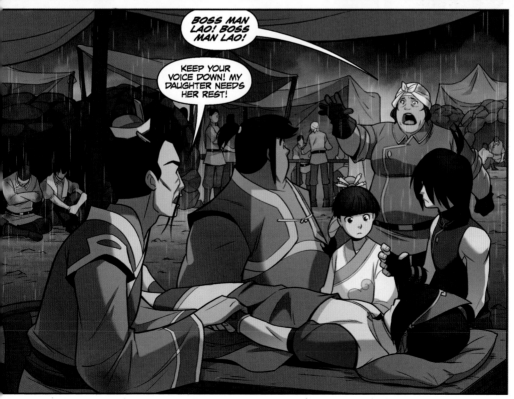

BOSS MAN LAO! BOSS MAN LAO!

KEEP YOUR VOICE DOWN! MY DAUGHTER NEEDS HER REST!

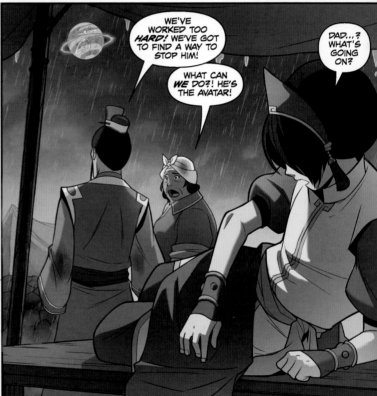

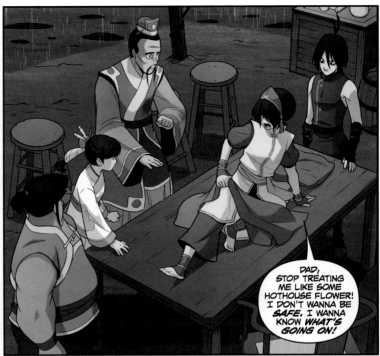

IT'S NOTHING FOR YOU TO WORRY ABOUT, MY DAUGHTER. *REST.* WHAT MATTERS IS THAT YOU'RE *SAFE.*

DAD, STOP TREATING ME LIKE SOME HOTHOUSE FLOWER! I DON'T WANNA BE *SAFE.* I WANNA KNOW *WHAT'S GOING ON!*

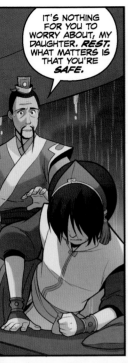

YOU'RE RIGHT. FORGIVE ME.

ONE OF MY EMPLOYEES JUST INFORMED ME THAT THE AVATAR IS ABOUT TO *DESTROY* MY REFINERY.

WHAT?! WHY?

I DON'T KNOW. LOSING THAT REFINERY WOULD RUIN ME, BUT IT'S MORE THAN JUST THAT.

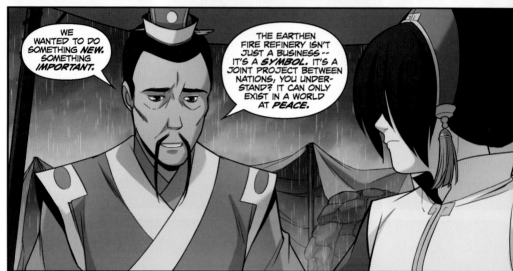

WE WANTED TO DO SOMETHING *NEW.* SOMETHING *IMPORTANT.*

THE EARTHEN FIRE REFINERY ISN'T JUST A BUSINESS -- IT'S A *SYMBOL.* IT'S A JOINT PROJECT BETWEEN NATIONS, YOU UNDERSTAND? IT CAN ONLY EXIST IN A WORLD AT *PEACE.*

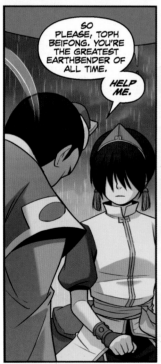

SO PLEASE, TOPH BEIFONG. YOU'RE THE GREATEST EARTHBENDER OF ALL TIME.

HELP ME.

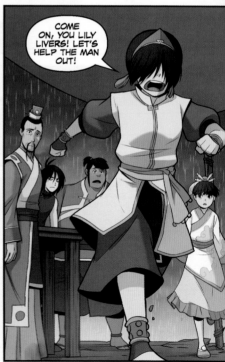

COME ON, YOU LILY LIVERS! LET'S HELP THE MAN OUT!

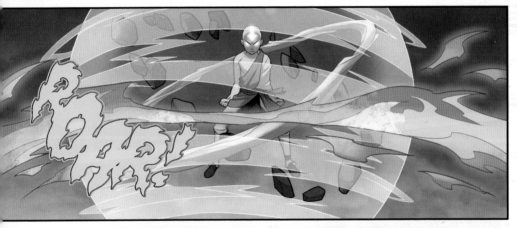

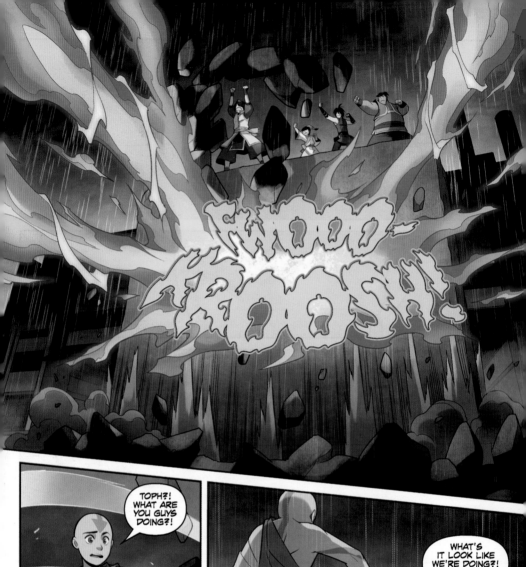

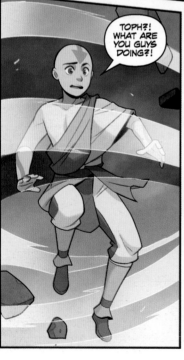

TOPH?! WHAT ARE YOU GUYS DOING?!

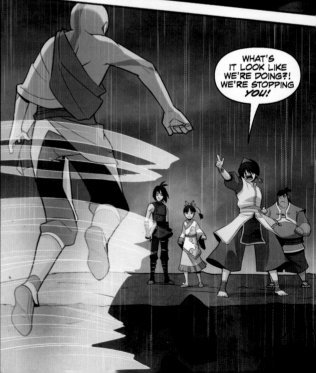

WHAT'S IT LOOK LIKE WE'RE DOING?! WE'RE STOPPING *YOU!*

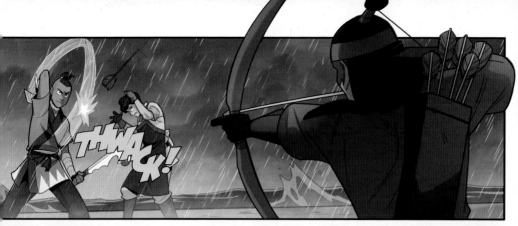

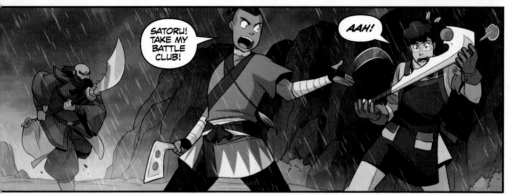

SATORU! TAKE MY BATTLE CLUB!

AAH!

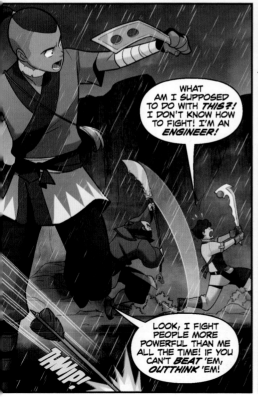

WHAT AM I SUPPOSED TO DO WITH *THIS*?! I DON'T KNOW HOW TO FIGHT! I'M AN *ENGINEER*!

LOOK, I FIGHT PEOPLE MORE POWERFUL THAN ME ALL THE TIME! IF YOU CAN'T *BEAT* 'EM, *OUTTHINK* 'EM!

THWIP!

OW!

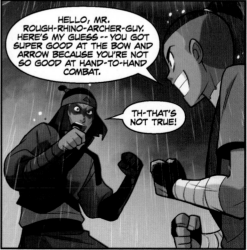

HELLO, MR. ROUGH-RHINO-ARCHER-GUY. HERE'S MY GUESS -- YOU GOT SUPER GOOD AT THE BOW AND ARROW BECAUSE YOU'RE NOT SO GOOD AT HAND-TO-HAND COMBAT.

TH-THAT'S NOT TRUE!

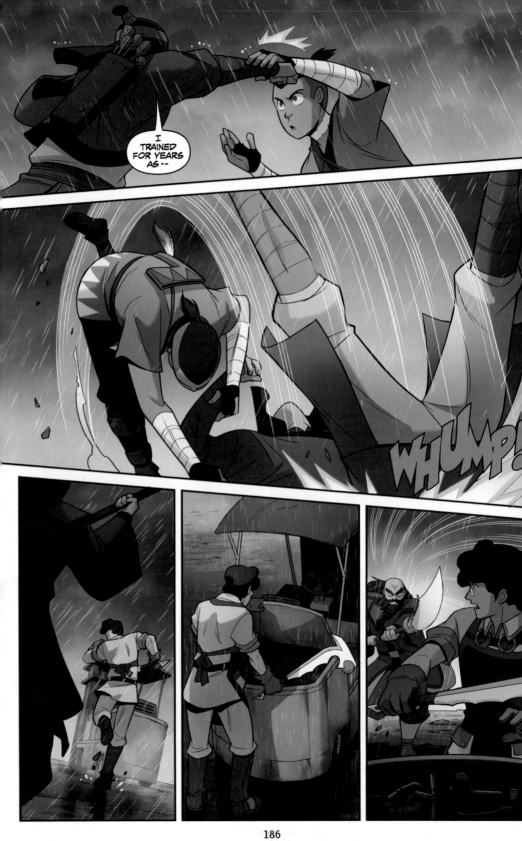

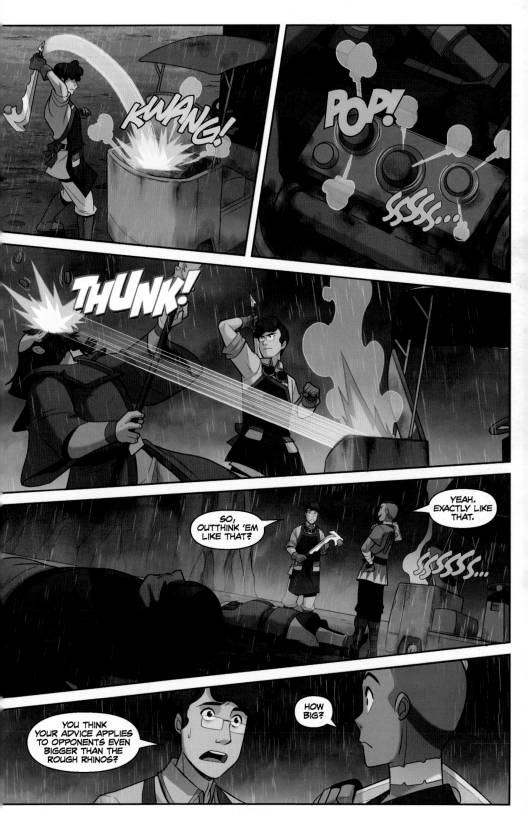

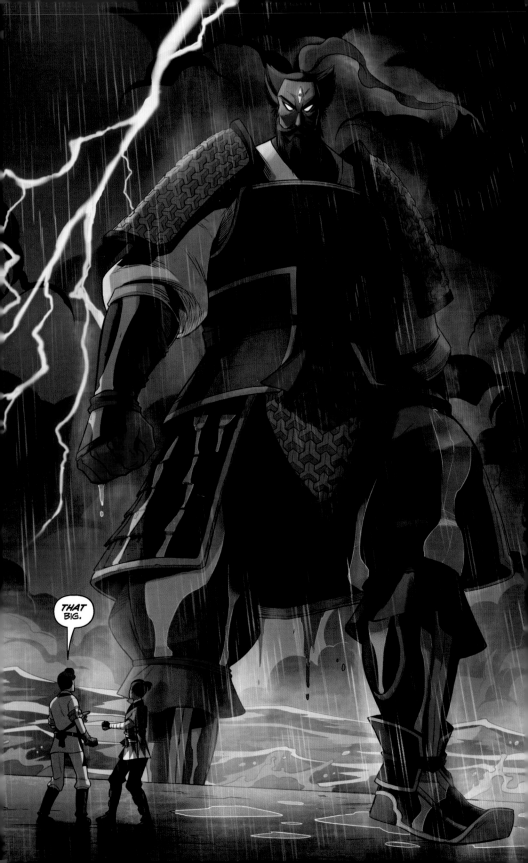

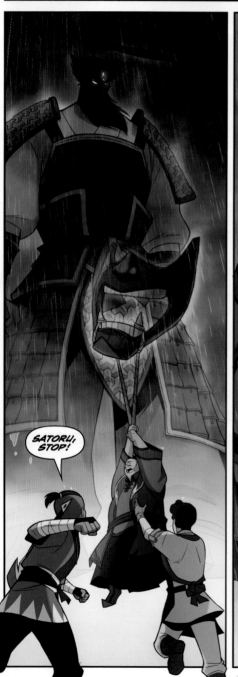

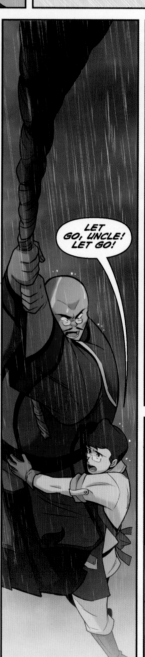

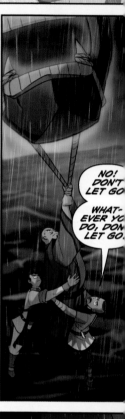

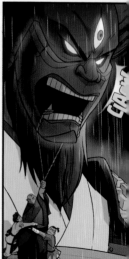

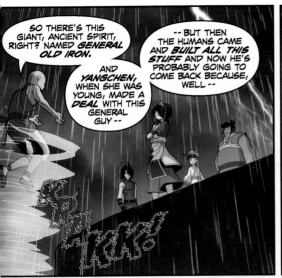

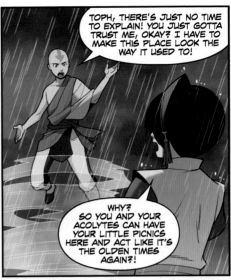

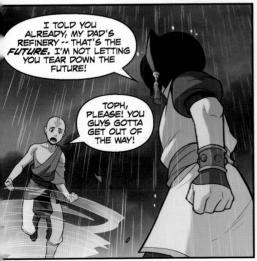

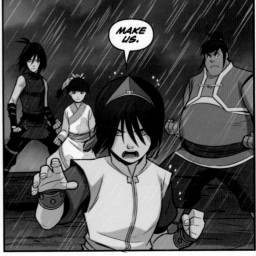

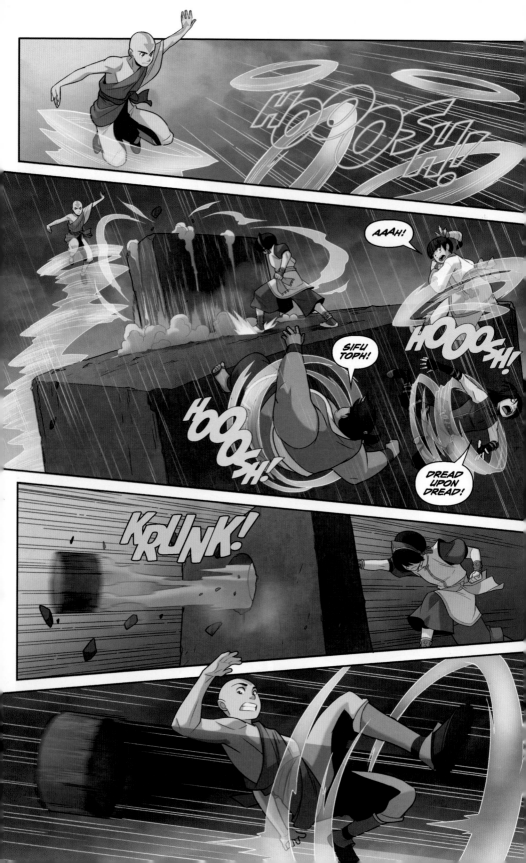

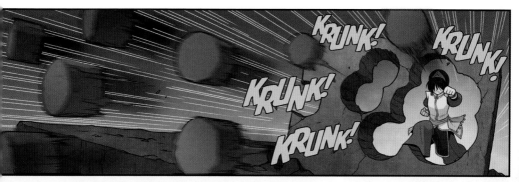

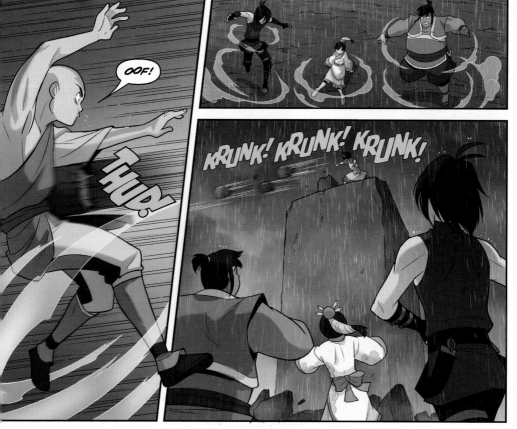

=GPH!=

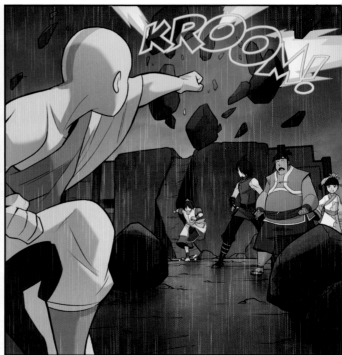

KROOM!

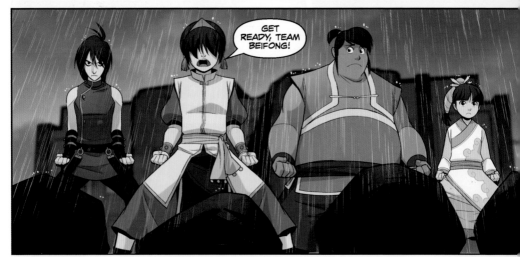

GET READY, TEAM BEIFONG!

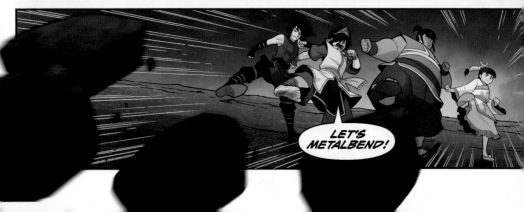

LET'S METALBEND!

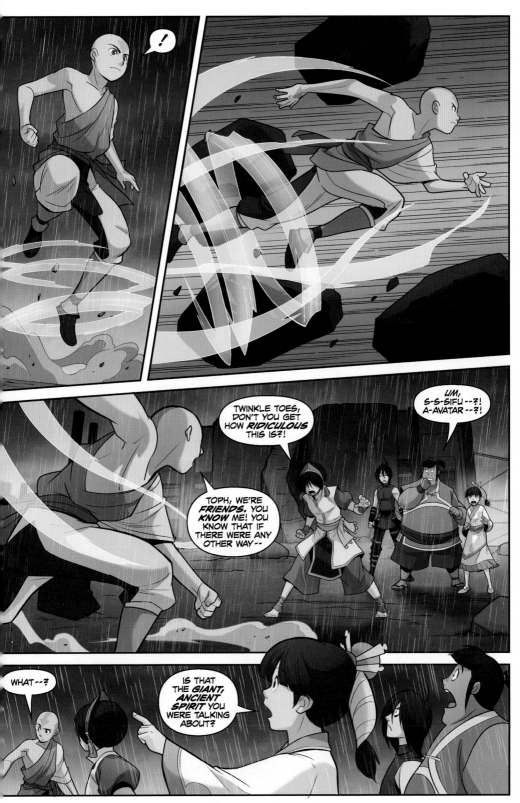

195

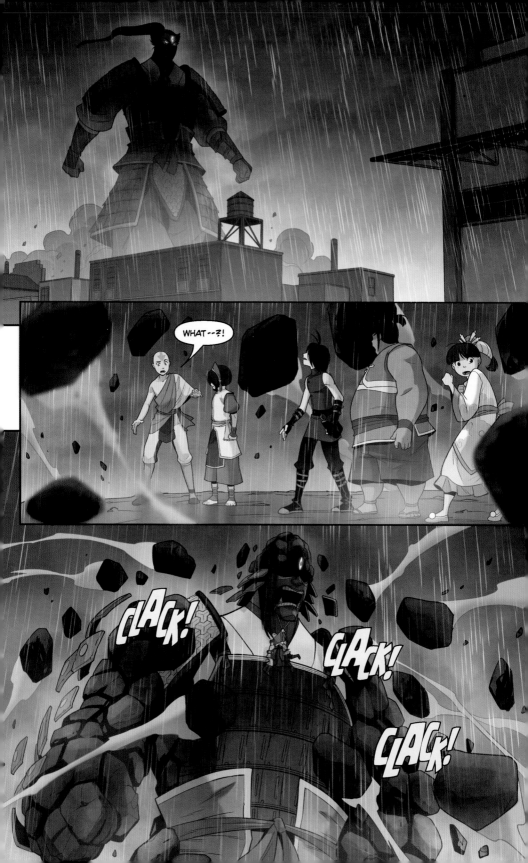

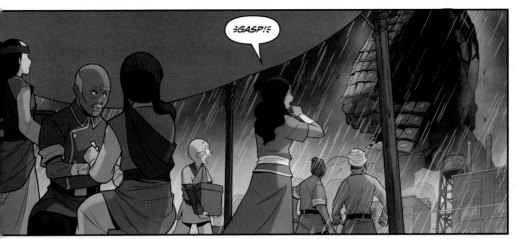

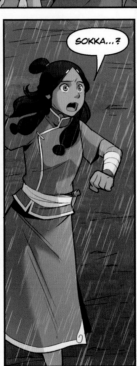

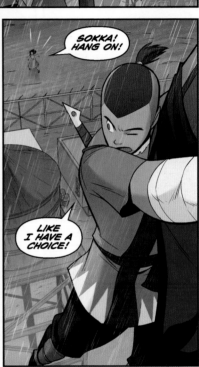

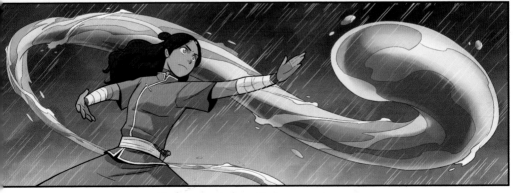

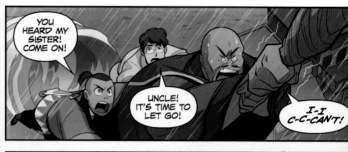

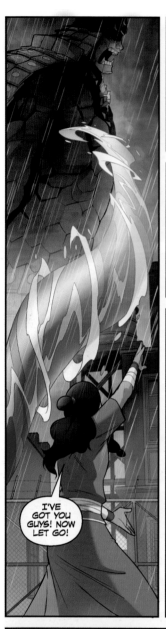

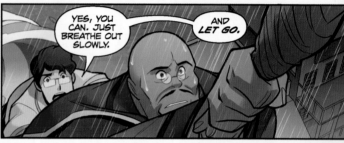

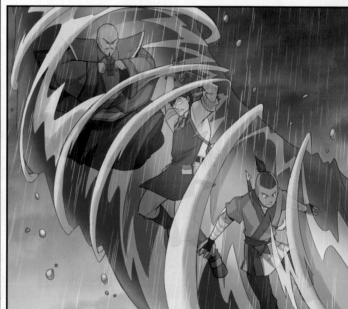

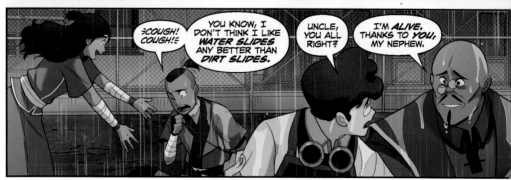

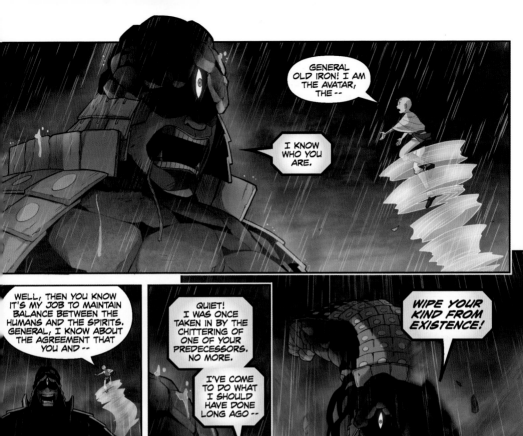

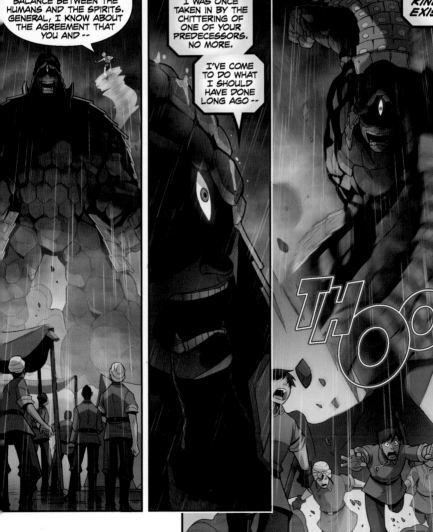

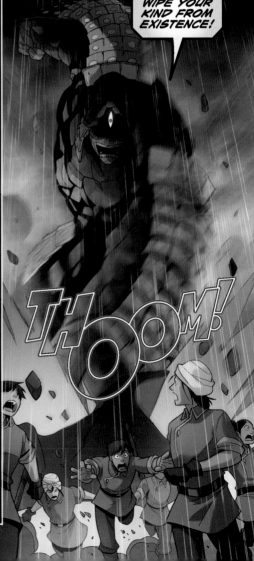

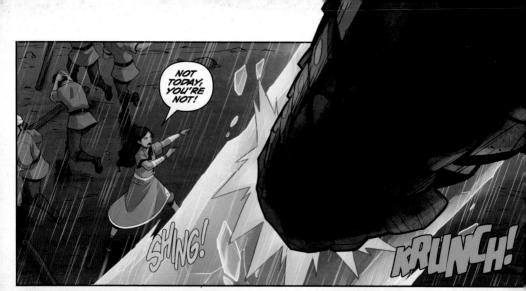

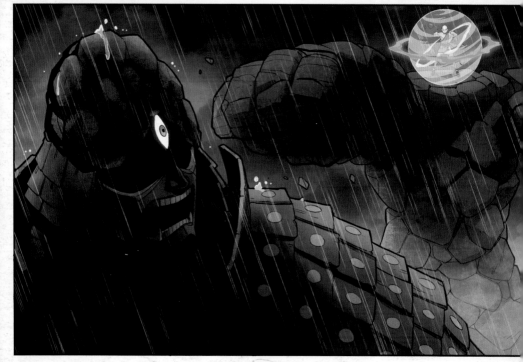

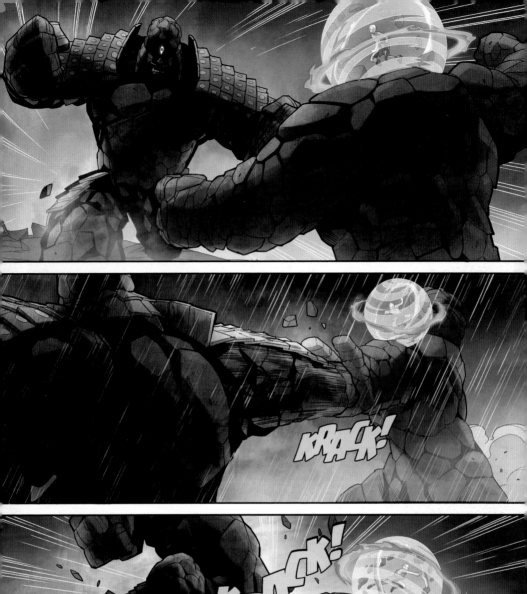

KRACK!

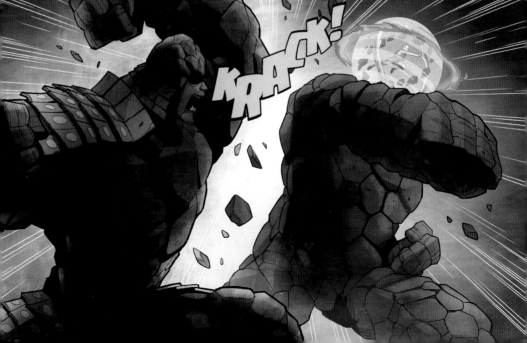

KRRACK!

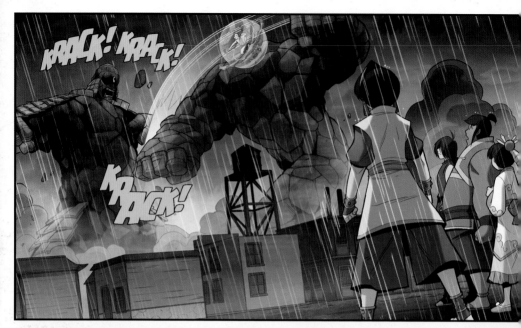

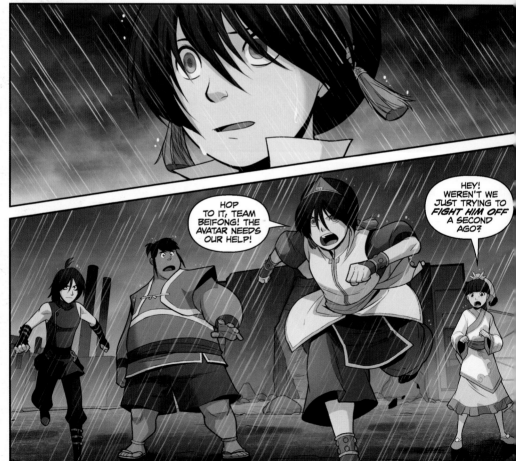

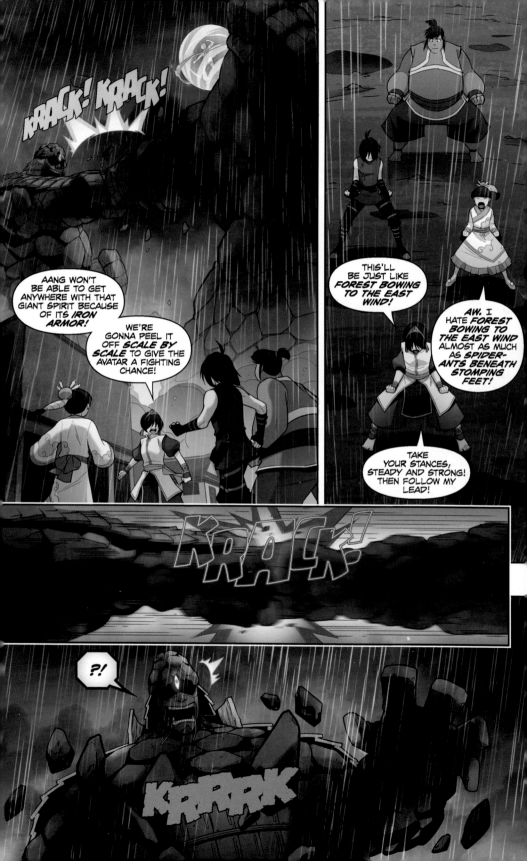

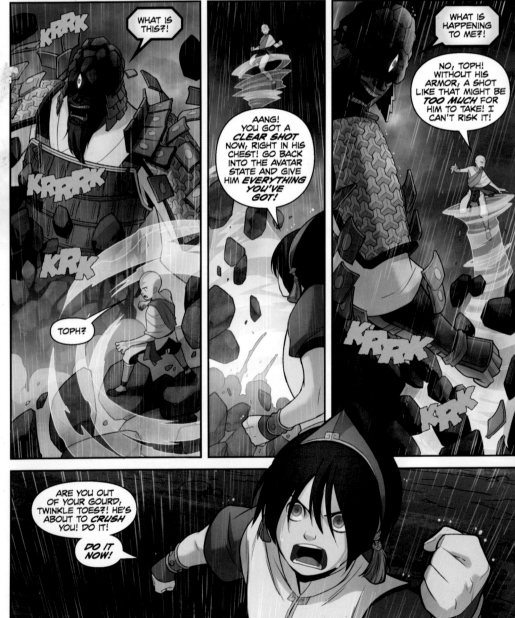

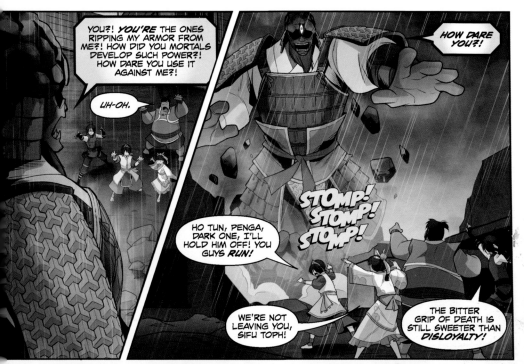

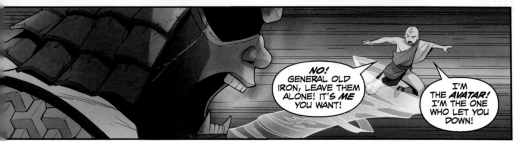

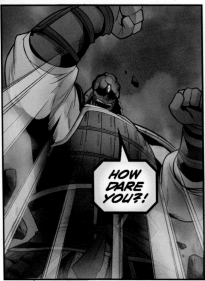

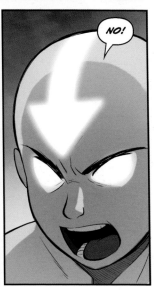

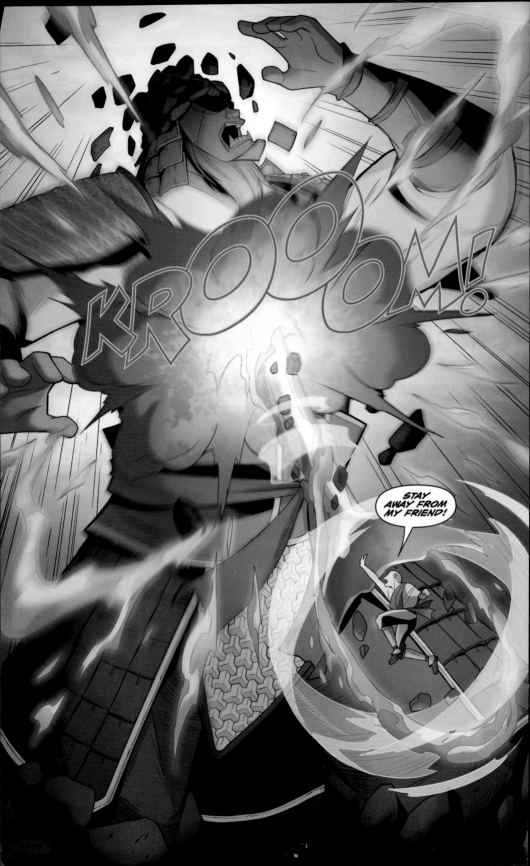

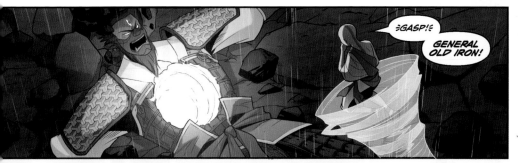

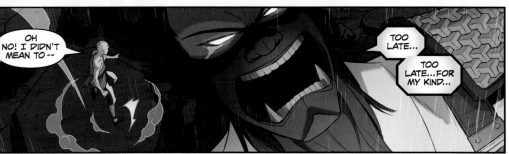

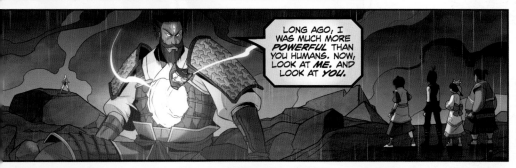

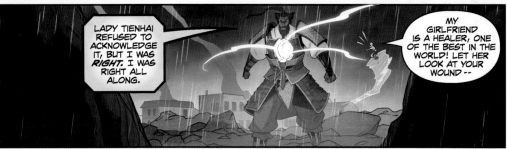

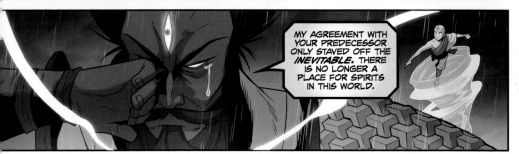

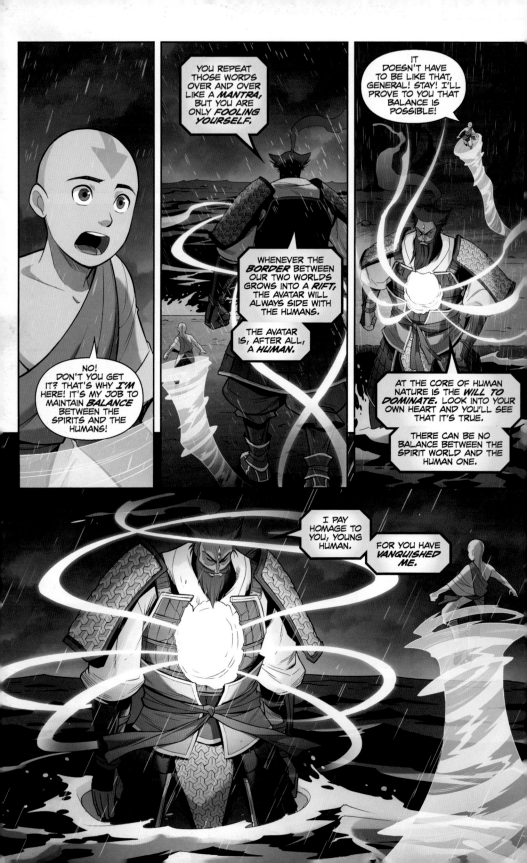

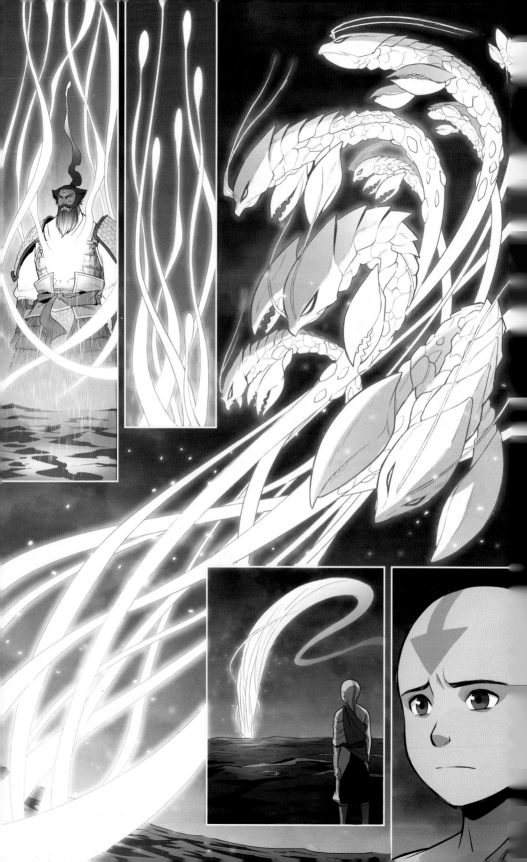

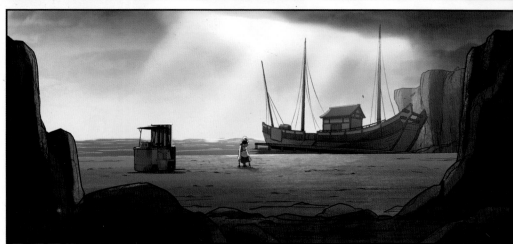

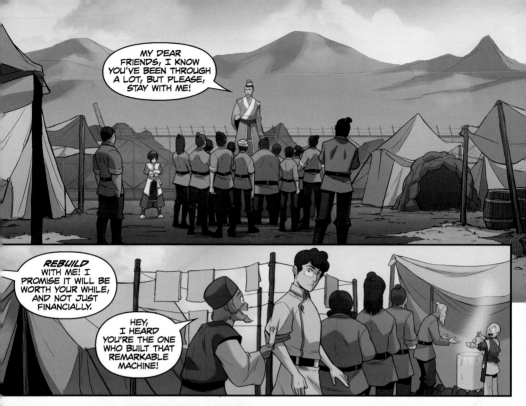

MY DEAR FRIENDS, I KNOW YOU'VE BEEN THROUGH A LOT, BUT PLEASE, STAY WITH ME!

REBUILD WITH ME! I PROMISE IT WILL BE WORTH YOUR WHILE, AND NOT JUST FINANCIALLY.

HEY, I HEARD YOU'RE THE ONE WHO BUILT THAT REMARKABLE MACHINE!

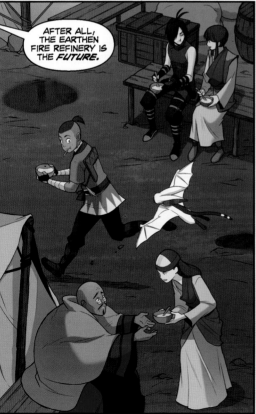

AFTER ALL, THE EARTHEN FIRE REFINERY IS THE *FUTURE.*

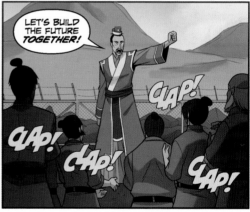

LET'S BUILD THE FUTURE *TOGETHER!*

CLAP!

CLAP!

CLAP!

CLAP!

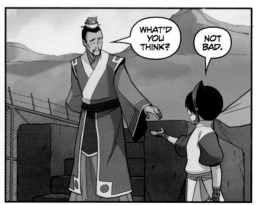

WHAT'D YOU THINK?

NOT BAD.

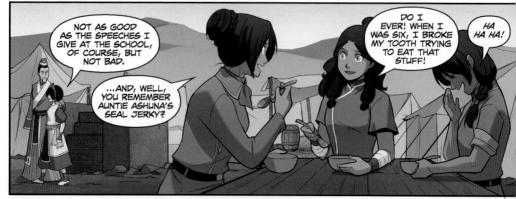

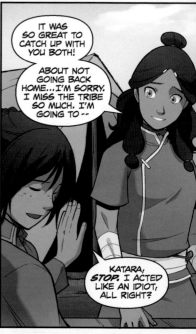

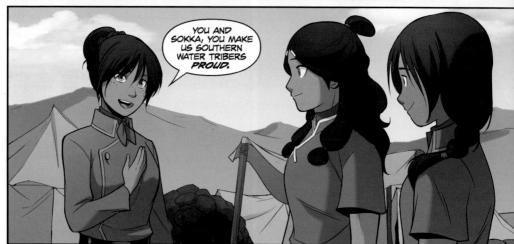

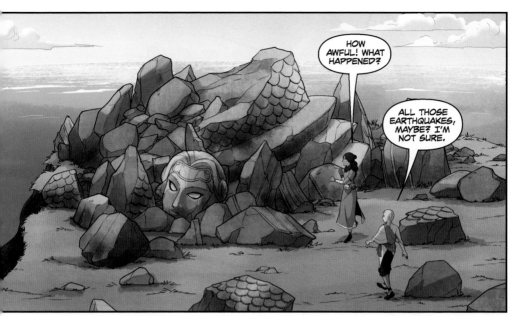

HOW AWFUL! WHAT HAPPENED?

ALL THOSE EARTHQUAKES, MAYBE? I'M NOT SURE.

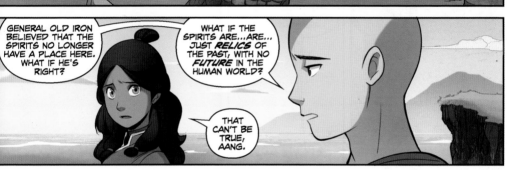

GENERAL OLD IRON BELIEVED THAT THE SPIRITS NO LONGER HAVE A PLACE HERE. WHAT IF HE'S RIGHT?

WHAT IF THE SPIRITS ARE...ARE... JUST *RELICS* OF THE PAST, WITH NO *FUTURE* IN THE HUMAN WORLD?

THAT CAN'T BE TRUE, AANG.

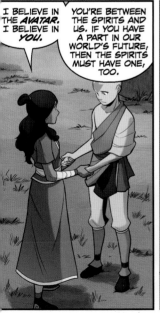

I BELIEVE IN THE *AVATAR.* I BELIEVE IN *YOU.*

YOU'RE BETWEEN THE SPIRITS AND US. IF YOU HAVE A PART IN OUR WORLD'S FUTURE, THEN THE SPIRITS MUST HAVE ONE, TOO.

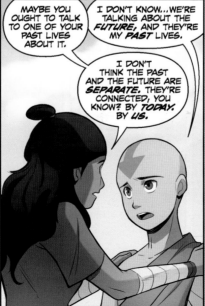

MAYBE YOU OUGHT TO TALK TO ONE OF YOUR PAST LIVES ABOUT IT.

I DON'T KNOW...WE'RE TALKING ABOUT THE *FUTURE,* AND THEY'RE MY *PAST* LIVES.

I DON'T THINK THE PAST AND THE FUTURE ARE *SEPARATE.* THEY'RE CONNECTED, YOU KNOW? BY *TODAY.* BY *US.*

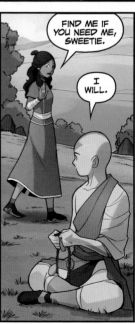

FIND ME IF YOU NEED ME, SWEETIE.

I WILL.

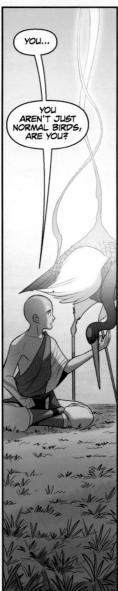

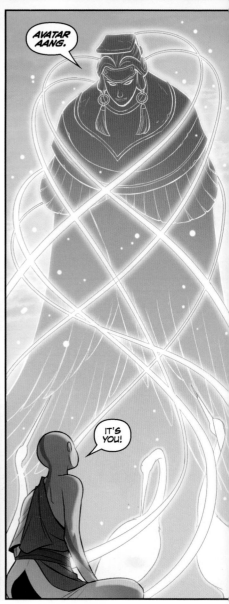

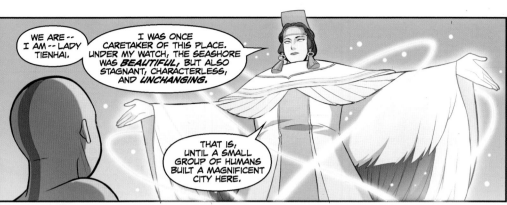

WE ARE -- I AM -- LADY TIENHAI.

I WAS ONCE CARETAKER OF THIS PLACE. UNDER MY WATCH, THE SEASHORE WAS *BEAUTIFUL*, BUT ALSO STAGNANT, CHARACTERLESS, AND *UNCHANGING*.

THAT IS, UNTIL A SMALL GROUP OF HUMANS BUILT A MAGNIFICENT CITY HERE.

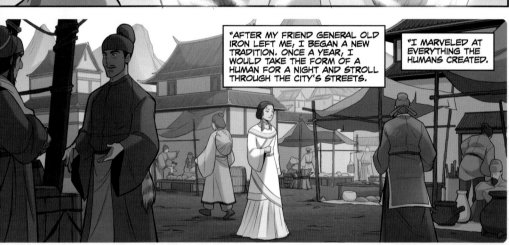

"AFTER MY FRIEND GENERAL OLD IRON LEFT ME, I BEGAN A NEW TRADITION. ONCE A YEAR, I WOULD TAKE THE FORM OF A HUMAN FOR A NIGHT AND STROLL THROUGH THE CITY'S STREETS.

"I MARVELED AT EVERYTHING THE HUMANS CREATED.

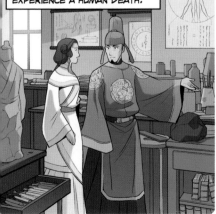

"ON ONE OF THESE VISITS, I MET THE CITY'S PRECOCIOUS YOUNG *PRINCE*. HIS CURIOSITY WAS ENDLESS, AND SO WAS HIS ENERGY. HE MADE THE MOST *BEAUTIFUL THINGS* -- MACHINES AND BOOKS, SCULPTURES AND BUILDING DESIGNS.

"I WANTED TO ALWAYS BE NEAR HIM. I WILLINGLY ACCEPTED MY HUMAN FORM AS *PERMANENT*, EVEN THOUGH IT MEANT THAT I WOULD EVENTUALLY EXPERIENCE A HUMAN DEATH.

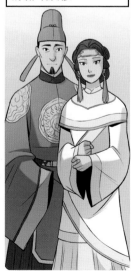

"WE MARRIED.

"MY PRINCE EVENTUALLY BECAME *KING*, AND WE LIVED IN HAPPINESS FOR MANY YEARS.

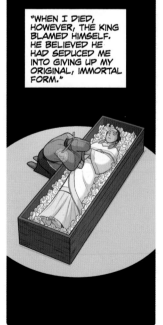

"WHEN I DIED, HOWEVER, THE KING BLAMED HIMSELF. HE BELIEVED HE HAD SEDUCED ME INTO GIVING UP MY ORIGINAL, IMMORTAL FORM."

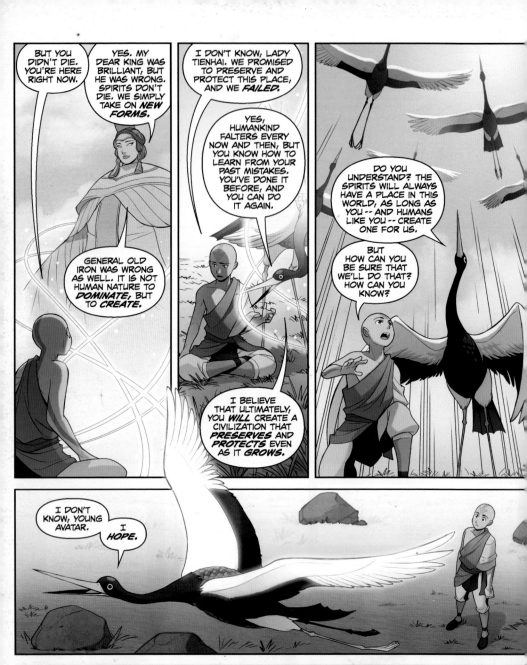

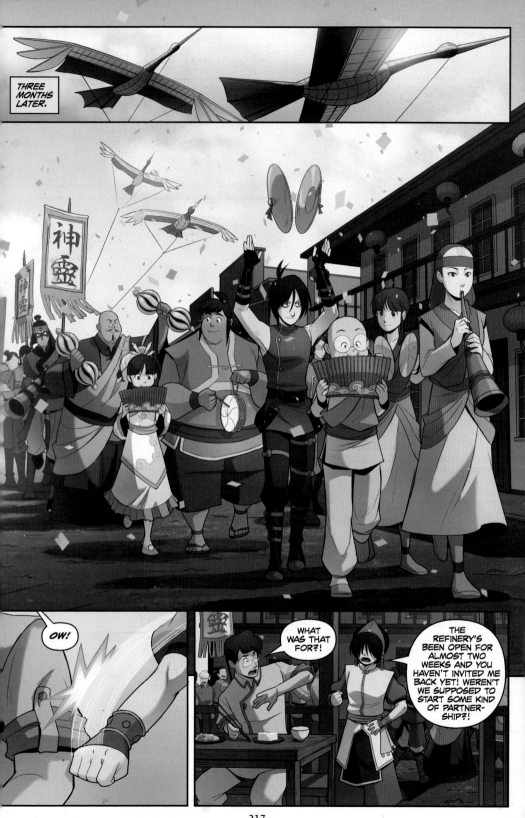

THREE MONTHS LATER.

OW!

WHAT WAS THAT FOR?!

THE REFINERY'S BEEN OPEN FOR ALMOST TWO WEEKS AND YOU HAVEN'T INVITED ME BACK YET! WEREN'T WE SUPPOSED TO START SOME KIND OF PARTNER- SHIP?!

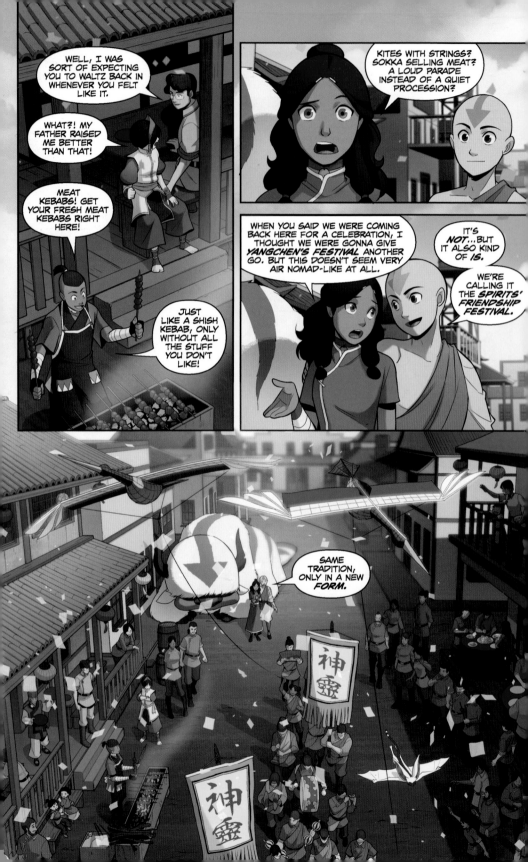

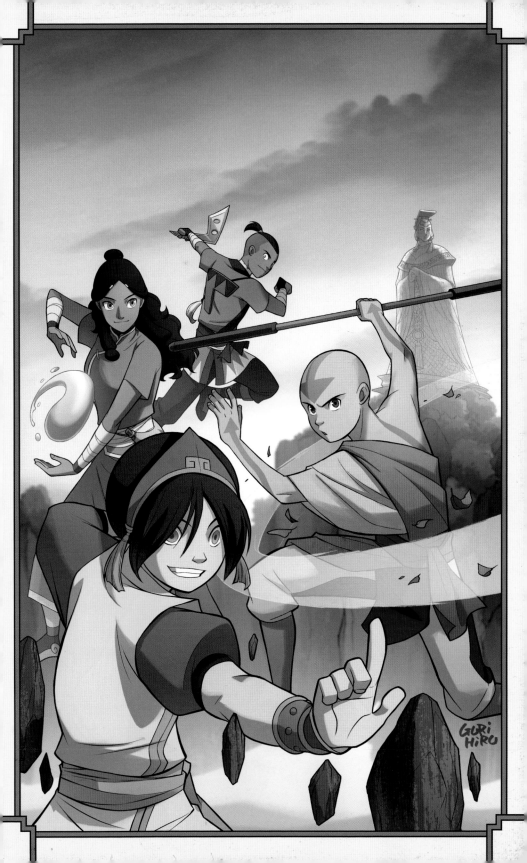

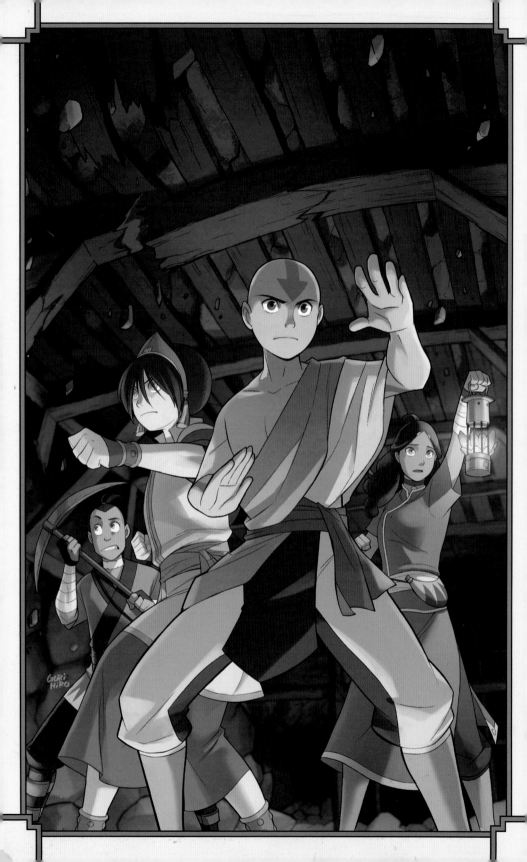

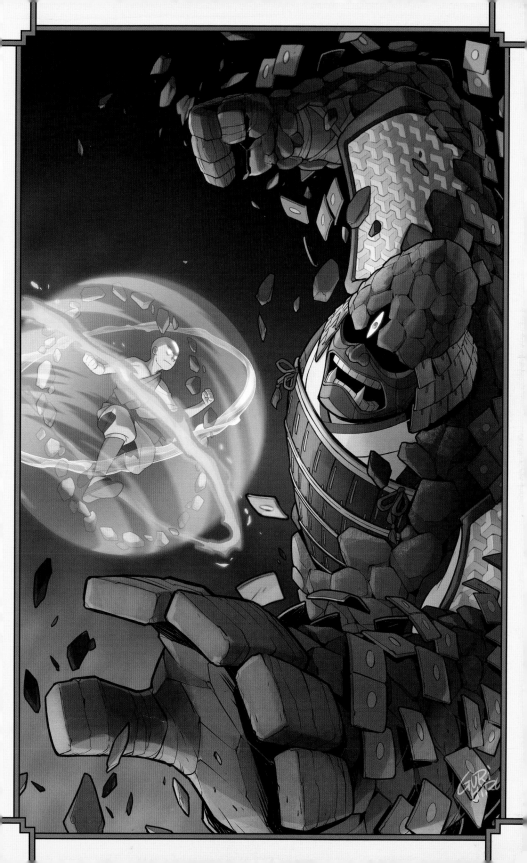

Artwork and captions by Gurihiru

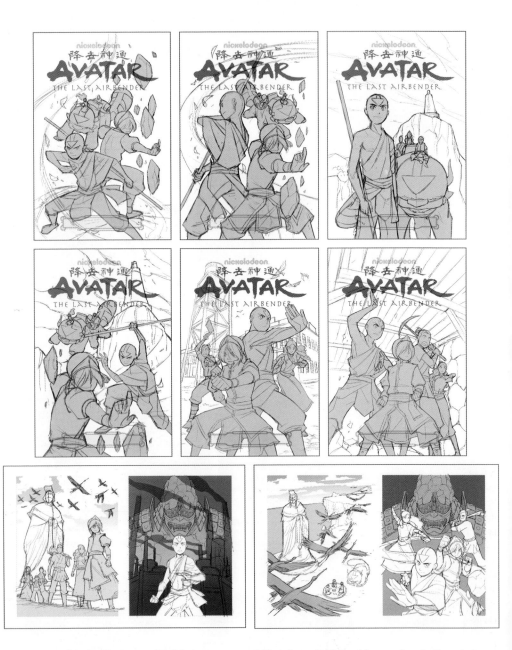

Because of the focus on Aang and Toph in the story, we made them the central focus of the cover layouts. We worked very hard to make each layout unique while keeping this character relationship in mind.

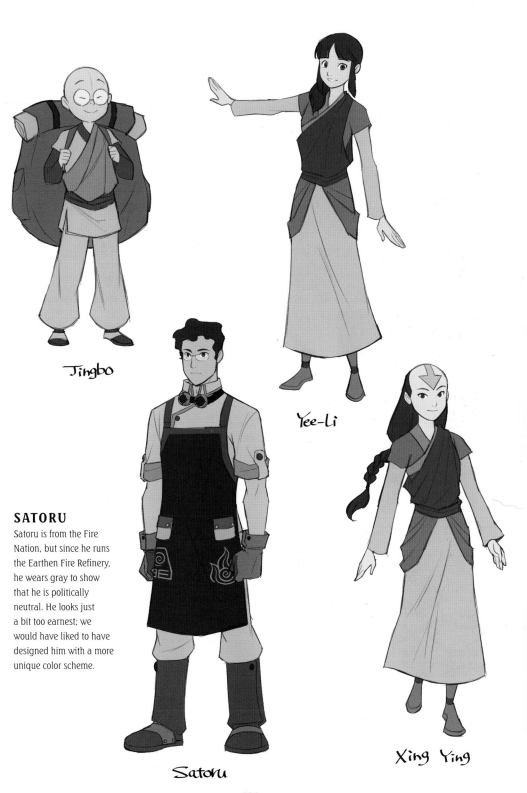

Jingbo

Yee-Li

SATORU

Satoru is from the Fire Nation, but since he runs the Earthen Fire Refinery, he wears gray to show that he is politically neutral. He looks just a bit too earnest; we would have liked to have designed him with a more unique color scheme.

Satoru

Xing Ying

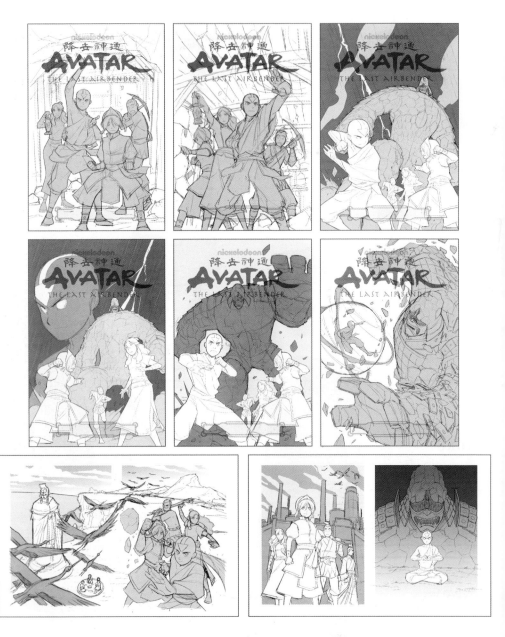

We wanted each trade paperback to be identifiable by its color scheme:
Part One was blue, Part Two was green, and Part Three was red.

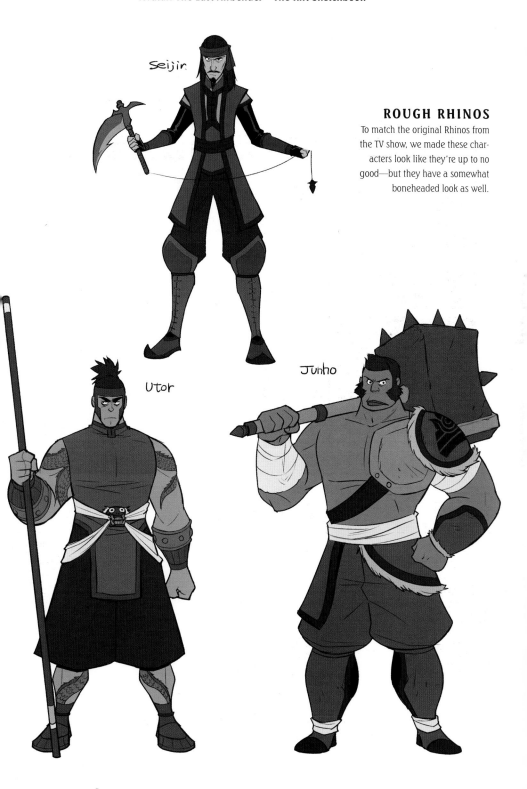

Seijir

ROUGH RHINOS

To match the original Rhinos from the TV show, we made these characters look like they're up to no good—but they have a somewhat boneheaded look as well.

Utor

Junho

Many different types of new machinery are introduced in *The Rift* that have never been seen before. Since the technology is still undeveloped, we wanted to make sure the machines didn't look too high tech.

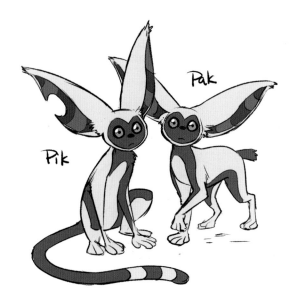

PIK AND PAK

Pik and Pak are winged lemurs, like Momo, and friends of Yangchen's. We gave them different ears and tails, but in the end they didn't appear much, which was too bad.

LADY TIENHAI

Tienhai's model is Mazu, a Chinese goddess of sailing and fishing. In her design we wanted to express the feeling that she loves all living beings.

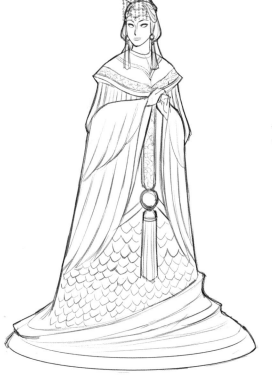

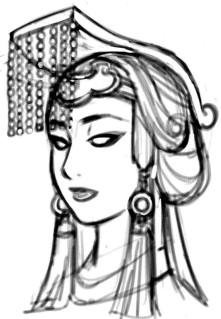

GENERAL OLD IRON

The reason Old Iron has three eyes is because he is based on a clairvoyant Chinese ogre, who used to be an evil god but was turned good by the goddess Mazu. The iron mask around his face is based on the armor worn by Japanese samurai.

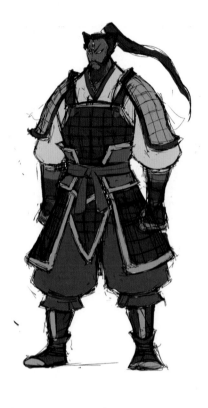

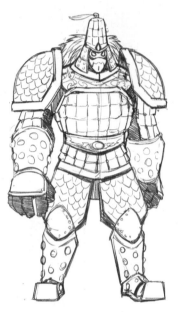

General Old Iron

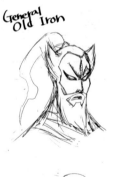

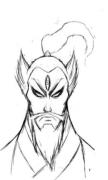

His model is Chinese protector deity "Thousand-Mile Eye"

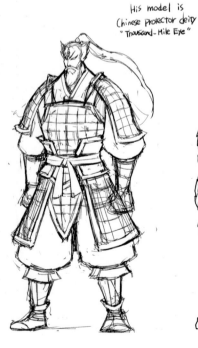

Armor made of interlocking iron ore scales

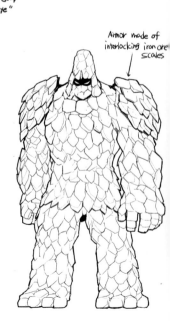

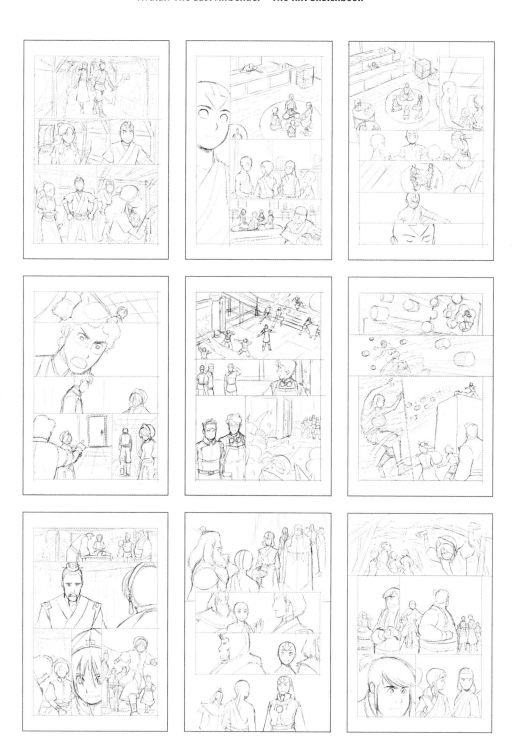

Because there were a lot of new characters to consider, we had to think out each panel composition very thoroughly in order to get them all into the scene clearly.

229

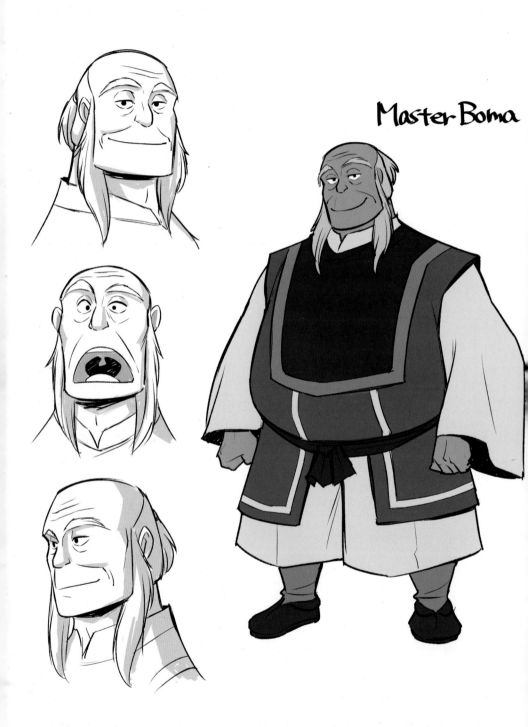

Master Boma

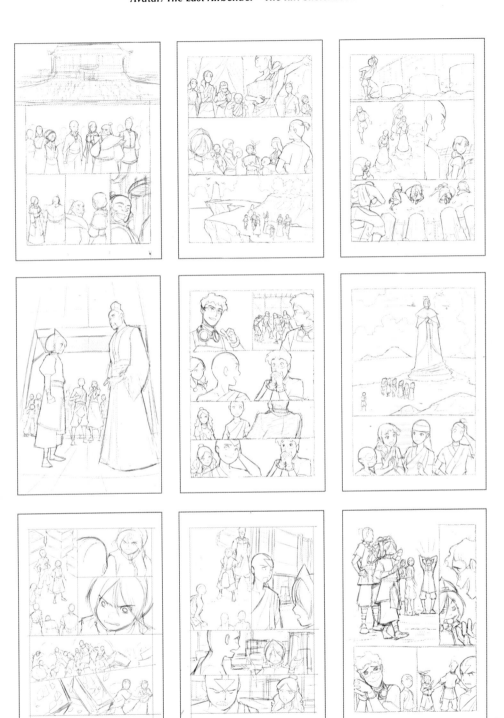

We're always happy when we've finished a story arc. It's great to look at it after it's done, but seeing it also makes us think about how we could have done certain things differently. We look forward to improving in the next story arc.

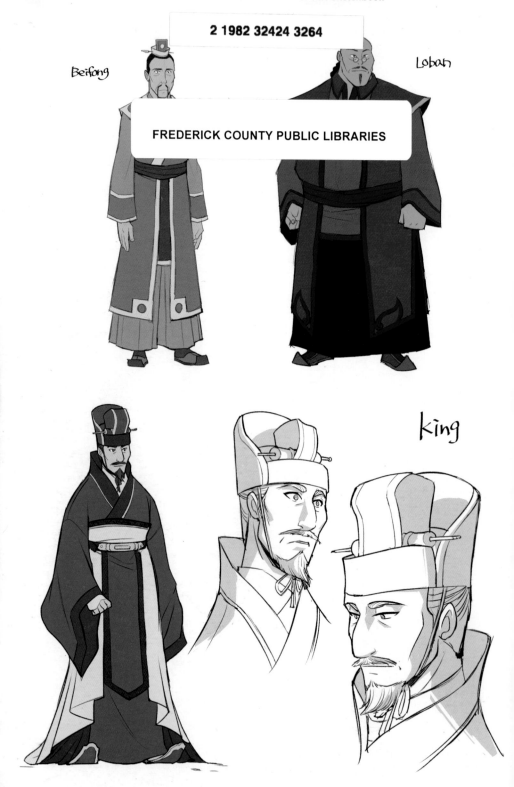

Beifong

Loban

King